SECOND EDITION

# FUJIFILM
# X SERIES

## UNLIMITED

Mastering Techniques
and Maximizing Creativity
with Your FUJIFILM Camera

## DAN BAILEY

rockynook

**FUJIFILM X SERIES UNLIMITED, 2ND EDITION**
Mastering Techniques and Maximizing Creativity
with Your FUJIFILM Camera
**Dan Bailey**
www.danbaileyphoto.com

Editor: Ted Waitt
Project manager: Lisa Brazieal
Marketing coordinator: Katie Walker
Interior design and composition: Kim Scott, Bumpy Design
Cover design: Kim Scott, Bumpy Design
Cover photograph: Dan Bailey

ISBN: 978-1-68198-965-5
2nd Edition (1st printing, June 2023)
© 2023 Dan Bailey
All images © Dan Bailey unless otherwise noted
FUJIFILM logo and X SERIES logo © FUJIFILM Corporation. Used with permission.
This product is not endorsed or sponsored by FUJIFILM Corporation.

Rocky Nook Inc.
1010 B Street, Suite 350
San Rafael, CA 94901
USA

www.rockynook.com

Distributed in the UK and Europe by Publishers Group UK
Distributed in the U.S. and all other territories by Publishers Group West

Library of Congress Control Number: 2022946162

This book is printed on acid-free paper.
Printed in China

# ACKNOWLEGMENTS

I would like to begin by expressing my gratitude to all of my readers, subscribers, blog followers, and everyone who has attended my workshops and presentations. Without your continued interest in what I have to say about photography and FUJIFILM gear, there would be no book.

Although I know you have learned from me, please know that I have learned a lot from you, too. I learn every time you ask me a question via email, on social media, or in person. I often find myself suddenly having to learn things I might not have understood in as much depth, and I have to figure out how to explain a certain topic or technique in an efficient manner so as not to confuse you or myself in the process.

In that way, your constant engagement as active and enthusiastic readers has continued to drive my knowledge and passion about photography and the Fuji cameras as much as anything else. I can say with full confidence that I'm a better photographer because of you.

For that reason, I would like to dedicate this book to all of you.

I'd also like to thank all the awesome people at FUJIFILM North America for making such incredible products that have inspired my photography so much, and for being such wonderful friends. It's been such a pleasure to work with all of you as friends and colleagues.

Special thanks to my editor, Ted Waitt, at Rocky Nook for helping me convert the original ebook version of this book to an actual printed book made with real paper and stuff.

Finally, thanks to Amy for her patience and understanding while I cranked through this project with furious intensity. Now that I'm done, it's time to step away from the computer and go have some fun outside for a while.

# ABOUT THE AUTHOR

**Dan Bailey** has been a full-time adventure, outdoor, and travel photographer since 1996. His immersive, first-person style of shooting often places him right alongside his subjects as he documents the unfolding scene and searches for the perfect convergence of light, background, and moment.

A longtime user of Fuji Photo Film and unwavering devotee of VELVIA, Dan first became enamored with the X Series in the fall of 2011. He fell in love with the X10 and then bought the X20 when it came out.

One of the first photographers to shoot with the X-T1, Dan switched to using the X Series full time in the spring of 2014. A year later, he traded in all his Nikon DSLR gear for more Fuji lenses and a second X-T1.

Currently shooting full time with the X-T5, Dan has used a number of X Series models.

This is Dan's third book. He has written two other print books—*Outdoor Action and Adventure Photography*, published by Focal Press, and *Adventure Photography*, a Falcon Guides title co-published by *Backpacker Magazine*—as well as seven ebooks. His blog was recently rated as one of the Top 100 Photography Blogs on the Planet.

Dan currently lives in Anchorage, Alaska, and he spends his free time exploring gravel bars in his little yellow Cessna, hiking and skiing in the mountains, touring on his mountain bike, and leading photo workshops.

Visit his website at danbaileyphoto.com.

## THE FINE PRINT

Although I have a professional relationship with FUJIFILM North America Corporation as an official FUJIFILM X-PHOTOGRAPHER, this book is in no way sponsored by FUJIFILM Corporation or any of its affiliates. Although I have asked a few friends who are FUJIFILM employees to help clarify certain topics covered in this book, the entire project was done strictly as a personal undertaking by me to help educate and inform other people who use X Series cameras.

Although I use the words "Fuji" and "FUJIFILM" interchangeably in this book when describing the gear, please note that the correct designation for this equipment is FUJIFILM, and that "FUJIFILM," "X SERIES"/"X Series," and the X SERIES logo are all trademarks of FUJIFILM Corporation. Any and all mentions of FUJIFILM or the X Series cameras herein are used solely to reference equipment manufactured by FUJIFILM Corporation. *Whew!*

# CONTENTS

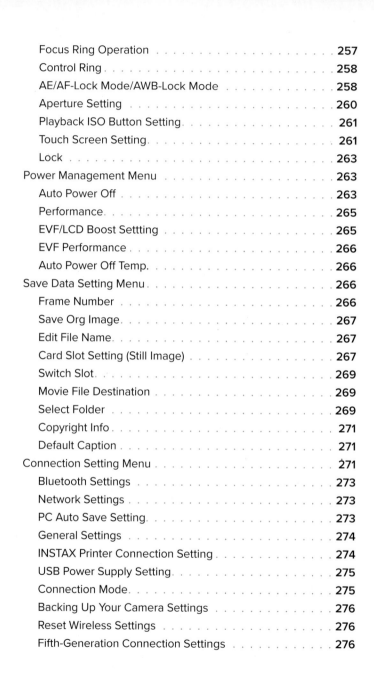

# INTRODUCTION

In 2015, I released my free *FUJIFILM Tips and Tricks* PDF guide.[1] (Note: I place a few endnotes like this throughout the book; they correspond with a collection of *Online References* listed at the back of the book.) Originally conceived as a potential blog post, it turned into a 28-page ebook that's been downloaded by thousands of people in over 30 countries around the world. Now, over eight years later, this new edition has been updated to keep up with Fujifilm's latest generation of X Series cameras.

My goal for the guide was simple. I wanted to share my passion for the X Series and introduce people to some of the features I feel best highlight the technical capabilities, the beautiful ergonomic functionality, and the sense of creative liberation these cameras offer.

My ideas appear to have resonated well with people. I often receive messages from readers who thank me for helping them become a little more familiar with their Fuji cameras. Nearly everywhere I host a Fuji-related event or teach a workshop, I meet people face to face who tell me that they've downloaded and enjoyed my guide.

After writing my tips guide, I worked hard to expand on this information with my blog, presentations, and my personal interactions with other shooters.

Then in June of 2017, after giving an "Advanced X Series" talk at Glazer's Camera in Seattle, where the questions never stopped coming from the full classroom of attendees, I decided it was time for me to write a full-length, advanced X Series book and pick up where my original guide left off.

I had intially resisted writing a book, probably because I was afraid it would get lost in the shuffle of all the other camera books out there. Also, I never would have thought I'd be writing a book of this scope right at the beginning of summer.

**However, I felt it couldn't wait.**

I meet a lot of photographers who are great shooters, and who are very excited about their Fujis, but who don't know even a fraction of what their cameras can do. This is not surprising, and it's certainly no comment on them as intelligent, creative shooters.

For as clean and classic as they are on the outside, when you dig deep, you find that there is an astounding set of features tucked away inside all of the X Series models. If you take the time and learn to master even a few of these features, you'll be able to take the technical and creative aspects of your photography to a new level of proficiency.

That said, the fact remains that most people simply don't have the time to spend learning what every single setting does or how to use them in real-life shooting situations.

**That's where I come in.**

I've been using the X Series cameras for ten years now. I was one of the first people in the United States to shoot with the X-T1 in early 2014, and one of a select number of

photographers to shoot with the X-T2 when the first pre-production models were sent out in 2016.

Having worked closely with the FUJIFILM tech reps and product managers, and having taught numerous Fuji-specific workshops and classes, I know these cameras inside and out, and not just on paper. I know how they function out in the world, and I've tested them with a wide range of subject matter in extremely challenging conditions, environments, and shooting situations.

Yes, the X Series cameras work fine in the cold

As a professional shooter, X Series ambassador, instructor, author, and expert user, I feel I'm exactly the right person to write this guide. Between my real-world X Series knowledge, my experience, and my genuine passion for sharing my photography insight with others, I'm confident I can help you get the most from your Fuji camera.

During the past decade, I've helped many photographers get the most from their X Series cameras, both online and in person at workshops, classes, trade shows, and in-store events. I've explained countless features in great detail, helped people set up and optimize their cameras, solved problems, and troubleshot common, and sometimes, uncommon issues.

**Now let me help you.**

## THE LAYOUT OF THIS BOOK

It took me a while to come up with the best format for this guide. I didn't want to just duplicate the camera menus, but in a way, that seemed like the best place to start.

Every single feature, function, and menu item is there for a reason, either to help you nail a particular kind of shot or to solve a specific photography problem. So, I figured I'd break them all down and explain each one with real-world applications in mind.

I've also included a variety of specific tips and personal insights designed to help you get the most from your FUJIFILM camera. These range from practical tips—like how to set up your Fn buttons and how to configure your camera for shooting fast action—to ideas geared more toward creativity and photographic approach.

However, my goal is not just to instruct you in mechanical operation, but with an overall approach to creative photography. I've included topics like how I use the Film Simulations and how you can customize the look of your images, and I show you ways the Fuji cameras have helped me achieve creative breakthroughs with my own photography.

In the end, I hope this guide does more than just teach you which buttons to press and when to use the XYZ menu setting. Ultimately, I want you to attain a level of mastery with your FUJIFILM camera as if it were a musical instrument or a paintbrush—only a really fancy paintbrush with lots of dials and stuff.

I want you to be able to know your camera so well and be so comfortable with its operation that it no longer becomes just a tool, but a **seamless extension of your own creativity**. My goal is to train you to achieve the ultimate level of creative freedom, inspiration, and artistic expression with your photography.

In Japan, there are a couple words to express this kind of path toward mastery:

- **Shūjuku** 習熟 means to "study and ripen" with your knowledge and skill level.
- **Jukuren** 熟練 means expertise, skill, or proficiency through practice and repetition. The literal translation is to "ripen and repeat."

This book will help you begin the process of **Shūjuku**, where you'll study and ripen your knowledge about everything your FUJIFILM camera can do.

Then, it will be up to you to try out all these settings and controls, figure out what works for your style of shooting, and then use your camera as often as possible.

A few minutes each day will make a huge difference. Even if you're not actually shooting anything, you can still practice and pretend. Anytime you play with the camera or fiddle with the buttons and menus, you'll learn something new and you'll get better.

Got a few minutes during your lunch break or while waiting for the train? Instead of checking Facebook, pick up your camera, learn one or two settings, and think about how you might use them in your photography.

Scroll through the menus to see where each setting lives. Find one that looks useful? Assign it to a Fn button or stick it in your **MY MENU** and put it into action the next time you're out shooting.

If you have the ebook version of this book, then I encourage you to keep a copy on your phone or tablet for quick recall reference when you're out in the field or away from your computer. Also, you'll see that the ebook has been formatted with links so you can quickly jump back and forth to find the specific entry you're looking for, or to read more about a particular topic.

In addition, I've included a number of links throughout the book that reference specific websites or resources I mention in the text. They're denoted with endnotes; if you're reading the print version, you can find the URLs for those websites and pages at the end of this book.

As with anything in life, the key is repetition. Only with regular practice will you attain the level of **Jukuren** photographer.

# DIFFERENTIATING CAMERA MODELS

In 2016, FUJIFILM redesigned the look and organization of the menu system. Moving forward, all of the cameras introduced since the X-Pro2 use the new system, which features white text on black and includes a brand-new "MY MENU."

At the time of this writing, cameras that feature the newer menu system are the X-Pro 2/3, X-T2/3/4/5, X-H1/2, X-T20/30, X-E3/4, and X-100F/V. For the purposes of identification, I'll refer to them collectively as the **"MY MENU"** cameras when discussing specific menu items or features that are specific to all of these models.

These cameras all feature the "X Processor Pro" processing engine. Compared to previous models, these updated chips have added an enormous jump in processing power, allowing for increased performance as well as specific features and upgrades the non–X Processor Pro models don't have.

For simplicity, when discussing specific features, I often specify fourth- and fifth-generation models. The fourth-generation models include the X-T3, X-T4, X-Pro 3, X-T30, X-E4, X-S10, and X-T200; and fifth-generation models currently include the X-H2, X-H2S, and X-T5.

When referring to the non–X Processor Pro cameras (I don't want to say "older," because that makes them sound less relevant, which they most certainly are not!), I'll use the term **"RED/BLUE MENU"** cameras. These include the X-Pro1, X-T1, X-T10, all X100 models prior to the "F" model, the X-E1, X-E2, X-E2S, X70, X-T200, and the X-A series, as well as the now-discontinued X10/20/30.

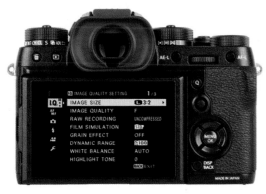 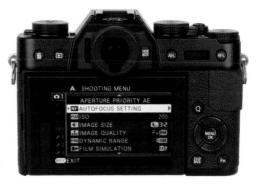

The "MY MENU" system (left) and the "RED/BLUE" menu system (right)

# HOW THIS BOOK IS FORMATTED

Since all X Series cameras moving forward use the newer menu system, I've decided to format this book according to the layout of the menus found in the MY MENU models.

So, if you have an X-T5, X-T4, X-T3, X-T2, X-Pro 3, X-Pro2, X-H1, X-H2, X-H2S, X-T30, X-T20, X-E3, X-E4, X100V, X100F, or X-S10 (or an even newer model), it should be extremely easy for you to follow along. Each section will correspond to the exact layout of the menu system on your camera. That said, most of the features found in the MY MENU cameras are also found in the RED/BLUE models as well.

Wherever possible, I will notate where you can find each feature I discuss in the RED/BLUE models with a simple color designation. For example, you'll find the IMAGE SIZE menu item in one of the RED MENUS and the BUTTON/DIAL SETTING in one of the BLUE MENUS, and so forth. I wish the RED/BLUE menus were standard on all cameras, but they're not. They differ wildly between models. This means you'll have to go looking, but at least you'll know where to start.

While many of the settings I cover in this book are universal to all models, keep in mind that **not all cameras have every single feature.**

Although I have tried to notate when specific features are limited to certain models, I'm simply not able to cover which cameras have what feature for every single model without making this book a big mess.

If you have a RED/BLUE model, know that **you still have a very capable FUJIFILM camera that has most of the settings discussed in this book**. It may not have everything, so as much as I hate to say this, if you're unsure about whether your camera has a certain feature or not, please refer to your camera manual.

If you don't like paging through your paper manual, you can find searchable electronic versions of all the X Series manuals on the FUJIFILM website.[2]

# THE REALLY IMPORTANT STUFF

There's a lot of information in this book, but I've tried to make it easy to follow. I don't want you to get bogged down or lost while you're trying to search for some setting you can't remember the name of. To help you find your way around, and also to let you skip around, if that's your style, there is a comprehensive Table of Contents. Also, if you have the ebook version, you can take advantage of all the internal links I've included.

I'm sure you'll want to read everything in here, but maybe not all at once or not necessarily in order. To get you started, here are a few random features, settings, and tips I find essential, useful, or at least interesting:

- **IN CAMERA RAW PROCESSING**: You can use the camera to process your RAW files using the RAW CONVERSION option (found in the PLAYBACK MENU [see Chapter 8]). You can even do this with older RAW files. As long as you still have the original RAW file, you can copy it to a memory card, stick it back into your camera (it must be the same model of camera you used to create the image), and the camera will be able to read and perform the conversion. Note: This also applies to images you want to transfer to your mobile device using the FUJIFILM Camera Remote app.

- **BACK-BUTTON FOCUS:** You may be eager to learn how to set up the camera for back-button focus. You can find information about that topic in the "Focus Control" section later in this chapter.

- **T MODE:** The X Series cameras all have a "T" setting on the shutter speed dial. This mode allows you to control your shutter speed with one of the command dials and allows for a wider range of shutter speeds, down to 15 minutes on the X-T2, X-E3, and X-Pro2. I talk about T mode shutter speeds later in this chapter.

- **FUNCTION BUTTONS:** All X Series models have customizable Function (Fn) buttons that allow for personalized setup of the camera based on your own shooting style. To set any Fn button, press and hold the DISP/BACK button to bring up the Fn Button menu. I talk about Fn buttons later in this chapter.

- **Q MENU:** The Q menu is a quick-access menu that can be customized to include the shooting features you use most. I discuss the Q menu later in this chapter.

- **HOW TO SHOOT FAST ACTION:** Many photographers struggle with how to set up their cameras for shooting action and how to achieve sharp images. I cover this in depth in the "Tips for Shooting Fast Action" section later in this chapter.

- **SOMETHING NOT WORKING?** If a specific function won't work, check to make sure you didn't accidentally switch your Drive dial to another setting or that your AUTO switch isn't engaged. These are often the likely causes of many issues. Read the troubleshooting section at the end of this chapter to see a few more solutions to common and uncommon problems.

- **FORMAT MEMORY CARD SHORTCUT:** If you have a MY MENU camera, press and hold the TRASH button for about 2.5–3 seconds, and then while still holding it down, press the rear command dial to bring up the FORMAT confirmation page.

## Other Interesting Settings

Here are a few other settings I find especially useful and where to locate them in the book:

- **AE/AF-Lock Mode:** *Chapter 7: Set Up Menus*

- **Custom Settings:** *Chapter 2: Image Quality (I.Q.) Settings*

- **AF+MF (Autofocus and Manual Focus):** *Chapter 3: Focus Menus—AF/MF (Autofocus / Manual Focus) Settings*

- **MF Assist:** *Chapter 3: Focus Menus—AF/MF (Autofocus / Manual Focus) Settings*

- **Store AF Mode by Orientation:** *Chapter 3: Focus Menus—AF/MF (Autofocus / Manual Focus) Settings*
- **Preview Exposure/White Balance in Manual Mode:** *Chapter 7: Set Up Menus*
- **NATURAL LIVE VIEW:** *Chapter 7: Set Up Menus*
- **Shutter AF/AE:** *Chapter 7: Set Up Menus*
- **Voice Memo Setting:** *Chapter 8: Playback Menu*
- **Photobook Assist:** *Chapter 8: Playback Menu*
- **INSTAX Printer Print:** *Chapter 8: Playback Menu*

## One More Thing

I have included a lot of pictures in this book. Some are used to directly illustrate specific topics within each section, while others are there to act as page breaks, chapter breaks, and eye candy. As you look at each picture, try to identify some of the techniques and settings you think I might have used in order to create that shot, and consider the specific settings *you* might use in a similar situation.

# CAMERA CONTROLS

The hands-on, traditional layout of FUJIFILM cameras allows for quick access to the tools and settings you need without forcing you to scroll through multiple pages of camera menus. This is one of the most fundamental and conceptual intentions behind their design, and in my mind, it's one of the things that helps make you a better, more efficient photographer. **The faster you can make a change, the more likely you'll be to nail the shot.**

It's also one of the reasons why many FUJIFILM shooters find these cameras so enjoyable to use. Traditional, mechanical dials and switches on the top deck and working aperture rings on the lenses provide tactile, physical controls with which to adjust all of your basic camera settings, like shutter speed, aperture, ISO, and exposure compensation. These controls lie right where you'd expect them to be, and it feels good to handle them as you change your settings quickly, with satisfying clicks.

Add in the command dials, Touch Screen, Function (Fn) controls, the PSAM/C1-7 mode dial on the X-H models, the Control Ring on the X100FV and X70, the Q menu,

and the MY MENU, and you have access to nearly every setting you would ever need to change in a real-world situation right at your fingertips.

This is the beautiful functionality of the X Series. You could shoot all day, all week, or even during an entire month-long trip without ever having to dig into the actual menus. If your fingers know exactly where to go and what to do in order to nail the shot, it will just be second nature.

Then, on any given day, you may find yourself in an entirely new type of situation. You'll suddenly remember a feature or setting you rarely use, but that might come in handy for this scene. Again, you'll know exactly where to find it, and you'll remember what it does because you read and studied this book and practiced with the setting, even if it was just once or twice.

Your fingers will already be navigating to the right menu; you'll pull it up, set it accordingly, and nail the shot. That's what it means to be a **Jukuren** photographer (see the Introduction for more on the term *Jukuren*).

## NAVIGATING THE MENUS

Although I just said that you could shoot all day without using the menus, the fact is that you'll have to dig down under the hood at some point. That's where all those special settings live that make the X Series cameras so powerful and highly customizable. The menus are where you'll set many of the specific parameters that make the camera *do what you want*, in the *way that you want*.

With this in mind, it helps to be as efficient as you can be with your camera, even when scrolling through menus and changing settings. Here's a quick primer on how the basic controls and the menu system work and how to get around the menus quickly and efficiently.

### Getting Into and Around the Menus

The way you access the menus on your X Series camera is by pressing the MENU/ OK button. I know that's probably pretty evident, but just in case...we got it out of the way.

This will bring you to the very first menu item in the very first menu. On the MY MENU cameras, you'll land at the IMAGE SIZE option in the IMAGE QUALITY SETTING menu at the top. On the RED/BLUE cameras, you'll land at the first RED MENU, which unfortunately has a different setting for almost every single model.

1.1

On the MY MENU cameras, pressing the OK button will bring you right to the first item in your MY MENU, if you have saved anything to this menu. See the MY MENU section, found in the SET UP > USER SETTING menu for more info (page 228).

**To move around the menus**, you can either scroll using the four buttons on the thumb pad, or you can scroll by using the AF joystick, which is found on the X-T2, X-Pro2, X-E3, and X100F. Or use the command dials to scroll. On the MY MENU cameras, use the front command dial to move between pages and the rear dial to move between items.

(Note: The X-E3 was built with an ultra-streamlined design, and instead of the four thumb pad/Fn buttons, it features a brand-new touch screen control system. Read more about this in the next section.)

**To select anything in the menu**, press the MENU/OK button. You can also press the AF joystick. The official name for this control is the FOCUS LEVER, but most people know it as the joystick, and that's what I usually call it, so I'll use that term most of the time.

If you have an X-T2, X-Pro2, X-E3, or X100F, using the joystick for both movement and selection is the fastest and easiest way to navigate the menus.

This is also the way you navigate through any settings you have assigned to a Fn button. Note: When using Fn button settings, you don't actually have to select anything; you simply scroll to the option you want and then resume shooting. This will save you even more time.

## Getting Back Out of the Menus

The easiest way to exit any regular menu, Fn button menu, or Q menu is to simply tap the shutter button lightly. This brings you right back to your viewfinder display. You can also press the DISP/BACK button, which does the same thing. I prefer the shutter button method, since it immediately puts you back into picture-taking position with your finger on the shutter.

# TOUCH SCREEN CONTROLS

Some X Series cameras feature a touch screen LCD, which allows you to perform certain functions by tapping and pinching in and out on the screen. As of this writing, all fourth- and fifth-generation X Series models have touch screen features.

All of these models allow you to use optional "Touch Shooting" features, which include **Tap to Shoot** and **Tap to Focus**, as well as **Tap to Zoom/Pinch to Zoom** during playback. (The X-A3 allows you to perform **Pinch to Zoom** in Shooting mode, which gives you a digital zoom effect. You can turn the touch controls off.)

In designing the X-E3, the Fuji engineers eliminated the four thumb pad/Fn buttons from this camera, and instead gave it an innovative set of new touch screen controls. The X-E3 touch screen has been programmed to recognize a number of commands, including **tap**, **double tap**, **pinch in and out**, **drag**, and **flick**. When performing these gestures, you can quickly control a number of camera functions. Here's what they do.

## Shooting Mode and Playback Mode

**Flicking** up, down, left, and right acts as your **Fn button controls**, just as if you were pressing the four thumb pad buttons. Like all the other X Series cameras, you can program and assign any number of settings to the Fn buttons and control them with just a simple swipe of your finger on the screen.

1.2

**Double tap** instantly zooms your image in and out to 100% during playback and performs **focus check** while shooting.

**Tap and/or Drag** controls **AF Area Selection**. Although the X-E3 has the AF joystick, it's even faster to select and move your selected AF point around the screen using the touch screen. This is a very cool feature. Even though I'm quite proficient with my AF joystick, I was highly impressed with how well this works. The points will pretty much move as fast as you can tap or drag your finger around the screen.

**Pinch in/out** operates **Playback zoom**. Whereas a double tap performs an instant 100% zoom, pinching lets you zoom in and out to view the image at different magnification levels and sizes on the screen.

**Swipe** left and right shows you your next picture in Playback mode.

**Q menu:** After bringing up the Q menu, you can quickly select and change your settings by tapping the screen.

### Touch Panel Operation While Using the EVF

I know what you're thinking: While these functions work extremely well if you're shooting via the LCD screen, it could be tough to navigate the screen if you've got your eye up to the electronic viewfinder, right?

Well, Fuji apparently thought of that, because these models give you the option to **set the touch range of the panel to Full Screen, Right Half Only, Left Half Only, or Off.** This function has also been added to the X-T20 in the v.1.10 firmware update.

**Note:** Wherever I indicate a function in this book that requires pressing a thumb pad button, you'll need to perform a flick gesture instead if you don't have a thumb pad.

## THE COMMAND DIALS

In addition to the very pretty and classic milled metal dials that control shutter speed, ISO, EV+/−, and Drive mode, the X Series cameras all have front and rear command dials, except for the X70, which has a rear "dial switch."

The command dials on every camera rotate and let you scroll through a number of parameters, like shutter speed, aperture, ISO, and EV+/−. They also let you scroll through the Q menu, switch between pictures in Playback mode, and zoom in or out when viewing your photos.

In addition, one or both dials are "pressable" on most of the Fuji cameras. In certain modes, this secondary function allows you to toggle between things like shutter speed, EV+/−, and ISO, and also performs zoom functions in Playback mode. As this varies between cameras, please refer to your manual to see what these functions do on your particular model.

### Front Command Dial

On most cameras, rotating the front command dial adjusts the aperture. On some models, it selects your exposure compensation value when **C** is selected on the EV+/− dial. It also lets you scroll through your pictures during playback.

In certain cameras settings, pressing the front command dial toggles between aperture, shutter speed, and exposure compensation if you're in C mode.

## Rear Command Dial

Rotating the rear command dial lets you choose your desired combination of shutter speed and aperture in Program mode, fine-tune shutter speed, adjust settings in the Q menu, choose size of focus frame, or zoom in or out in full-frame or multi-frame playback.

Pressing the rear command dial lets you zoom in to 100% on your selected focus point in shooting mode, or on your shot images when playing back your photos. **This is an extremely useful and highly recommended function, as it instantly allows you to check your scene or your images for sharpness.**

You can also swap command dial functions. See the "Command Dial Setting" section in *Chapter 7: Set Up Menus* for more info.

# DRIVE CONTROL

The DRIVE control allows you to select between your shooting modes. All X Series cameras have the following DRIVE modes:

- STILL IMAGE/SINGLE
- CONTINUOUS L (CL)
- CONTINUOUS H (CH)
- BRACKETING (AE/ISO/FILM SIM/ WB/DR)

- PANORAMA
- MULTIPLE EXPOSURE
- ADV FILTER

Depending on which camera you're using, you access your DRIVE settings either via the selector switch beneath the ISO dial, the left top deck dial (X-T10/20/30), or a dedicated DRIVE button, either on the back of the camera or on the top deck (X70). See Figures 1.3 and 1.4.

**1.3** Image courtesy of FUJIFILM

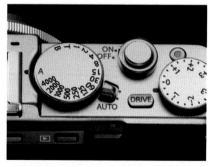

**1.4** Image courtesy of FUJIFILM

Again, depending on your camera, there are different ways to change your DRIVE settings. On the X-T2/3/4/5 and X-T20/30, you access your DRIVE SETTING options within the SHOOTING SETTING menu.

On the X-T1, X-T10, and older X100 models, look for the BKT/Adv. SETTING, which is found somewhere in the RED MENUS. (I wish all the RED/BLUE menus were standard, but they're not. *Sigh*. On the X-T1, it's RED1. On the X-T10, it's RED5.)

On cameras that have a dedicated DRIVE button, you'll adjust all of your DRIVE settings right from there. Simply scroll down until you find your desired function, then adjust accordingly.

## PASM/C1–7 MODE DIAL

The X-H cameras and the X-S10 use a slightly different control layout that's built around the Mode Dial, which is found on the top deck.

The **P, S, A, M** settings allow you to choose between shooting in Program, Shutter Priority, Aperture Priority, and Manual, as described in the Exposure Modes section. **AUTO** and **SP** correspond to the Full Auto Switch and Scene Modes. Or switch to MOVIE mode to shoot video.

**FILTER** allows you to shoot with the super-fun creative filters described in the ADV Mode Filters section.

Modes **C1–7** are Custom Modes that allow you to switch between still photography or movie shooting presets that you assign. To set up your Custom Modes, go to the CUSTOM MODE SETTING menu inside the IQ Menu. From here, you can choose each of the C modes and designate whether it will be set as a STILL or MOVIE preset.

Then go to the Custom Settings menu and select either SAVE CURRENT SETTINGS, to save the current camera configuration to one of the CUSTOM slots, or EDIT/CHECK, to highlight and add specific camera settings to that slot by following the menu prompts. When you're done, hit OK. You can also RESET, COPY, and even create a CUSTOM NAME for your settings. You now have instant recall access to your saved custom presets.

Note: The X-S10 only has C1–4, and you can only use still photography presets.

# EXPOSURE COMPENSATION DIAL

The Exposure Compensation dial (EV) is an extremely useful tool. When working in any auto exposure mode (Aperture Priority, Shutter Priority, or Program), turning the EV+/– dial will adjust your exposure by the number of stops indicated on the dial, up to +/– 3 stops.

**I use this dial *all the time*.**

I often shoot in Aperture Priority mode, and if the scene I'm looking at in the view-finder is lighter or darker than what I'm intending, I simply nudge the dial one way or the other in order to adjust the exposure of the scene. In that way, it's essentially an exposure override knob that lets me fine-tune my scenes exactly how I want.

I *highly encourage* you to make use of the EV+/– dial in your photography. Work it into your shooting style and you'll see how it can help you. One of the best things about shooting with mirrorless cameras is that what you see is what you get, no matter if you're looking through the EVF or on the LCD screen.

If your exposure looks too dark, then lighten it up with the EV dial. If it's too light, turn it the other way until your scene looks exactly how you want. The key is that you can make it look how you want because what you see in the viewfinder will be exactly what you get when you press the shutter. See Figures 1.5 and 1.6.

Get to know the EV+/– dial. If you shoot in Auto mode, it's your best friend.

Of course, if you shoot in Manual mode, the EV+/– dial does nothing. When shoot-ing in Manual mode, you change your exposure by directly adjusting an exposure parameter (aperture, shutter speed, or ISO).

**1.5** Auto metered exposure

**1.6** Reduced exposure value using the EV+/– dial

## EV "C Mode" on the "MY MENU" Models

Some models have a special Custom, or "C" setting, on the EV+/− dial that lets you adjust up to +/− five stops of exposure compensation. To operate this mode, turn the dial to C and press the front command dial to active. You can now rotate the front command dial to make your EV adjustments. When you've got the look you want, press the dial again to lock it.

Locking the dial prevents you from inadvertently nudging it and making accidental adjustments. You can also combine this with the special AUTO ISO DIAL SETTINGS A setting (see the "Button/Dial Setting Menu" section in *Chapter 7: Set Up Menus*, page 246) when the ISO dial is set to A. This allows you to toggle between setting the ISO and shutter speed (and aperture, if there isn't an aperture ring on the lens) by using the front command dial for both.

# AE-L AND AF-L BUTTONS

All X Series cameras have AE-L and AF-L/AF-ON buttons, which function as Auto Exposure Lock (AE-L) and Autofocus Lock (AF-L) controls. Some cameras (X-Pro1, X-E1, X70) have a single button that controls both AE-L and AF-L. For these cameras, there's a specific menu item that allows you to set the button to control either AE-L, AF-L, or both.

When shooting in any of the auto exposure modes, if you press the shutter halfway down, you engage your camera's exposure meter and autofocus system. If you keep your finger pressed halfway on the shutter *and* you press and hold either the AE-L or AF-L button, you'll lock the exposure and/or focus for your scene.

You can then remove your finger from the shutter and recompose your scene, and as long as you keep your finger pressed on either of those "lock" buttons, your exposure and/or focus will remain locked until you take your picture.

There's also a menu item called AF-LOCK MODE, which allows you to configure the AF-L button to function as either **AF LOCK ONLY** or **AE/AF LOCK**, which locks both exposure and focus. Also, most X Series cameras have a menu setting called AE/AF-LOCK MODE, which is found in the BUTTON/DIAL SETTING menu. This setting allows you to further customize how these buttons operate.

The AF-L/AF-ON button can also be used to operate back-button focus. (See the "Focus Control" section later in this chapter for details on how to set up your camera for this mode.) Once you have this configured, pressing the AF-L button will activate focus. Depending on the camera, you may have to set the AF Selector Switch to Manual Focus mode for this to work. For some reason, it doesn't quite work the same way across all models. For example, the X-T1 needs to be in Manual Focus, but the X-T10 doesn't.

These two buttons can also be changed. In the BUTTON/DIAL SETTING menu on most models, you can even swap the function of the AE-L and AF-L buttons, and on the MY MENU cameras, the AE-L and AF-L operate as two additional Fn buttons. This means you can either keep them as AE-L/AF-L buttons or assign them to any other function you desire.

# FUNCTION (FN) BUTTONS

All of the X Series models are designed with a number of programmable Function (Fn) buttons. These are great tools that let you customize the operation of your camera according to your own personal style. I consider this to be one of the most powerful features they have, because it allows you to access often-used menu items with a single tap of your thumb or finger, without actually having to dig into the menus.

For this reason, the Fn buttons add a high degree of streamlined usability to the FUJIFILM cameras. As you'll see in this book, every single model contains over 100 menu items. Many of these items are designed to solve very specific problems or allow you greater efficiency and speed when faced with specific shooting situations.

Some of these menu items and settings are universal, and thus commonly used by every Fuji user. A few are things you might use on a regular basis, some not so often. However, all of them add a certain level of power and performance to the camera and are designed to make you a better photographer.

However, not everyone has the same style and approach to photography. For this reason, the Fuji cameras allow you to customize all of the Fn buttons, so you can access the most useful settings with the mere tap of your thumb or index finger.

All the newer Fuji cameras have at least seven programmable Fn buttons, and some have eight. (Older models, such as the X100, X100S, X-Pro1, X-E1, X10, X20, and X30 only have one.) Most come with default settings, which you may elect to keep.

Depending on the camera, there are about 25 separate menu items and functions you can assign to the Fn/AE-L/AF-L buttons. (The X-H2S reigns supreme with a current list of over 70 items.) To see all of the options or assign any Fn button, **press and hold the DISP/BACK button** until the Fn Button menu comes up (see Figure 1.7). From there, you can select which button you'd like to change, press OK, then scroll through all of the possible items you can set.

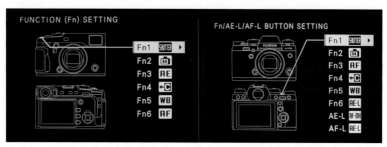

1.7

With a couple of the X Series models, you can also press and hold a particular Fn button to bring up the assign menu for that button. You can also find this as a menu item called Fn/AE-L/AF-L BUTTON SETTING (it's called Function (Fn) Settings on most newer models). This is found in the SET UP > BUTTON/DIAL SETTING menu, inside the BLUE MENUS on the RED/BLUE menu models.

However, you should *never* have to go into the menu to assign or change a Fn button. Always do one of the "press and hold" actions as described above. (On some cameras, press and hold the Fn button itself.)

## HOW SHOULD YOU SET YOUR FN BUTTONS?

Good question.

The answer depends somewhat on which model you're using, but mostly on your own shooting style and preferences.

I often recommend leaving some or all of them at the default setting, as these functions have been well thought out based on the specific layout and capabilities of each model. Get used to the camera before you go wild changing things, unless you know that there's a setting you really want to assign.

1.8

## My Favorite Settings to Use as Fn Buttons

**AUTOFOCUS/AF AREA:** The most important Fn setting to think about is FOCUS AREA. This is how you activate and display your green autofocus points. The default button for this action on all models is "thumb pad bottom." Once you press the top button and bring up your FOCUS AREA display, you can move it around the frame by using any of the four thumb pad buttons, even if they're set to other functions. **The key is that you have to press the down (thumb pad bottom) button first.**

Some photographers like to assign all four thumb pad buttons to AF AREA selection. This gives you the most control for choosing AF point(s) when you're shooting since you don't have to press the down button first; you can just activate and start moving your AF points around the frame by pressing any of the thumb pad buttons. (This is how I set up my X-T1 and X-T10.)

1.9

You can also set all four thumb pad buttons to operate as FOCUS AREA selection buttons in the SELECTOR BUTTON SETTING menu item (see the "Button/Dial Setting Menu" section of *Chapter 7: Set Up Menus*, page 246). (If you have an X-E3/4 or X-T20/30, remember, "thumb pad button controls" equate to "flick gestures" on your LCD screen.)

The obvious downside to this method is that you eat up four thumb pad Fn buttons for AF instead of just one. If you can train yourself to always press "down" first when activating your AF system, then by all means, run with that and give yourself more Fn buttons to play with.

**Note: The joystick** allows you to open up those four thumb pad buttons for assigning other settings. On those cameras, "thumb pad top" is the button for FOCUS MODE. That said, I leave three of them on their default settings on my X-T4, which are: **Left:** FILM SIMULATION, **Top:** AF MODE, and **Right:** WHITE BALANCE.

The default mode for **Bottom** is PERFORMANCE (BOOST/NORMAL), but I've changed mine to AF-C CUSTOM SETTINGS. I figure if I'm in BOOST mode, there's a good chance I'm using the vertical grip, which has its own BOOST mode switch.

After the AF settings, here's a list of what I feel are the most important settings to assign to your Fn buttons. Keep in mind, these may already be assigned as the default button functions.

**FOCUS MODE:** This is another important setting; it's where you choose between Single, Zone, and Wide/Tracking autofocus. You'll want to keep this easily accessible.

**FILM SIMULATIONS:** For me, the next most important Fn button setting is FILM SIMULATION. After autofocus, this is probably the function/setting I access more than anything else, so I want it right where I'll be able to find it with my eyes closed.

**ISO:** If your camera doesn't have a dedicated ISO dial, then I'd highly recommend setting one of your Fn buttons to ISO. It might already be assigned that way. That said, if you usually shoot in AUTO ISO, or if you don't change ISO settings very often, then you could probably get by with accessing ISO in the Q menu. This will free up yet another Fn button. Yay!

**DRIVE SETTINGS (DRV):** This has multiple functions, depending on your current Drive dial settings. (The default Fn button for DRIVE on the X-T1 and X-T2 is the front button.) The DRIVE SETTING menu is where you'll find all of your bracketing and ADV mode settings, and it's where you set your frame rate for shooting in continuous mode on the MY MENU cameras.

Some cameras already have a dedicated DRIVE button, so you don't need to set another one.

**WIRELESS COMMUNICATION:** This is one of the default settings on all X Series cameras. This function allows you to connect your camera to your phone or tablet in order to transfer images or operate the camera remotely via your device. This should be easy enough to find in the PLAYBACK menu, so perhaps you don't need it assigned to a Fn button.

**PREVIEW EXP/WB IN MANUAL MODE:** If you regularly shoot with flash, you may want to assign a Fn button to this feature. You'd turn it OFF whenever shooting with flash, which would allow you to still see the subject in the EVF/LCD when shooting at higher sync speeds or when shooting in very low light.

With so many possible options, assigning Fn buttons allows for intense customization based on your shooting style. I currently have the AF-L button assigned as a second Playback button. This lets me press it and review my images when I'm shooting one-handed.

Finally, nothing says that once you assign a Fn button you have to keep it that way. You may find that you have separate configurations for specific types of photo shoots or different subject matter. Experiment with the options and see what works best for you.

## CONTROL RING

If you have an X100F or an X70, then you have a Control Ring on your camera. The Control Ring is the free-turning ring on the lens right in front of your aperture ring (see Figure 1.10), and it acts as another type of quick-access function dial.

The Control Ring can be set to one of the following modes:

- DEFAULT
- WHITE BALANCE
- FILM SIMULATION
- DIGITAL TELE-CONV

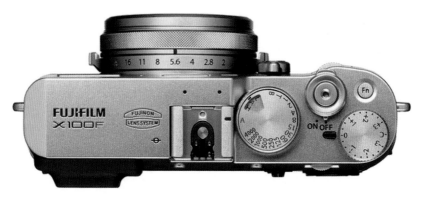

**1.10** The Control Ring on the X100F is just in front of the aperture ring

The Default mode switches between functions, depending on what shooting mode you're in. In Full Auto on the X70, it allows you to select your "Scene Mode."

In the other shooting modes, it functions as the Digital Teleconverter, which gives you three traditional view angles: 35mm, 50mm, and 70mm. Essentially, it's just cropping and enlarging the image, but there's some special pixel-wrangling going on inside the image processor, so the quality is quite good.

You can also set the Control Ring to adjust/select ISO, Film Simulation, or White Balance. You can see all your Control Ring options in the "Button/Dial Setting Menu" section of *Chapter 7: Set Up Menus*, page 246.

# Q MENU

The Q menu gives you another place to store often-used settings and allows for even further customization.

Pressing the Q button on the back of the camera opens a 16-slot menu where you can quickly access any number of settings and menu items. (See Figure 1.11.) To select any of the settings, navigate to that slot via the thumb pad buttons or the AF joystick and change it by rotating the rear command dial.

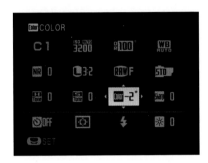

**1.11** The Q menu

Once you're done, simply press OK, DISP/BACK, or press the shutter button lightly. The latter is always my preferred method, as my finger usually lives near there all the time anyway. (Note: This works for anything. If you're ever in a menu and want to escape, you can simply hit DISP/BACK or tap the shutter button lightly.)

To customize the Q menu, press and hold the Q button until you get the customization screen. Then scroll to any slot, press OK, and then scroll through the list until you find the item you'd like to assign to that slot. Press OK to assign it, then hit DISP/BACK or tap the shutter to escape.

## What Should You Put in the Q Menu?

The Q menu is a great place to put frequently used settings that may not get used in every situation, but that you still want to access quickly when the need arises. Things like Image Size/Quality, Highlight/Shadow Tone, Self Timer, Movie Mode, Face Detection, Shutter Type, ISO, ADV Filter, LCD Brightness, and MF Assist.

I recommend putting the most important settings near the top and left, so you can access them as quickly as possible. The lesser-used items should live down near the bottom and right side of the grid. Also, nothing says you can't assign the same function to two or more slots for even quicker access.

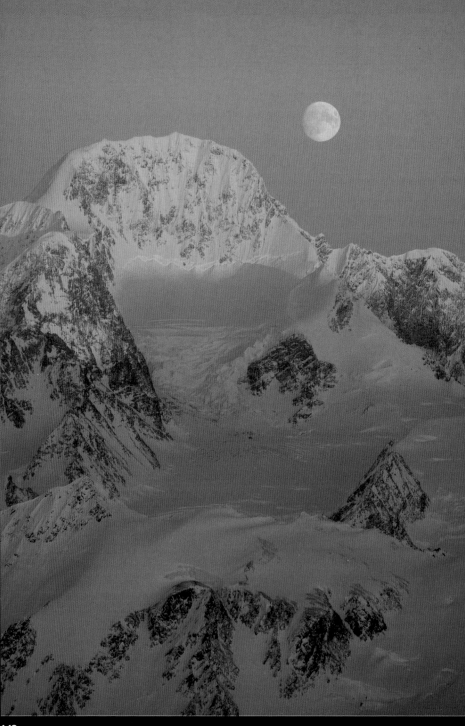

# MY MENU

The newer 24MP X Series cameras feature a new MY MENU slot at the bottom of the camera menu. Offering even more customization and quick access to commonly used features and settings, once you put anything in your MY MENU, even if it's just one item, the top item in your MY MENU will be the first thing that comes up whenever you hit the MENU/OK button. See Figure 1.13.

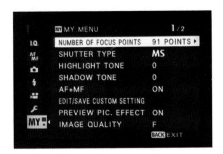

**1.13** The MY MENU menu system

You access the MY MENU SETTING options in the USER SETTING menu. This is where you add, remove, and rank (reorder) your MY MENU items. You can store 16 items as two banks of eight.

As with the Q menu, this is where you store important settings that you don't (or can't) have assigned as Fn buttons. However, unlike the Q menu, which can only store certain items, your MY MENU can store almost any item and setting found in any of the camera menus.

As of this writing, my current MY MENU on my X-T2 contains: Number of Focus Points, Shutter Type, Highlight/Shadow Tone, AF+MF, MF Assist, Focus Check, Image Size/Quality, and Edit/Save Custom Settings.

# THE DISP/BACK BUTTON

The DISP/BACK button has a number of different functions, depending on whether you're in Shooting or Playback mode, and whether you're looking at the LCD or the EVF.

In Shooting mode, using the LCD screen, DISP/BACK toggles between four display settings. These are the first three:

- **STANDARD: Full magnification with all shooting data displayed**, as well as Film Simulation, image size/quality, exposure meter, battery level, and other

screen effects you've turned on in the DISPLAY CUSTOM SETTING menu (such as framing grid, electronic level, histogram, and shooting mode).

- **FULL: Scene with no data at all**, for a nice, quiet uninterrupted view of your scene.

- **Comprehensive shooting data only, with no scene.** This shows you nearly every single setting currently applied inside your camera, including your focus zone and location, histogram, Film Simulation, highlight and shadow tone, color, noise reduction, and more.

This is a good way to quickly preview your camera's settings and make sure that nothing is on that you *don't* want on. Maybe you shot with a SHADOW TONE adjustment yesterday and forgot to turn it off. (You can also check the Q menu to see if any of your settings are still on.)

**If you press DISP/BACK when looking through the EVF,** you toggle between the two image magnification sizes: large, and not-quite-as-large. I always opt for the large view, but this is personal preference.

**The fourth display setting, DUAL DISPLAY mode, is available when shooting with Manual Focus.** In this mode, the viewfinder shows you a split screen that lets you see both a regular view of the scene and a Focus Assist view at the same time (when using Focus Peaking and Digital Split Image Focus). This helps make manual focusing even easier and more precise. See Figure 1.14.

Most models have a special Dual Display setting, which lets you swap views, so you can see the entire scene on the big screen and the closeup view on the second screen, or vice versa.

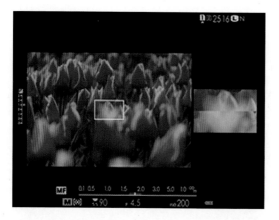

**1.14** Dual Display mode on the X-T2

In Playback mode (both EVF and LCD), DISP/BACK toggles between four settings:

- **STANDARD:** Full-size image with shooting data.

- **Full-size image with no shooting data.** Nice and clean!

- **Regular and thumbnail image with comprehensive shooting data, as described above.**

- **Full-size image with date/time, image number, and assignable "Favorites" or star rating.**

## EXPOSURE MODES

All X Series cameras have four standard exposure modes: P, S, A, and M, which stand for **Program**, **Shutter Priority**, **Aperture Priority**, and **Manual**.

### Program

Program mode is essentially "Auto" mode. When you put the camera into Program mode, you're letting the camera make your exposure decisions. The shutter speed and aperture are set automatically, according to your current ISO setting.

Program mode is an ideal mode when you don't want to worry about exposure and you just want to focus on how to use the light and compose your scene. That said, you can always adjust your exposure using the EV+/– dial.

Also, if you like your current exposure but you'd rather use a different combination of shutter speed and aperture, you can make a "Program Shift" adjustment by simply turning whichever command dial you have set to control shutter speed. (You set this with the Shutter Speed Operation menu item.) This lets you override the camera's basic exposure settings with the command dial.

To set the camera to Program mode, **turn the main Shutter Speed dial to A** and **set the aperture ring on your lens to A.** You'll see P at the bottom left of your display.

For lenses that don't have a numbered aperture ring, such as the XF18–55mm or XF18–135mm lens, **turn the main Shutter Speed dial to A**, then **set the Aperture switch on the lens barrel to A.**

For lenses that don't have an aperture ring at all, like the 27mm f/2.8, **turn the main Shutter Speed dial to A**, then **turn whichever command dial controls aperture**

**all the way past the maximum aperture** on the lens, which is f/16 on the 27mm lens. You should see the color of the aperture setting change. (To see which dial to turn, look at the exposure settings in the bottom of your LCD/EVF display—it will tell you which dial does what.)

See the "Aperture Setting" section in *Chapter 7: Set Up Menus* to learn more about how to adjust aperture when using lenses without aperture rings.

## Shutter Priority

With Shutter Priority mode, you adjust the shutter speed and then the camera automatically adjusts the aperture based on the current ISO setting. In that way, it's sort of like "Half-Auto" mode because you're still making decisions about the exposure and how you want your picture to look.

To make adjustments to your exposure, turn the EV+/– dial.

To set the camera to Shutter Priority mode, **choose a shutter speed on the main Shutter Speed dial** and **set the aperture ring on your lens to A**. You'll see S at the bottom left of your display.

For lenses that don't have a numbered aperture ring, such as the XF18–55mm or XF18–135mm lens, choose a shutter speed on the main Shutter Speed dial, then set the Aperture switch on the lens barrel to A.

For lenses that don't have an aperture ring at all, like the 27mm f/2.8, choose a desired shutter speed on the main Shutter Speed dial, then turn whichever command dial controls aperture all the way past the maximum aperture on the lens, which is f/16 on the 27mm lens. You should see the color of the aperture setting change. (To see which dial to turn, look at the exposure settings in the bottom of your LCD/EVF display—it will tell you which dial does what.)

Again, see the "Aperture Setting" section in *Chapter 7: Set Up Menus* to learn more about how to adjust aperture when using lenses without aperture rings.

## Aperture Priority

With Aperture Priority mode, you adjust the aperture and then the camera automatically adjusts the shutter speed based on the current ISO setting. It's the other "Half-Auto" mode, because again, you're still making your own decisions regarding how you want the picture to look.

**1.15**

To make adjustments to your exposure, use the EV+/− dial. **This is my preferred method for shooting.**

To set the camera to Aperture Priority mode, **turn the main Shutter Speed dial to A**, then **manually adjust your aperture ring on the lens with your left hand.** (I like to hold the camera so that my left hand is cradling the lens from the bottom.) You'll see A at the bottom left of your display.

For lenses that don't have a numbered aperture ring, such as the XF18–55mm or XF18–135mm lens, turn the main Shutter Speed dial to A, then set the Aperture switch on the lens barrel to the "aperture symbol" and rotate the aperture ring.

For lenses that don't have an aperture ring at all, like the 27mm f/2.8, **turn the main Shutter Speed dial to A**, then **turn whichever command dial controls aperture.** Don't go past the max setting, or you'll shift to Program mode. (To see which dial to turn, look at the exposure settings in the bottom of your LCD/EVF display—it will tell you which dial does what.)

Again, see the "Aperture Setting" section in *Chapter 7: Set Up Menus* to learn more about how to adjust aperture when using lenses without aperture rings.

In a way, both Shutter Priority and Aperture Priority modes do the very same thing. Think about it: With S, you set the shutter speed with your command dial and watch the aperture change automatically. With A, you set the aperture with the appropriate command dial and watch the shutter speed change.

Keep an eye on the display and stop when you see the parameter you want, whether it's shutter speed or aperture. Neither way is right or better, and both methods will get you to the same place.

I prefer Aperture Priority mode, partly because it's what I've always used. More than anything, it's a carryover from my early days when aperture was adjusted by rotating the f-stop ring on the lens with your left hand. This is one reason I like the X Series camera system: most of the lenses have functioning aperture rings.

Regardless of which method you use, consider S and A modes interchangeable methods to get the exact same results.

## Manual

Manual mode is the original exposure mode. It's actually quite easy and fast to use Manual mode on the X Series cameras because you can instantly see your exposure changes. In addition, the controls are quite easy to manipulate with your fingertips while you're looking through the viewfinder.

With Manual mode, you set both the shutter speed and the aperture yourself. A little graph inside your viewfinder tells you if your current settings will give you proper exposure, or if you'll over- or underexpose the scene. As long as you have PREVIEW EXP/WB IN MANUAL MODE set to ON, you'll be able to see exactly what your exposure will look like.

To set the camera to Manual mode, **choose your desired shutter speed on the main Shutter Speed dial,** then **manually adjust your aperture on the lens with your left hand.** (I like to hold the camera so that my left hand is cradling the lens from the bottom.) You'll see M at the bottom left of your display.

For lenses that don't have a numbered aperture ring, such as the XF18–55mm or XF18–135mm lens, choose your desired shutter speed on the main Shutter Speed dial (or use T mode, discussed next), then set the Aperture switch on the lens barrel to the "aperture symbol" and rotate the aperture ring.

For lenses that don't have an aperture ring at all, like the 27mm f/2.8, **choose your desired shutter speed on the main Shutter Speed dial**, then **turn whichever command dial controls aperture.** Don't go past the max setting, or you'll shift to Program mode. (To see which dial to turn, look at the exposure settings in the bottom of your LCD/EVF display—it will tell you which dial does what.)

I still use Manual mode quite a bit, especially when I'm shooting in tricky light or with flash. I'm not alone here; many X Series photographers love using Manual mode.

## T MODE SHUTTER SPEEDS

This is one of the hidden gems in Fuji cameras. All of the X Series models have a "T" (Time) setting on the Shutter Speed dial, located between "1" and "B." By setting the dial to T, you gain full control of all shutter speeds via the front or rear command dial, depending on which dial you have set to control shutter speed. (I currently have mine set to the front command dial on my X-T2.)

With the first generation of X Series cameras, T mode only allowed you to set speeds between 2 and 30 seconds. The firmware 4.0 update on second-generation models changed this so that in T mode, you can now use the command dial to set any shutter speed.

Combine this with the ELECTRONIC SHUTTER (ES) in the SHUTTER TYPE menu, and you can use the dial to select any exposure time between 1/32,000 sec. and 30 seconds. The latest models allow you to shoot all the way down to 15 minutes. Just think of what you could do with that! A 10-stop neutral-density filter and super-long exposures can produce some pretty cool results when shooting water, moving clouds, traffic, and city scenes. See Figures 1.16–1.18.

I love using T mode because it speeds things up dramatically. You can shoot in Manual or Shutter Priority mode without having to mess with the Shutter Speed dial. (When the lens is set to "A," you're in Shutter Priority mode; when you're manually selecting the aperture on the lens, you're in Manual.)

With your left hand on the aperture ring and your right index finger or thumb on the command dial, T mode makes shooting in Manual mode a breeze. It's even fast enough to shoot action and fast-moving scenes in tricky light. You don't even have to move; you just crank your finger/thumb back and forth on the dial. This makes it much easier to keep your eye glued right to the viewfinder and your subject.

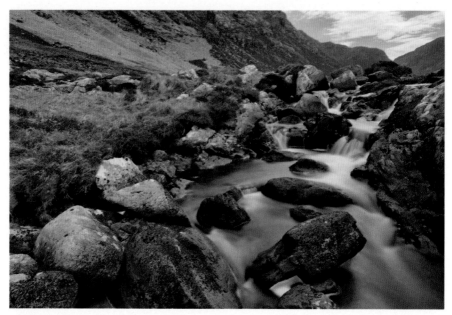

**1.16** A 10-second exposure in the Scottish Highlands, shot using T mode on the X-T2

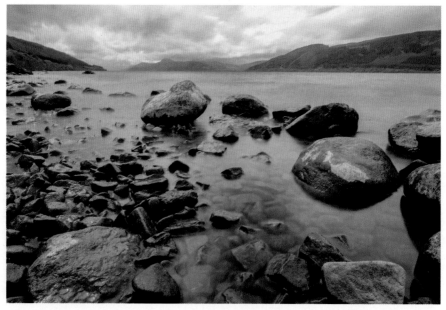

**1.17** The restless shores of Loch Ness—a 13-second exposure, shot using T mode on the X-T2

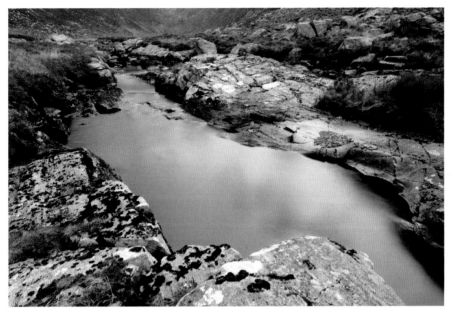

**1.18** Another Scottish Highlands long exposure, shot using T mode on the X-T2

Add the HISTOGRAM to your viewfinder in the DISPLAY CUSTOM SETTING menu, turn PREVIEW EXP/WB IN MANUAL MODE to ON in the SCREEN SETTING menu, and you speed things up even more, since you'll be able to see the effects of your exposure adjustments in real time.

And while we're talking about the DISPLAY CUSTOM SETTING menu, I like to add the ELECTRONIC LEVEL to my viewfinder as well. It looks a bit intrusive at first, but it's an easy way to make sure your pictures come out straight.

Note: On the X-E1, you control your T mode shutter speeds via the left and right thumb pad buttons.

## FULL AUTO SWITCH & SCENE MODES

The X-T10, X-T20, X-T30, X70, and X-E3 all have a special AUTO switch on the top deck of the camera. (See Figure 1.19.) Flipping this switch puts you into FULL AUTO mode, which disables and overrides a number of focus options, IMAGE QUALITY settings, and SHOOTING MODE options. (Note: The Drive dial/menu must be set to S, or STILL IMAGE, to use this setting.)

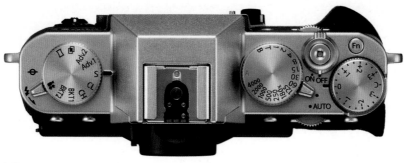

**1.19**

For example, the camera defaults to ISO AUTO and WIDE/TRACKING, and it disables all of your IMAGE QUALITY settings, including FILM SIMULATION and the exposure and tone control options.

It drops into what's called SCENE POSITION mode, which allows you to use any number of presets and let the camera make all the decisions with regard to exposure settings, color, and focus.

In addition to specific modes that reflect a variety of shooting conditions, like SUNSET, FLOWER, SNOW, BEACH, UNDERWATER, PORTRAIT, SPORT, and LANDSCAPE, you can also choose ADVANCED SR AUTO, or SR+, which throws the camera into "Full Auto." In SR+, the camera evaluates the lighting conditions and chooses its own settings. (Note: The EV+/– control still functions normally.)

In other words, you outsource everything in the entire picture-taking process except for your own compositional ideas.

Sometimes it's nice to go Full Auto. You don't have to think about anything, and that can be liberating. Just flip the switch and go. It's also what you do right before you hand the camera to your non-photographer friend or family member, or when you ask a stranger to take your picture.

To change SCENE POSITION modes, look for the SCENE POSITION menu; when the switch is set to AUTO, this becomes the RED 1 menu item on the X-T10 and X70. On the X-T20, you'll find SCENE POSITION in the SHOOTING SETTING menu.

On the X70, you can also select your SCENE MODES by rotating the Control Ring. Note: The Control Ring must be set to the DEFAULT setting for this to work.

1.20

## SHOOTING LIKE FILM

Shooting RAW with X Series cameras is awesome. The X-Trans sensor captures a vast amount of tonal information, and the two new flagship models, the X-T2 and X-Pro2, hold even more tonal range and color accuracy, thanks to their faster image processors. This gives you enormous latitude when working with your images in Lightroom or whatever post-processing software you use. See Figures 1.21 and 1.22. (My post-processing software of choice these days is Luminar.[3])

**1.21** "Moon Rising over the Knik Glacier" (original RAW File)

**1.22** "Moon Rising over the Knik Glacier" (processed from the RAW file)

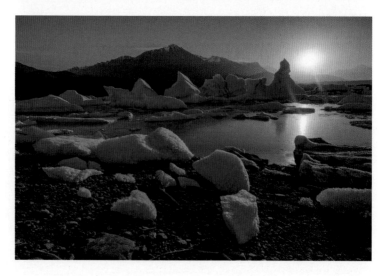

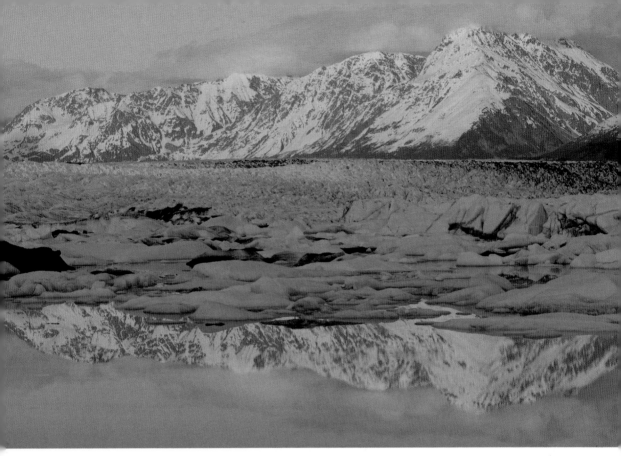

**1.23**

However, this isn't why I love the Fuji cameras. On the contrary, my love for the X Series revolves around the fact that **I don't have to shoot RAW** in order to get great images.

Besides that, processing RAW files takes time, and I'm a high-volume shooter, so this means spending hours at the computer. While some people genuinely enjoy working with photo software, not everyone has the time, the skills, or the same enjoyment level for this aspect of digital photography.

Another inherent problem with a traditional RAW workflow is that you defer an important element of your creative process to a time that's far removed from the actual emotions and experiences you had when you shot the photo. Hours, days, or weeks later when you're back at your computer, are you going to remember the look and feel you were going for with every single frame? Probably not.

In the days before digital, there was no deferring this part of the process. As soon as you loaded a roll of film and snapped the shutter, you applied a specific color palette onto your photos that could never be altered. Your creative decisions about how you

wanted your images to look were forever fixed into the acetate, and since film had such limited latitude, you either nailed your exposure or threw the slide away.

We've largely gotten away from this fixed approach with digital photography, but thankfully, the design of the X Series fosters this style of picture taking. For much of my work, I'm back to shooting with a film mindset, and it has brought me a sense of creative liberation.

These days, my goal as a photographer is to shoot the scene as it reflects my ideas in the moment, and walk away with an image I love. Of course, now I have an LCD screen and histogram, so I instantly know if I nailed my exposure or not. In the end, if I can spend as little time processing my photos as possible, I'm a happy guy.

I'm not advocating against shooting RAW. There are times when you want maximum exposure control in order to take full advantage of your luscious, high-latitude X-Trans captures. That said, **I often encourage photographers to explore a more "back to basics" style of photography.**

While RAW definitely has its place, we all know how awesome Fuji JPEGs are, don't we? In most situations, you'll get the look you want without the post-processing work, and you'll get to enjoy all the instant, organic creative satisfaction that goes with this kind of approach. Of course, you can always shoot RAW+JPEG (which I often do), but over time you may find that most of those extra RAW files just end up stealing hard drive space.

You'll also avoid the dreaded agony of choice. Lightroom gives you endless options for adjusting your color, exposure, and tone. This is not always a good thing, as too many choices can paralyze us in life.

Don't believe me? How often do you spend more time trying to choose something to watch on Netflix versus actually picking something and watching it? Now think about the endless number of hours you could spend dragging sliders in Lightroom and wondering if you got it right. Don't worry, it's not your fault; it's the curse of our culture.

Fortunately, Fuji cameras give you a wide range of creative control without going overboard. The combination of film simulations and on-board processing tools are powerful without being overwhelming; they're deliberate, with just enough variation to inspire a wide range of creativity.

Besides, why not outsource your color choice to the experts? You know, the ones who have been innovating in the field of color reproduction for over 80 years.

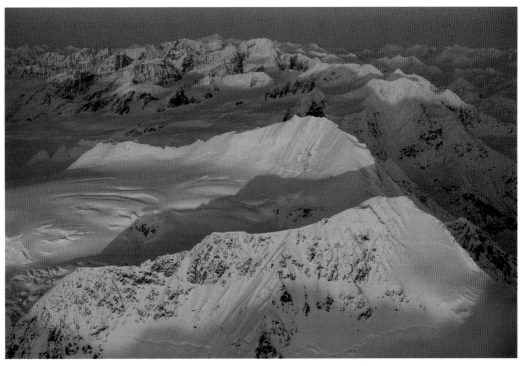

1.24

## It All Starts with Film

The Film Simulations are the lifeblood of the X Series. This wonderful collection of six ultra-classic color palettes and four monochrome styles, including the ACROS film simulation, gives you some of the most iconic looks in the history of photography.

Developed over decades and culled to perfection for the X Series, these built-in color presets offer you a diverse and dynamic set of tones with which to craft your electronic artistry.

Before snapping away, gauge your subject matter and think about how you want the photo to look. What are you going for? Bold and beautiful? Subtle and subdued? Rich and powerful? Careful and contemplative? Clean and crisp, or garish and gritty?

You've got it all right there at your fingertips: the dramatic eye-popping saturation of VELVIA; the kinder, gentler brush of ASTIA; the soft, muted colors of PRO Neg Std; the timeless palette of CLASSIC CHROME. And we haven't even talked about the black-and-white simulations!

Forget about shooting "flat," a common technique when shooting RAW—your only concern is to make sure your histograms aren't blown. **Shoot how you want it to look**. Pick a color and run with it. Bring your creativity into the mix right then and there. See Figures 1.25 and 1.26.

Make sure you set your FILM SIMULATION control to one of the Fn buttons so you can access it quickly, and then experiment. If you're shooting quick scenes or if you can't decide which one you like best, you can always bracket your Film Simulations. This lets you pick three different looks. Maybe go bold with one, have another be a more subdued look, and have the third be black and white.

**1.25** Shot using the VELVIA Film Simulation

**1.26** Shot using the PRO Neg Std Film Simulation

## Adding Grain, Adding History

Nothing says your photos all have to be smooth and tight. Pixel peeping is fun, but so is playing with tradition. That's why you have an X Series camera, right? A little film grain never hurt anyone, and neither will cranking up the ISO dial on your Fuji. Remember, photography is supposed to be representational and symbolic, not exact. It's supposed to have a mood, and nothing adds mood like a little grain.

Or a lot of grain. Don't be afraid to crank it up into the nosebleed section. These cameras do high ISO really well, especially those models that have native ISO speeds of 12800. Combine ISO 12800 with the ACROS Film Simulation and you have pure magic. See Figure 1.27.

**1.27** Shot at ISO 12800 with the X-T2

You'll find that at higher speeds, the noise isn't noise anymore; it's grain—gorgeous, messy film grain that's dripping with history and style. I also love the look of ISO 3200 with black and white. It's got rich, bold contrast and it holds together well. Heck, ISO 3200 even looks great in color! In my mind, ISO 3200 produces some of the best-looking photographs. See Figure 1.28.

If you have one of the new MY MENU cameras, you can also use the new GRAIN EFFECT setting, which is found in the IMAGE QUALITY SETTING menu. This lets you add two types of grain to your image—STRONG or WEAK—regardless of your current ISO setting. They both look great.

**1.28** Shot at ISO 3200 on the X-T2

When compared to the look of the higher ISOs like 3200, 6400, and 12800, the GRAIN settings give you more "straight grain," whereas the higher ISO speeds add a tiny bit more noise. The STRONG grain setting is quite bold and even adds some noticeable sharpness.

If you want a film grain look but you want to shoot wide open in bright light, the GRAIN EFFECT is your answer.

## Tweaking the Film Simulations

Buried in the menus and the Q menu by default, you'll find a set of useful but little-understood exposure controls. These consist of COLOR, SHARPNESS, SHADOW TONE, and HIGHLIGHT TONE.

These controls are overlooked by many photographers, myself included. We can all be forgiven, because the Fuji camera manuals don't offer much explanation for what they do. I'll admit that having been an X Series shooter for five years, I only recently started experimenting with them. I'm kicking myself for waiting so long, because they're quite useful, and they increase the times when you can get by without having to shoot RAW.

Basically, all these controls go from +4 down to –2. "Plus" gives you more of whatever control you're tweaking and "minus" gives you less. Zero is neutral. With Shadow Tone and Highlight Tone, a setting of –1 or –2 can help rescue your lights and darks from the edge of the histogram.

With the waterfall example in the "Highlight Tone and Shadow Tone" section of *Chapter 2: Image Quality (I.Q.) Settings*, a –2 on the Shadow Tone helps brighten those dark areas and adds definition, much like the Shadow slider in Lightroom. Or I could increase the contrast by going +2 instead. At the same time, –2 on the Highlight Tone helps bring the bright whites of the water under control.

Color increases or decreases saturation and vibrancy, just like in Lightroom. Want to bump up VELVIA even more? Go to +4 for maximum, candy-color pop. Make it a little less contrasty? Go minus on the Shadows. Want to mute PRO Neg Low even more? Go to –1 or –2 and you're even softer. You get the idea. Finally, Sharpness is kind of like the Clarity slider in Lightroom; plus adds crispness, minus softens things up.

You will realize how powerful these simple controls are when you start combining settings. I often go for bold colors (VELVIA) when photographing things like bike racing, especially when shooting in bright sun. (See Figures 1.29 and 1.30.)

**1.29** Shot with the VELVIA Film Simulation on the X-T2

**1.30** Shot with the VELVIA Film Simulation on the X-T2

However, to shake things up while shooting a particular cyclocross race, I decided to tweak CLASSIC CHROME with settings of +1 Shadow Tone, –2 Highlight Tone, –3 Color, and +1 Sharpness. This gave me a crisp, high-contrast look—sort of like if I had pushed a roll of Kodachrome, but with very muted colors. See Figures 1.31 and 1.32. I loved the results so much that I saved those settings as a Custom Setting, which I can now access again in the Q menu.

In addition to the four exposure controls I mentioned above, you can even add White Balance as one of your saved parameters. Go a little blueish or greenish with your White Balance and you've got the cross-processed look. Lean toward red or magenta and you can simulate the look of film that's well past its expiration date. Go orangeish-yellow and you've just aged your photos by a few decades.

Think about it; the options are endless. Whether you're simply rescuing lights and darks or radically altering colors, these simple controls offer a huge amount of creative flexibility.

Not only has my "film" approach to photography saved me an enormous amount of time, it has freed up my brain to focus on being more creative on the spot. I'm more

**1.31** CLASSIC CHROME Film Simulation with additional adjustments to Highlight Tone, Shadow Tone, Color, and Sharpness

**1.32** My "gritty" look, created by tweaking the CLASSIC CHROME Film Simulation

passionate about my photography now than I have ever been, and I don't feel that I've given anything up. On the contrary, I feel as if I've come full circle and gained every advantage on the way around.

I'll occasionally shoot RAW when I'm faced with really challenging light or if I'm shooting a complex assignment. For the majority of my photography, though—and I hear this from many Fuji shooters—I'm shooting JPEGs and loving it. I encourage you to experiment with this kind of film mentality and see what it does for your photography.

## WHY FUJIFILM IMAGES ARE SO "FILM-LIKE"

Image files from just about every camera that's made today look really good. Nikon images look great. So do Canon, Olympus, and Sony images.

However, there's something slightly different about the way the Fuji images, especially their JPEGS, look compared to other cameras' images, and this appeals to many photographers.

Fuji's secret sauce is their proprietary X-Trans sensor. Let's look at how it's different and, more importantly, why it's different.

Digital camera sensors are built with a set number of equally sized and equally spaced photosensors, or as we commonly refer to them, pixels. A 16MP sensor contains 16 million pixels.

In order to reproduce color, each pixel is covered with a single filter, which is either red, green, or blue. Since the cone cells of the human eye are most sensitive to green light, camera sensors use twice as many green pixels as red and blue in order to best mimic the way that we see.

During capture, each pixel on the sensor records the incoming light as a single color. During the demosaicing stage, which occurs in the camera's image processor, various algorithms are used to interpolate this information into a full-color image. When

**1.33**

shooting and processing RAW files, the demosaicing stage happens inside your computer's imaging software, i.e., inside Lightroom or Photoshop.

(Note: Previous versions of Lightroom and Photoshop had a hard time processing the Fuji RAW files because the software's demosaicing algorithms were written for Bayer pattern sensors. They weren't able to bring out the maximum level of detail in the files, which led many people to believe that the Fuji files weren't as sharp as they actually are. The latest versions of Lightroom and Photoshop CC do a vastly better job in this area.)

The most common filter array is the Bayer pattern arrangement, which is named after Bryce Bayer, a former Kodak employee who developed this technology in 1974. Patented in 1976, the checkerboard Bayer filter pattern is used in nearly every single digital capture device today (see Figure 1.34).

The FUJIFILM X-Trans sensor, however, does not use the 2x2 Bayer filter pattern. Fuji sensors use a proprietary, non-regular 6x6 color filter array that creates a much more "random" color gathering process (see Figure 1.35). This gives it two very distinct advantages over Bayer-type sensors: sharpness and a film-like look.

**1.34** Bayer pattern sensor array

**1.35** FUJIFILM X-Trans sensor

The Bayer filter pattern can sometimes produce moiré effects with certain subjects. To combat this, most Bayer pattern cameras use an optical low pass filter (OLPF) in front of the sensor. However, the OLPF can cause a slight decrease in sharpness.

With its non-regular array, the X-Trans sensors do not use optical low pass filters, which is why the smaller APS-C-size sensors of the X Series cameras are able to compete with full-frame sensors with regard to sharpness and detail.

In addition, **the irregular pattern of the X-Trans sensor more closely replicates the look of film**. This is no accident. With their 80-plus-year legacy of film photography, the FUJIFILM team continues to work very hard to bring their traditional film heritage into the modern era.

In designing the X-Trans sensor, the Fuji engineers went outside the box and looked backward as much as they looked forward. Their goal was to adopt the legacy and artistic heritage of film photography, which is anything but regular. Anyone who has shot film knows that the medium produces very "representational" and often very "irregular" images.

After all, there is nothing regular about film. It's just a pile of silver halide crystals mixed up in a liquid emulsion, poured onto an acetate base and cut into strips. These crystals are the actual "grain" you see when you enlarge a negative or slide, and if you look closely, you can see that film grain is about as random as you can get. It is in no way uniform with regard to its size, shape, or placement in the emulsion. As much as Kodak, Fuji, Agfa, Ilford, and every other film manufacturer tried to create a consistent product, it was simply impossible to arrange these little grainy crystals into any kind of regular rows of red, green, and blue.

In Figures 1.36 and 1.37, we see two close-up photos of the potato starch grain structure found in Autochrome Lumière film[4], which was first produced in the early 1900s. It's striking to note how closely the first image resembles the pattern found on FUJIFILM's X-Trans sensor. Again, this is no accident, and it clearly illustrates where Fuji is coming from and what they're trying to do.

**1.36** Close-up of the grain structure of early 1900s Autochrome Lumière film (Creative Commons)

**1.37** Enlarged colored starch grains in an early 1900s Autochrome plate (Creative Commons)

Now let's look at a close-up of Kodak T-MAX 3200, one of Kodak's later, modern black-and-white films, which was sold until late 2012 (see Figure 1.38). And in Figures 1.39 and 1.40, two images I shot with the X-T2 at ISO 12800, which, to my eyes, closely replicates the grain size of T-MAX 3200 film.

You can see just how similar the modern FUJIFILM images look when compared to the Kodak film image. Again, this is no coincidence; it's the result of a very carefully crafted sensor design and the algorithms Fuji has programmed into their on-board image processors.

**1.38** Close-up of Kodak T-Max 3200 film grain (photo by Robert Boyer)

**1.39** 100% crop of ISO 12800, shot on the X-T2

**1.40** ISO 12800, shot on the X-T2

**1.41** Original scanned image from a FUJIFILM VELVIA slide

**1.42** Close-up of the film grain of a scanned 35mm VELVIA slide

Here are a couple of color examples as well. Figure 1.41 is a photo of Long's Peak at sunrise, shot back in the late '90s on 35mm VELVIA slide film and scanned. In the enlarged version (see Figure 1.42), you can see the pronounced film grain in the sky.

Figures 1.43 and 1.44 show an X-T1 image shot earlier this year. Again, in the enlarged version, you can see the "grain-like" quality of the digital noise in the sky.

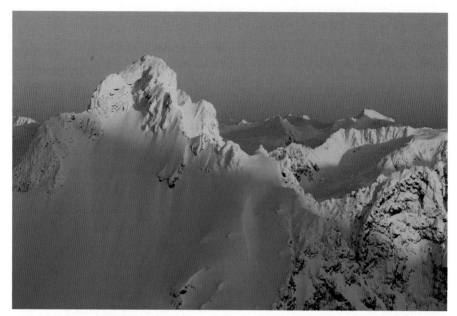

**1.43** FUJIFILM X-T1 image

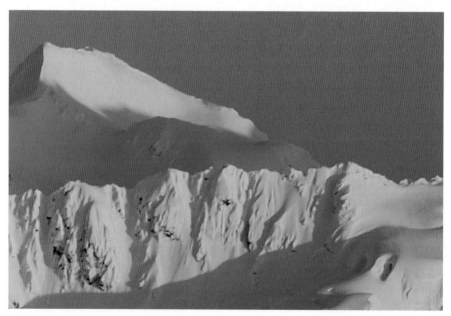

**1.44** FUJIFILM X-T1 image, 100% crop

As discussed earlier, another feature the Fuji cameras offer are their carefully crafted Film Simulations. Where most cameras give you the option to shoot JPEGs in other modes like "Vivid," "Neutral," and "Monochrome," the X Series cameras have imported the color profiles of some of their classic color slide films into the image processing software in their cameras—films like VELVIA, PROVIA, and ASTIA, as well as some of their professional color and black-and-white films. The MY MENU cameras feature the new ACROS black-and-white Film Simulation.

Having shot many of these films back in the day, I love having these familiar color palettes at my disposal once again.

With their sensor design and Film Simulations, it appears that FUJIFILM is striving for something beyond image quality alone. Their mission, as stated by FUJIFILM Chairman and CEO Shigetaka Komori in his book *Innovating Out of Crisis*[5], has always been to ***"preserve and sustain the culture of photography."***

While this statement could certainly be interpreted in any number of ways, FUJIFILM's dedication to combine the traditional heritage of photography with modern technology is clearly evident in the X Series. It seems these efforts have paid off, because to my eyes, and to the eyes of other Fuji shooters, their images have a distinct and very appealing "film-like" quality to them.

As I said above, this is all very subjective, as is much of photography. After all, we're talking about art, and there's no concrete way to prove that the images from one camera or photographer are "better" than any other images. We all perceive images a little differently, and when it comes down to what's right, there is no "right." It's only what we like and what drives us visually or emotionally, based on our own experiences and desires.

As a photographer who came from film, I'm drawn to this blend of technology, craftsmanship, and tradition that FUJIFILM has put forward with their cameras. Does it resonate with everyone? Obviously not. People love their Nikons, Canons, and Sonys, and that's okay. Differing opinions is what makes the world go around.

At the end of the day, the most important things in photography are your own creativity and how much you love what comes out of your camera, no matter which camera it is.

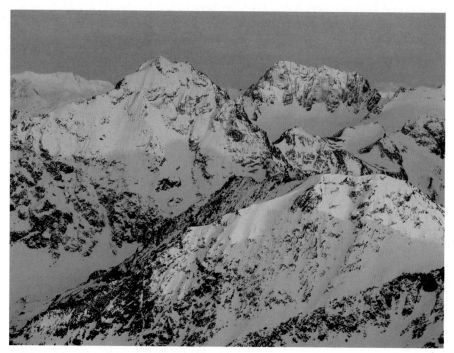

**1.45** The rich, bold colors of the VELVIA Film Simulation

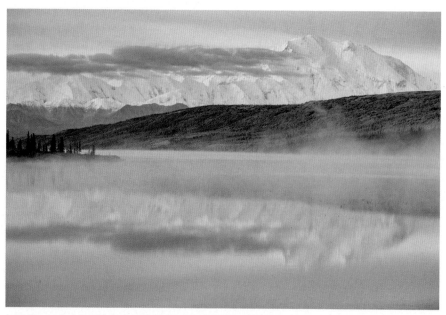

**1.46** The muted tonality of the CLASSIC CHROME Film Simulation

# FOCUS CONTROL

The X Series cameras operate with traditional focus operation, where you activate autofocus by pressing the shutter button halfway. However, it's possible to configure your camera in alternate ways, and you can even decouple focus operation from the shutter button and set it up for back-button focus.

## Back-Button Focus

Personally, I'm not a back-button focus guy. I just don't see the advantage of this method. Either that or I've just being doing it the other way for so long. However, I know that there are many photographers who prefer to use back-button focus, so if you're one of those people, rest assured, the Fuji engineers have your back. At least with most cameras.

There are two different ways you can achieve back-button focus on FUJIFILM cameras. Both methods work with the newer MY MENU cameras, like the X-T2.

**METHOD 1:** The first way is to assign your AF-L button (or any Fn button you wish) to the AF-ON setting. This activates focus as soon as you press the button. (Press and hold DISP/BACK to bring up the Fn Button settings options.)

You'll also want to disable autofocus from the shutter button. In the BUTTON/DIAL SETTING menu, look for SHUTTER AE/AF, and select OFF for either AF-S, AF-C, or both. This will keep the shutter button from focusing when pressed halfway.

With this configuration, you can activate focus with your selected Fn button and use the shutter button to lock your exposure and take the picture.

**METHOD 2:** The other way to achieve back-button focus is to go into the AF/MF SETTING menu and select either AF-S or AF-C for the INSTANT AF SETTING. Then assign your AF-L button to either AF-ON, AF LOCK ONLY, or AF/AE LOCK. Now, if you're in Manual focus mode, you can activate the autofocus by pressing the AF-L button.

This is a workaround for decoupling focus from the shutter button. By putting your camera into Manual focus, your shutter button won't perform focus operations, but the AF-L button will. Since SHUTTER AF is a newer feature only found on the MY MENU cameras, this is the only method you can use for back-button focus on RED/ BLUE menu cameras, like the X-T1. Note: Some older cameras, like the X-E1, don't even have this option.

1.47

1.48

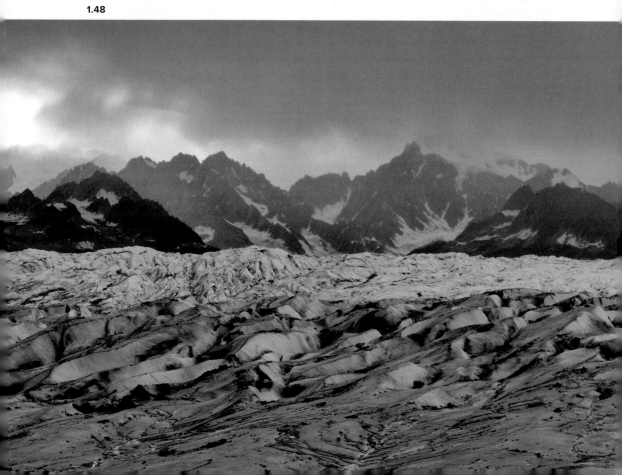

## Manual Focus and Manual Focus Override

All Fuji cameras can be focused manually. Simply switch the Focus Mode Selector on the front of the camera to M and rotate the focus ring on the lens barrel. To help you determine whether your subject is in focus, you also have a set of MF ASSIST tools in the AF/MF SETTING menu, which help you achieve focus more quickly and accurately, much like the fresnel and split screens did back in the days of film cameras.

There's also an extremely useful setting called AF+MF, which lets you perform manual focus override. This can be helpful when the autofocus gets close (but doesn't quite nail it) or confused due to busy subject matter surrounding your main subject or if there's not enough contrast for the sensor to determine focus.

Note: If you're using one of the three "clutch" lenses (14mm f/2.8, 16mm f/1.4, or 23mm f/1.4), you'll need to pull the focus ring back in order to allow for manual focusing. With most cameras, the camera will still perform autofocus even with the ring pulled back.

This feature is further enhanced by the FOCUS CHECK option, which allows the cameras to automatically zoom in whenever you turn the manual focus dial.

In addition, those three wide-angle clutch lenses also have a Depth of Field (DOF) scale printed right on the top of the lens barrel. (Pull the focus ring back to reveal it.) This makes them ideal landscape lenses, and it allows you to quickly make relatively precise DOF assessments and adjust your focus for Hyperfocal Distance without having to use one of those DOF mobile apps.

Use the lens's DOF scale in conjunction with the camera's DEPTH-OF-FIELD SCALE menu item for even more accurate focus assessments.

## The AF Selector Switch

This is the little switch on the front left side of the camera (as you're looking through the viewfinder). It has three positions: S, C, and M.

**S stands for AF-S, or Single Autofocus.** This is the mode you use when shooting still subjects in Single Shot Mode, taking one picture at a time. Use this when shooting landscapes, flowers, street scenes, etc.

In AF-S Mode, the shutter won't fire until the camera's autofocus system achieves a successful lock on your subject and you see the little AF box turn green. However, if you or your subject moves after the boxes turn green, it won't reacquire focus on your subject and your picture will be out of focus.

1.49

**C stands for AF-C, or Continuous Autofocus.** This is the mode you use when tracking moving subjects or if you're moving in relation to your subject matter. It's also the preferred mode to use when shooting Continuous mode, or Burst mode as it's sometimes called.

In AF-C mode, the autofocus system will continue to track and "hunt" as it constantly tries to keep your subject in focus. The camera will fire whether the subject is in focus or not. Don't let that deter you, though. It's not uncommon for the camera to miss a shot or two within a burst, but depending on the subject, the camera can usually reacquire the focus lock and keep going. Keep in mind that how well the camera acquires and retains proper focus is largely determined by which model you have. (I cover this topic in more depth in the upcoming section section, "Tips for Shooting Fast Action.")

**M stands for Manual Focus.** When you flip the switch to M, you put the camera into manual focus. Turn the focus ring on your lens to achieve focus.

Note: These are the default settings, although you can customize the behavior and parameter settings for your AF-S and AF-C settings in both the RELEASE/FOCUS PRIORITY option in the AF/MF SETTING menu and in the SHUTTER AE/AF menu option in the BUTTON/DIAL SETTING menu within the SET UP menus. On the RED/BLUE menu cameras, you'll find these customizations under AUTOFOCUS SETTINGS in the RED MENUS.

# VIDEO SHOOTING

Every X Series camera will shoot HD video, and all of the models from the X-Pro2 on will shoot 4K. The fourth- and fifth-generation X Series models can capture 10-bit color (4:2:2), which gives your videos improved clarity and brilliance, although these models can only export 4:2:2 to HDMI. Movies recorded to a memory card are saved at 4:2:0.

To record video, set the DRIVE control/dial to MOVIE mode, and simply press the shutter button to start and stop. Some models also have a dedicated MOVIE REC button, or an Fn button that can be set to MOVIE RECORDING RELEASE, which you can press anytime to start and stop, even when the camera is not set to MOVIE mode.

The X-T4 is different in that it has a dedicated STILL/MOVIE switch, which allows for an easy and seamless transition between shooting stills and capturing video.

# The MOVIE MENU

All of the current X Series cameras have a dedicated MOVIE menu, which allows you to apply any number of camera settings separate from your regular still shooting options.

On most newer X Series models—X-H2S, X-H2, X-T4/5, X-E4, and X-S10—**the MOVIE menu is separate, and it's only accessible when you put the camera into MOVIE mode.** This helps keep things a little cleaner, as these models all have six different menus full of "movie-specific" settings and functions you can control.

Some cameras have a menu called MOVIE SETTING, which you'll find inside the regular camera menu. This menu is where you can adjust the options for shooting movies in STILL PHOTOGRAPHY mode, when using either that dedicated MOVIE REC button, or if you have set one of your Fn buttons to MOVIE RECORDING RELEASE. The cameras that have this function are the X-H2S, X-E4, X-S10, and the updated X-T30II.

The new fifth-generation models have a setting called MOVIE SETTING LIST, which will display all of your currently enabled movie settings.

If you have a RED/BLUE menu Fuji, you'll find the MOVIE SET-UP menu inside the RED MENUS.

## Creative Movie Shooting With the X Series

In addition to offering a host of settings to control all your video parameters, all of the X Series camera allow you to apply any number of creative "Image Quality" settings when shooting movies. These settings include things like the Film Simulations, White Balance, Monochromatic Color, etc.

By making use of these options, you can create a wide range of looks, moods, and color styles in-camera, without having to resort to post-production to get the look you want, and then export fully stylized videos that are ready for sharing or uploading to your favorite video service, just as if you were shooting in-camera JPEGs.

You can even shoot movies in black and white, and apply tonal and color adjustments to your video using tools like HIGHLIGHT and SHADOW TONE.

Of course, if you want to do full post-production work on your videos and apply color grading and other effects, you can shoot and export your videos in F-Log, which is a very flat-looking color profile that gives you the most flexibility for adjustments in post. With the X-T5, X-H2, and X-H2S, you can even shoot RAW video footage for output to external recording devices.

Either way, the expanded video capabilities on the X Series cameras offer everything you need to make high-quality videos and even shoot full-featured productions, like films, documentaries, and music videos.

## Professional Audio Options

In addition to all the creative visual features you can utilize when shooting movies, most X Series cameras allow for expanded audio capabilities as well. You can use external microphones, and with an adapter like the IK Multimedia iRig PRE 2 (ikmultimedia.com), you can plug a high-quality XLR microphone right into the camera's mic jack. Some models even allow you to plug an external line-level audio device—like a keyboard, mixer, or even the audio output from your phone, tablet, or stereo—into the mic jack.

If you have an X-T4/5 or the new X-H2 and X-H2S models, you can capture immersive 2- and 4-channel audio for recording or streaming by using multichannel adapters like those made by IK Multimedia and TASCAM. Again, the creative possibilities are as big as your imagination can take you!

# TIPS FOR SHOOTING FAST ACTION

Now that we've covered the focus control settings, let's put these techniques into practice. There you are, standing out in the wilds with your camera in your hands, photographing things that aren't moving, such as flowers, mountains, or people standing still.

Suddenly, a flurry of motion catches your eye and you see a fantastic action scene unfold in front of you. Maybe it's a majestic eagle taking off from its perch and getting ready to fly right past you.

Maybe it's a cheetah bolting across the Serengeti. Maybe it's a mountain biker blazing right toward you along the trail (see Figure 1.50). Or a bright red Formula One car about to race by at high speed. Anything. Sports. Wildlife. Your friend running along the beach. Bank robbers. Bigfoot. Or your friend on his mountain bike.

**1.50**

You bring your camera to your eye, press the shutter, and...you miss the shot. Or you make one picture that's sort of okay. However, wouldn't you rather have taken multiple shots and hopefully nailed a great one?

**You can shoot fast action with any of the X Series cameras**. They all have highly advanced autofocus systems and high frame rates, but you need to configure them the right way. And you should know how to do it quickly so you won't miss those awesome shots.

**It's actually quite simple, but it requires a very specific workflow. So...**

## Follow These Directions

### Step 1: AF-C (Continuous Autofocus)

With your left index finger, reach around to the front of the camera and **flip the AF Selector Switch from S to C.** You don't even have to look; just do it by feel. C is in the middle, so it's just one click. Just to make sure, push the bottom of the little dial toward the lens to make sure it's on S, then pull back one click to C.

This switches the camera to AF-C mode, or Continuous Autofocus, and it's the mode used for tracking moving subjects and shooting bursts.

## Step 2: CH (Continuous High)

Now **reach up to the Drive dial** on the top left, again with your left hand, and **switch it to CH**. This sets you up for Continuous High shooting mode, which is 8 frames per second (fps), or an optional 11 fps if you're using the X-T2 with the Vertical Booster Grip set to BOOST mode.

If you don't have a Drive dial (X-Pro1, X-Pro2, X100 series, X-E1, X-E2, X-E3, and X70), **look for the DRIVE button** on the back of the camera. To go from S to CH, press the DRIVE button and navigate down one click to Continuous Mode. From there, you can go back and forth between CL (Continuous Low) and CH (Continuous High).

There. Now you're set. With these two steps, you're ready to track your subject and capture multiple shots in high speed.

**You may have to do a couple of other things,** depending on your current exposure mode and the current lighting conditions.

## Step 3: Fast Shutter Speed

In order to shoot fast action, **you'll usually want a fast shutter speed** (unless you're doing slow shutter and motion blur shots). This means you'll want at least one of the following, or in some situations, both: **a wide open f-stop or a high ISO setting.**

If you're shooting in **Aperture Priority mode**, simply rotate the aperture ring all the way counterclockwise to open up the aperture. This will automatically get your shutter speed as high as possible, based on your current ISO setting.

In **Shutter Priority mode,** simply turn the Shutter Speed dial to a fast speed—usually at least 1/250 sec. or higher. If you're using a long lens, you'll want to go at least twice that speed.

In **Manual mode**, you'll have to set both shutter speed and aperture. I actually prefer using T mode to control my shutter. It's just faster and easier.

In **Program mode**, the camera will be doing everything, so you won't need to adjust shutter speed or aperture, though you can make a Program Shift adjustment and increase the shutter speed by rotating whichever command dial you have set for Shutter Speed Operation.

### Step 4: ISO

If you're shooting in bright, sunny light, then ISO 200 will work fine for any kind of action shot. However, if your light is anything less, you may have to adjust your ISO to a higher setting.

If you're using the X-T2, simply reach up and crank the ISO dial to a higher setting. If you have time to think, you can be precise and set it where you want; at least go up a whole stop or two, if not more.

If the action is unfolding in front of your eyes and you don't have time to spare, **just give it a great big spin**. Who cares how high you end up; images look great at all settings. Unless it's really dark or if you're shooting completely in the shadows, ISO 800–1600 will probably be adequate. However, don't be afraid to go up to 3200 or higher if you need to; the X Series cameras do great at higher ISO settings, especially the new 24MP MY MENU models.

The X-Pro2 and X100 series cameras also have a dedicated ISO dial. Use the same method. On all the other cameras, you can find ISO in the Q menu, or else you can set ISO to one of your Fn buttons.

## Recap

I'll go through the workflow again and just list the steps as simply as possible so you can memorize what you're supposed to do:

1. **Set the AF Selector switch to AF-C.** You can do this without even looking.

2. **Set the Drive dial to CH.**

3. **Make sure you have the camera set to a fast shutter speed.** This may require you to: **open up the aperture all the way** (A mode); **set the camera to a fast shutter speed** (S or M mode); and/or **crank up the ISO** (only if it's not bright and sunny).

There you have it. In three, maybe four, very simple steps, you can configure the camera for fast-action shooting and be ready to capture those killer sports and wildlife images. If you know what you're doing, this switch should take no more than five seconds. That's the key to nailing awesome images. You need to be ready.

You should practice this method until it becomes second nature. Pick up your camera, turn it on, and run through the routine a few times. Learn to be fast. Practice until you've got it down pat. Then get outside and shoot some great action photos!

1.51

## More Action Photography Tips

**Don't be afraid to burn lots of frames.** Film is cheap. At least that's what we used to say. Digital frames are even cheaper.

**Shoot in CH (Continuous High) and fire off short bursts of images as the action unfolds.** This will help ensure that you get at least some keepers.

**Realize that you may not get every single image sharp, but this isn't your goal.** It's not even the goal of pro sports shooters. The goal is to nail one or two really great shots that are both sharp and capture a great moment or expression. If you shoot 20 frames but only get one superb, excellent, memorable image, consider that a success.

**Fast-action photography is largely lens-dependent.** All the newer Fuji XF lenses have faster AF motors than the first generation of Fuji glass. That said, the XF18–135mm weather-sealed kit lens has a very fast AF motor. So do the 90mm f/2 and the 50mm f/2. The XF50–140mm f/2.8, the XF16–55mm f/2.8, the XF100–400mm, and the two long telephoto lenses are all excellent action photography lenses.

**Learn how to anticipate your action scenes.** This will help you in a big way. Knowing—or at least having a pretty good idea about—what's going to happen will go a long way toward success when shooting fast-moving subjects. Seeing something move, then thinking, *"Hey, I think I'll shoot that!"* won't get it done most of the time. Knowing your gear, knowing the potential behavior of your subject matter, and being ready will.

**Although we often think telephoto lenses are the ideal action lenses, don't be afraid to try shooting action with wide-angle and even normal lenses.** With a shorter lens, you'll have to stand a lot closer, but you can sometimes achieve a more intimate, "right in the middle of the action" feel to your shot. A shorter lens also allows you to shoot with smaller apertures; sometimes a wider depth of field will make a difference.

1.52

If you have an older X Series body or one that doesn't have very fast AF (X-Pro1, X-E1, X-E2, X70, older X100) or if you don't have a very fast AF lens, try anticipating where your subject will be and manually prefocus on a specific point. When your subject hits that point, shoot a quick burst. This is how people shot action before the invention of autofocus.

Try using Zone AF or Face Detection AF. Once it locks on your subject, it will track pretty fast. Sometimes this can make a huge difference, especially if it's moving around the frame.

Practice, practice, practice. In the end, nothing will make you a better action shooter than regular practice with your camera.

One more thing: You should practice this stuff a lot.

## BRACKETING

In addition to AE Exposure Bracketing, the X Series cameras also allow you to perform ISO, Film Simulation, White Balance, or Dynamic Range bracketing.

Here's how to operate the Bracketing menu (DRIVE SETTING > BKT SETTING):

- **BKT SELECT:** Choose from AE BKT, ISO BKT, FILM SIMULATION BKT, WHITE BALANCE BKT, and DYNAMIC RANGE BKT.

- **AE BKT:** You can bracket up to +/–2 stops in 1/3-stop increments, or +/–3 Stops on the X-T2.

- **ISO BKT:** You can bracket up to +/–1 stop in 1/3-stop increments.

- **FILM SIMULATION BKT:** You can choose any three Film Simulations to bracket. When you press the shutter, the camera will shoot one frame, process the color data, and give you three separate images that match your three selections (see Figure 1.53).

**1.53** Film Simulation Bracketing: VELVIA, ACROS, and ASTIA

- **WHITE BALANCE BKT:** Similar to bracketing film sims, with this option, you can choose three different white balance settings. Again, nice if you're shooting JPEGs and want to try out different looks for your scene.

Film Simulation bracketing is a really fun option. I often shoot the same scene using multiple film sims, and although I usually do it manually (using a Fn button), I know photographers who use this method all the time. It's a faster and easier solution.

It's also a much better way to bracket film sims if you're shooting moving subjects, any kind of quickly changing scene, or when you have an "only one chance to nail it" type of shot. I would encourage you to play around with this setting.

## MULTIPLE EXPOSURE

The MULTIPLE EXPOSURE option found on the Drive dial/menu allows you to shoot two exposures on one frame. This offers yet another fun way to explore your creativity with the camera.

This seldom-used feature can actually be quite fun. Yes, I know, *"serious photographers"* would *never* use this feature (or at least admit they do), but who says photography has to be such a serious activity?

What's wrong with having a little (or a tremendous amount of) fun? Sometimes I think my mission in life is to dispel this notion with my happy-go-lucky style. If you've taken a workshop with me, then you know what I'm talking about.

After all, the words *Fuji* and *fun* begin with the same letter, right? Having fun with your camera is very important to your sense of well-being, your happiness, and your creative process. And it can open up doors for new ideas you might never have thought of.

The options for how you can use this mode are only limited by your imagination. Your imagination is the catalyst for great ideas, all of which begin with the question, *"What if I try this…?"*

When we think of multiple-exposure photography, we often think of superimposing specific elements over a dramatic background, or vice versa. A huge moon over a landscape. A toy looming over a cityscape. A dramatic sky over a serene foreground. A front and side profile of your friend in the same image. Endless possibilities.

But what about the practical applications for a multiple-exposure image? Using this feature, you could make superimposed images for web pages, presentations, ads, flyers, and other types of documents. Capturing it right in the camera would prevent you from having to do it in Photoshop. Hmmm...where have we heard this before?

## How to Create a Multiple Exposure

1. **Select the MULTIPLE EXPOSURE option and shoot your first (background) photo.** It helps to have an idea of the type of image you want to create before capturing your first frame, although this kind of pre-planning isn't necessary. Also, it helps to have open areas in the first frame where you can place the subject in your second exposure.

2. **If you like your first frame, press OK to take your second shot.** If you'd like to redo your first shot, press the Left button to RETRY. If you'd like to save your images as standalone, non-multiple-exposure images, press DISP/BACK.

3. **Compose and take your second shot.** Your first image will be superimposed in the viewfinder as a visual guide, so you'll be able to see exactly how the final double exposure will appear.

4. **If you like your second shot, press OK to save the multiple-exposure photo, or hit Left to redo your second shot.**

# PANORAMA

Now this is a feature I love on the X Series cameras, and I use it all the time. The PANORAMA setting lets you shoot sweeping panos of your scene in two sizes, either M (normal) or L (extra wide).

I've stitched panorama images together from multiple frames in Photoshop many times over the years. Fortunately, this process has become easier with each new version of the software; however, it still requires more time at the computer. It's so nice to be able to do this automatically and walk away with a finished image instead of having to wait. (Are you starting to see a regular pattern here?)

Yes, I know the serious photography purists will point out that a stitched pano created from numerous full-sized images will ultimately produce a higher-resolution image, but how much resolution do you need? How often do you make huge, mural-sized prints of your pano images?

1.54

1.55

A 9600 x 2150–pixel image from your X-Trans sensor cameras is more than big enough to make a decent-sized print. I once had a client use an image from my tiny 12MP X10 camera to make a 4 x 6–foot display print for use in a hospital lobby, and it looked fantastic! Trust me, for most uses, an in-camera pano will be more than adequate.

Plus, it's fun.

Of course, if you want the highest-resolution panorama with no distortion, then you're probably better off shooting multiple frames with a view camera like the ACTUS MINI View Camera for FUJIFILM, and then stitching in Photoshop.

To shoot a panorama image using this mode on your X Series camera, simply select PANORAMA mode on your Drive dial/menu. Then select Left to choose your ANGLE and select your DIRECTION: either Left to Right, Bottom to Top, Top to Bottom, or Right to Left.

Most of us shoot Left to Right panos. Why? Who knows. We're a left-to-right culture. That's how we read, and it's how we organize everything from bookshelves to digital

photo catalogs in Lightroom. Here's a question: do people who read and write in Arabic shoot Right to Left panos?

So, with all this in mind, why would you want or need to shoot panos in other directions? Maybe Right to Left just feels more natural for you, or it works better for your chosen scene. You don't always know where your pano will end, so if there's a particular feature or subject you want to feature on the right side of your frame, then it makes sense to shoot Right to Left.

What if you want to shoot a vertical pano? You can actually do that! With the right subject matter, this can be a lot fun! Think buildings, interiors, certain landscapes, and the sky.

You can also shoot regular horizontal panos, using the Bottom to Top direction setting. To do this, you hold the camera vertically while you sweep. This gives you a taller, and thus, higher-resolution panorama image. I use this technique a lot.

Here are the image sizes you can get with each pano size (see Figure 1.56):

- **M:** 6400 x 1440 pixels
- **L:** 9600 x 1440 pixels

Holding the camera vertically and shooting with the Top to Bottom/Bottom to Top direction (see Figure 1.57):

- **M:** 6400 x 2160 pixels
- **L:** 9600 x 2160 pixels

1.56

1.57

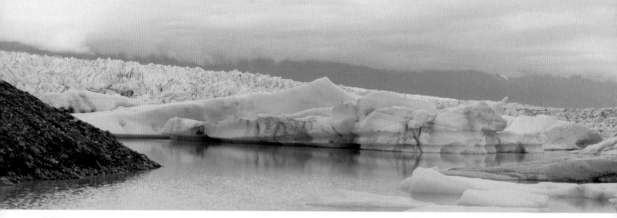

1.58

1.59

## ADV FILTERS

Finally, we're at the most fun setting of all: the ADV FILTERS!!! These are things like MINIATURE, DYNAMIC TONE, and PARTIAL COLOR—you know, features that have no real redeeming use other than simply to add joy and creativity to your photography.

And let's just get this out of the way right now: According to the manual, Fuji says that ADV stands for "Advanced," but that's clearly a mistake. It really stands for "Adventure."

As with the previous two settings, serious photography purists might want to look away and skip ahead to the next section. This section is only for people who want to goof off and have fun with their cameras. That said, if you're that serious, you probably need help. I should *make* you read this section because it sounds like you could use a little fun in your life.

You'll find the ADV FILTER shooting option on your Drive dial, or by pressing the DRIVE button and scrolling down to the bottom.

Note: With most cameras, you can only shoot JPEG with the ADV FILTERS, and you cannot shoot in either Continuous mode (CL or CH); it's a one-shot-only function. Also, you cannot track moving subjects. However, with a recent firmware update, you can now shoot in RAW+JPEG with the ADV filters using the X-T2 and X-Pro2.

## Choosing Your ADV Filters

How you select the ADV filter you'd like to use depends on which camera you're using:

- **X-T2:** Turn your Drive dial to ADV. To select a filter, go to DRIVE SETTING in the SHOOTING SETTING menu, and scroll down to ADV FILTER SETTING. **Better yet, assign DRIVE SETTING to a Fn button** and press that to bring up the ADV FILTERS menu. By default, the front Fn button on the X-T2 is already assigned to this option.

- **X-T1:** Press MENU/OK. The very first thing that comes up in RED1 is BKT/Adv. SETTING. Select this and scroll to the bottom of the menu to Adv. FILTER SELECT, and hit OK to bring up the options.

- **X-T10 and X-T20:** Turn the Drive dial to Adv.1 or Adv.2. (You can store your two favorite filters for quick selection using these two settings on your Drive dial.) To assign which filter is assigned to the 1 and 2 settings on your dial, go to Menu RED5 and select BKT/Adv. SETTING. Scroll down to Adv. FILTER SELECT for buttons 1 and 2, and assign whichever two filters you want. The default selections are TOY CAMERA and MINIATURE.

- **Any camera with a DRIVE button, X-E2 and later:** Press the DRIVE button and scroll down to ADVANCED FILTER. Press OK to choose your filter.

Sadly, the X-Pro1, original X100, X-E1, and the X-10/X-20 don't have the ADV FILTERS. However, the X10/X20/X30 all had them. (Turn to Adv on the Drive dial and press OK to find the ADV MODE menu.)

Now let's go through all of the different filter options you can choose from.

## Toy Camera

Retro toy camera effect. Nice, classic old-timey look with a greenish tint and a pronounced vignette (see Figure 1.60). The camera calls it Nostalgia Effect.

**1.60**

## Miniature

If you follow my blog, then you know this is my favorite ADV filter! See Figures 1.61–1.64.

The MINIATURE effect essentially blurs two-thirds of the frame, based on the location of your selected focus zone. The one-third of the frame that contains your selected focus point stays in focus, while the other two-thirds of the frame are artificially blurred by the camera.

It's called MINIATURE because it fools our eyes, making us think we're seeing something very small. The blur effect creates a selective, yet extremely shallow, depth of field, which tricks our eyes. When we're looking at (and photographing) things up close, we're used to seeing subjects with a very shallow depth of field. Since we never see distant subjects with a shallow depth of field in real life, this blur effect totally messes with our normal visual perceptions.

1.61

1.62

1.63

1.64

Also, we're not used to seeing things that are the same distance from the film plane with different amounts of focus. A tilt-shift lens allows you to shift focus in such a way that two things at the same distance from the camera can have different levels of sharpness and blur. It can also create an effect whereby two points that are at different distances have the same amount of focus. MINIATURE mode won't do that. You can only do that with a tilt-shift lens or a view camera.

All that being said, I don't use MINIATURE mode to make things look small. I'm in love with the dreamlike quality this effect produces, and I often use it to create ethereal, intimate images that evoke a mood of wonder.

I also love shooting portraits with MINIATURE mode because it allows me to accentuate the shallow depth of field; it's like a bokeh effect to the max. Figures 1.65 and 1.66 show portraits that were all shot with the X-T2 and 50mm f/2 lens. Depth of field is already quite shallow here, and the MINIATURE special effect makes it even more dramatic.

Mostly, though, I just like to shoot MINIATURE mode because it's fun.

1.65

1.66

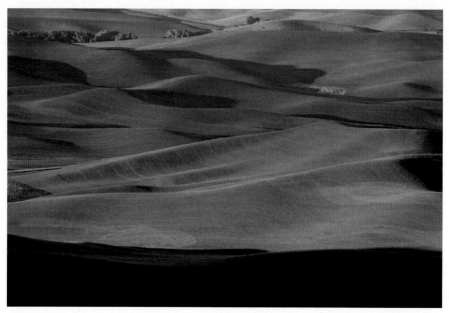

1.67

## Pop Color

This mode creates high-contrast images with saturated colors. Consider it VELVIA on steroids (see Figure 1.67). I've used it a few times to bump up the colors on already vibrant landscapes.

## High-Key

This gives you overall bright images with higher, softer tones and very low contrast. This mode is great for shooting portraits or adding a dreamlike quality to already bright subject matter.

## Low-Key

This does just the opposite as HIGH-KEY. It creates images with a pronounced dark exposure and higher contrast. I haven't used this mode much, but looking at it again, the color palette reminds me of a certain type of look I sometimes go for when I purposefully underexpose and increase my SHADOW TONE. It gives dark, gritty, hard-edged tones. I should try using this mode more often.

## Dynamic Tone

I love Fuji's description for this mode! It says, "Create fantasy effect by dynamically-modulated tone reproduction." It's really just quick and dirty HDR. (Billy from the FUJIGUYS calls it "cooked mode.")

Not being much of an HDR guy, you'd think I would never use this mode. You'd be surprised, though. With the right scene, it can look really cool (see Figures 1.68 and 1.69). Actually, it looks cool with *every* scene, but it's easy to get carried away and overdo this effect. Either way, you can have lots of fun with it.

1.68

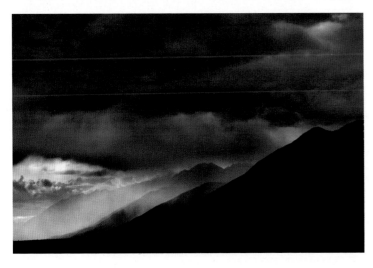

1.69

## Soft Focus

Also called "cheesy wedding photo" mode. Just kidding. This setting gives you a low-contrast look with a very pronounced halo of softness on everything. It's great for shooting portraits of pretty girls and photos that have the classic "dreamy flashback" look that you see in the movies and on TV.

## Partial Color

I *love* the PARTIAL COLOR ADV modes! They're super fun. Basically, you get an overall monochrome image, but anything that matches your selected color mode is rendered in that color (see Figures 1.70–1.74). When you want a particular element in your scene to stand out, try using this mode and see what happens. Sometimes it just looks funny, but occasionally you'll get something really awesome.

1.70

1.73

1.71

1.74

1.72

Here are the color choices you get from the PARTIAL COLOR mode:

- Red
- Orange
- Yellow
- Green
- Blue
- Purple

Okay. We're done with the really fun stuff, at least for now.

Serious photographers, you can resume reading from this point.

# FIRMWARE UPDATES

A large part of FUJIFILM's design philosophy revolves around the notion that when you buy a camera, it should last a while. This is a refreshing attitude in today's digital world where so much electronic gear becomes obsolete within a year or two.

Even though FUJIFILM keeps releasing new cameras with improved specs—which every business needs to do in order to remain competitive—they are very proactive about keeping their existing cameras relevant. They do this with regular firmware updates.

Since most of the features and functions found in mirrorless cameras are software-based, it's possible to upgrade and improve nearly every feature inside the cameras, provided there's enough internal memory and processing power to handle it.

All of the X Series products have received multiple firmware updates, even the older ones. Every single camera and lens have received at least one update, including the X-Pro1, which was released back in 2012. The X-T2 got a handful of updates, which added over 30 new features, performance upgrades, and bug fixes to the camera.

A great example of their commitment to supporting older cameras is the X-E2. Released in the fall of 2013, just three months before the X-T1 was announced, the poor X-E2 got totally lost in the excitement of the X-T1, which was followed soon after by the excitement of the X-T10.

However, FUJIFILM kept supporting the X-E2 with regular firmware updates, eventually giving it the same high-performance autofocus system that had become standard in the X-T bodies. This gave the X-E2 a brand-new life as an affordable rangefinder camera for people who preferred a rangefinder camera over an SLR-style body. In all, the X-E2 has received 42 new features and fixes during its life.

1.75

This led to the X-E2S, which is really just an X-E2 with the updated firmware and an "S" painted on the body. Mechanically, it was the exact same camera. Pretty cool, huh?

## You Should Always Update Your Firmware

The point of all this is that you should always update the firmware for your Fuji cameras and lenses. Not only will it improve your camera's performance, it will ensure maximum compatibility and performance between the gear when new models are introduced.

You can see a list of all the current X Series interchangeable-lens camera and lens firmware updates on the FUJIFILM website.[6] If you have an X100, an X70, or any of the other non-interchangeable-lens models, visit the firmware page for fixed-lens cameras.[7]

**The process for updating your firmware is simple**. Download the firmware to your computer, copy it to an SD card, stick the card in your camera, and turn the camera on while pressing and holding down the DISP/BACK button.

Then follow the prompts. In most cases, the update will take about a minute. You can also upgrade your firmware on newer models using the FUJIFILM Camera Remote App.

If you're updating a lens, download the proper firmware and perform the same steps. Just make sure you put the lens you're trying to update on the camera. Again, hold down the DISP/BACK button, turn the camera on, and follow the prompts.

# TROUBLESHOOTING

I rarely have real problems with my X Series cameras, but things do get a little wonky sometimes. More often than not, it's one setting that causes a conflict with some other setting. Certain settings will disable one or more functions and, in some cases, will prevent the shutter from firing. At the very least, you'll get a grayed-out menu item, which leaves you stuck wondering what the heck to do.

Here are the most common settings that can disable or cause conflicts with other settings or impede the camera's operation in some way:

- **Electronic Shutter:** Disables the flash/hot shoe.

- **AF-S Mode:** Will disable Digital Split Image.

- **AF-C Mode:** Will sometimes limit your options in the Face Detection menu. Also, you cannot use AF+MF in AF-C mode.

- **AF+MF:** You cannot use Digital Split Image while using AF+MF mode.

- **Manual Focus:** Will disable Face Detection.

- **AF ALL Mode:** If your camera is set to AF ALL mode, you will not be able to select your Number of Focus Points. The camera will default to 91 AF Points.

- **AUTO Switch:** Flipping the AUTO switch on the X-T10, X-T20, and X70 automatically overrides a number of your FOCUS and IMAGE QUALITY settings and SHOOTING options.

## Other Errors

Your camera manual has a complete troubleshooting section, and it lists solutions to most of the common problems that shooters face. However, there are a few obvious things not covered in the manual that are not always so obvious when they're happening to you. Here are a few of those issues.

Note: If you experience any issues, **make sure the Drive dial is not set to CL/CH, MULTIPLE EXPOSURE, or ADV.** It can sound obvious, but in the moment, this is an easy one to miss. Turning the camera off and back on again can also solve certain errors.

**If the EVF is not working:** Make sure there's nothing blocking the little eye sensor at the bottom of the EVF. A piece of lint, a water drop, or a snowflake can cover the sensor and cause it to blank out.

**If the autofocus seems to be constantly hunting:** Turn off Pre-AF.

# IMAGE QUALITY (I.Q.) SETTINGS

The first menu on the MY MENU cameras is IMAGE QUALITY SETTING. This is where you'll find all of the functions that control the look and feel of your images. There's a lot of stuff in the IMAGE QUALITY SETTING menus—almost three pages worth—and most of it is pretty important.

The items you'll probably use most often are things like Film Simulations, Image Size, Image Quality, RAW Recording, White Balance, and maybe things like Highlight Tone, Shadow Tone, and Custom Settings. Keep in mind that these are all things that are already assigned by default to either a Fn button or a Q menu slot.

On RED/BLUE models, you'll find most of these settings in the RED MENUS, as well as in the Q menu.

# IMAGE SIZE AND IMAGE QUALITY

Let's take a look at the first two menu items here: Image Size and Image Quality.

## Image Size

The X Series cameras allow you to shoot in three different aspect ratios, with three different sizes for each (**S**, **M**, and **L**). Keep in mind, these only apply to JPEG files. If you're shooting in RAW only, this menu will be grayed out and your file will be full size. The aspect ratios are:

- **3:2** has the same proportions as a frame of 35mm film
- **16:9** is similar to the display of HD devices
- **1:1** is square

I usually shoot in **L3:2,** which gives the largest dimensions. However, nothing says you have to shoot in 3:2. There are times when my creative idea and the subject matter call for shooting a widescreen 16:9 image or 1:1 square. Sometimes it's fun to experiment with different aspect ratios. Note: Fifth-generation models also allow shooting in **4:3** and **5:4.**

One advantage of shooting in RAW+JPEG is that you can shoot in a different aspect ratio, like 1:1, without giving up any quality. Your JPEG will be square, but you'll still have a RAW file that contains all of the pixel data from your entire sensor.

I usually recommend shooting the largest size possible. Memory and card space is cheap, and you'll get the highest quality.

That said, there are times when you might find it advantageous to shoot smaller sizes. If you're on a space budget and you're only showing your photos on a computer, a Small 3MB file will be perfectly adequate. At 3000 x 2000 pixels, this size will still fill most computer screens, and it's suitable for a 5 x 8–inch print.

However, as I said, memory is cheap and you never know what you'll do with your pictures or if you might get a one-of-a-kind image. What if you shoot a photo of Bigfoot, or Nessie? You'd want that photo to be shot at full resolution.

## Image Quality

All X Series cameras can shoot in both RAW and JPEG formats. Choose **RAW** to record RAW images, use **FINE** or **NORMAL** to record JPEG images, or select either the **(RAW)F** or **(RAW)N** setting to save both RAW and JPEG images at the same time. This mode is typically called RAW+JPEG.

2.1

**FINE** and **(RAW)F** produce higher-quality JPEG images with lower compression, while **NORMAL** and **(RAW)N** use higher-compression algorithms to increase the number of images that can be stored on your memory card, with the tradeoff being slightly lower image quality.

If you shoot JPEG, I recommend using **FINE**. This produces the highest-quality images, and although they'll take up more room on your memory card, memory is cheap. Keep in mind, if you shoot RAW+JPEG, the FINE or NORMAL image quality setting only applies to the JPEG.

## Shooting JPEG vs. RAW vs. RAW+JPEG

Let's take a look at the different ways in which you can shoot only JPEGs, only RAW files, or the combination RAW+JPEG.

### JPEG

When you shoot in JPEG mode, the camera's image processor reads all of the exposure information that was recorded by the sensor, applies all of your current Image Quality settings, and distills the file down into an actual image. This is what you see when you play back the image, and it's what gets saved to your memory card.

During the distilling process, the camera makes decisions about what data should be saved and what should be thrown away in order to create an acceptable image that fits into a reasonable file size. Some data is inherently lost and can never be recovered, even if you open up your JPEG image in Lightroom, Photoshop, or any other software.

This usually isn't a concern, because the FUJIFILM image processors do an amazing job reading the info and producing great-looking files in nearly all conditions. However, due to the way the image processor crunches the numbers in order to produce a JPEG, the camera may not be able to save all of your data when shooting scenes that contain extreme highlights and very dark blacks.

The final image may still look fine, but if you open up the file in Photoshop and try to rescue those extreme tones, you will probably end up introducing more noise, because that info simply doesn't exist anymore.

## RAW

If you shoot RAW, the camera doesn't actually store an "image"; rather, it records all of the exposure information from the sensor as pure data to your memory card. This data also includes any camera settings you had applied at the time. This is a lot of information, which is why RAW files are so large.

At the time of shooting, the camera also processes the file and creates a medium-sized JPEG preview that gets embedded with the RAW data. It does this so you can view your image on the LCD; this processed JPEG is what you see when you look at the back of the camera. You're not actually looking at the RAW file, because that's just data.

Since a RAW file contains all of the original sensor data, you have a much better chance to rescue, recover, and manipulate your tones and colors when processing your image in your photo software of choice. In other words, a RAW file has way more latitude than a JPEG image.

Keep in mind, this doesn't automatically mean an image shot in RAW will ultimately produce a better photo. In fact, under most conditions, the Fuji JPEGs look incredible, and since they come straight out of the camera that way, you don't have to spend any time processing your photos.

Since most software imports and saves RAW files with a "flat" color profile and without your chosen Film Simulation, you'll actually *need* to do some processing just to get back to what they looked like on the back of the camera when you shot them.

By outsourcing your image processing to the camera, you save yourself a lot of time and end up with images that, in many cases, will probably end up looking better than if you tried to process them yourself. And your images won't take up nearly as much space on your card or your computer. (You can also always use the built-in RAW CONVERSION option to convert RAW images to JPEGs.)

## RAW+JPEG

This gives you the best of both worlds. In this mode, the camera saves both the RAW file and the processed JPEG to your memory card. You'll have a JPEG file that will probably look great straight out of the camera, and you'll also have the RAW file in case you want to do some more extensive processing on your image.

Another benefit of shooting in this mode is that your Film Simulation gets saved. As I mentioned above, when you import your RAW files into Lightroom or Photoshop, Adobe throws away the Fuji Film Simulation and applies its own standard, flat Adobe color profile.

So if you specifically chose one of the film sims, but you only shot RAW, you'll lose those colors when you import the file into Lightroom. You can reapply them in the Lightroom/Photoshop Camera Calibration tab, but keep in mind, these aren't the true Fuji film sim color profiles; they're Adobe's version of the Fuji film sims. They're good, but they don't perfectly match with the film sims you get in the camera.

However, if you shoot RAW+JPEG, you'll still have a JPEG that looks just like it did when you shot it, and it's ready to be posted, emailed, shared, or transferred to your mobile device. And you'll have the RAW as your "digital negative."

You'll probably find that with most scenes you won't end up needing the RAW file anyway. The RAW file will most likely just sit there, taking up space on your hard drive. If you're shooting in tricky light, though, or if you're shooting a professional job, you might be really glad you have the RAW file as insurance.

A friend of mine recently shot a wedding with her Fuji, and apparently, the bride hated the colors on all the images. Fortunately, my friend was able to go back to the RAW files and redo the colors.

**Most of the time I shoot in straight JPEG mode**, but during those times when I prefer to have a RAW file, **I'll always shoot in RAW+JPEG instead of RAW only.**

## RAW RECORDING

The MY MENU models give you two options for capturing RAW files. The default setting is **UNCOMPRESSED**, which gives you the RAW file with no compression.

**LOSSLESS COMPRESSED** stores the RAW files with a reversible compression algorithm that gives you a much smaller file with no loss in quality.

Uncompressed files are very large and take up much more room on your card. For example, an uncompressed RAW file from the X-T2 is about 50–60MB. To compare, a Lossless Compressed file is around 25–35MB in size.

**2.2**

So if Lossless Compressed produces no loss in quality and saves you card space, why do they include an Uncompressed option at all? Because a very small number of overly serious pixel peepers who have convinced themselves that it makes a difference would complain and probably not buy the camera if it didn't have this option.

For everyone else, I recommend you set your camera to **LOSSLESS COMPRESSED** and forget about it.

## SELECT JPEG/HEIF

The fifth-generation X-H2 and X-H2S allow you to choose whether your pictures are saved as JPEG or HEIF format images. JPEG has long been the industry standard, and it's still used for ADV. Filter Effects pictures, panoramas, and photos created in HDR mode.

2.3

HIEF is the format that's used by your smartphone. It has excellent compression, quality, and smaller file sizes, but it has limited options for viewing and sharing. Fortunately, these cameras also have a HEIF To JPEG/TIFF Conversion option in the Playback Menu.

## FILM SIMULATIONS

When designing the X Series, the Fuji engineers decided to incorporate the looks of some of their older films right into the cameras. This was a brilliant move, because if there's one thing that Fuji knows best, it's color; they have more than 80 years of experience and history surrounding film and color imaging.

Ask any photographer who has used Fuji photo film why they shot it, and they'll tell you it's because of the colors. In short, no one does color like Fuji, which is why this is such an integral feature on the cameras.

I'd even go so far as to say that the Fuji Film Simulations are the lifeblood of the X Series cameras. This wonderful collection of ten ultra-classic color palettes and nine monochrome styles (including the wonderful ACROS film sim, which comes inside all recent models) give you some of the most iconic looks in the history of photography.

Developed over decades and culled to perfection for the X Series, these built-in color presets offer you a diverse and dynamic set of tones with which to craft your artistry.

You should know that **whenever you're shooting with a Fuji camera, you're always using one of the Film Simulations**. There isn't an option to turn them off. The idea behind the film sims is the same as if you were shooting film.

If you're shooting JPEG, then what you get is what you get. Just like it would be if you had shot a piece of actual film, a specific color palette is fixed onto your image—only it's done by the image processor instead of through chemistry. Even if you're only shooting RAW, the selected film sim is tagged onto the file—though your software may toss it on import, which is what Lightroom does. You can get it back with John Beardsworth's X-LR Plugin for Lightroom.[8]

Before snapping away, gauge your subject matter and **think about how you want the photo to look.**

Again, what are you going for? Bold and beautiful? Subtle and subdued? Rich and powerful? Careful and contemplative? Clean and crisp, or garish and gritty? You've got it all right there at your fingertips, from the rich drama of VELVIA and the wonderful skin tones of ASTIA, to the soft, muted colors of PRO Neg Low, and the classic journalistic tones of CLASSIC CHROME, as well as a fantastic selection of black-and-white modes!

Forget about shooting "flat," which is a common technique for shooting RAW. **Shoot how you want it to look**. Pick a color and run with it. Bring your creativity into the mix right then and there. **Make sure you set your Film Simulation control to one of the Function (Fn) buttons so you can access it quickly,** and then experiment.

If you're shooting quick scenes or if you can't decide which one you like best, you can always bracket your Film Simulations. (See the "Bracketing" section in the previous

chapter.) This feature lets you pick three film sims to bracket. It's up to you. Maybe go one bold, one slightly subdued, and one black and white. Or whatever.

Here's a detailed rundown of each of the Film Simulations and what kinds of subjects I typically use them for. However, don't just rely on my recommendations. **I strongly encourage you to play around** with them. **Get to know the film sims intimately**. Commit them to memory and make them an integral part of your own shooting experience.

## PROVIA/STANDARD

PROVIA is the default setting. Based on the professional ISO 100 slide film, PROVIA offers a great balance of tonality with average contrast and good color reproduction that's not overly saturated (see Figure 2.4). It's well suited to a wide range of subject matter. It's the Jack-of-All-Film-Simulations, and it will handle just about any kind of light and subject.

## VELVIA/VIVID

In 1991, Fuji Photo Film (as they used to be called) unveiled an ISO 50 color reversal (slide) film that shook the world of photo imaging with its wonderfully rich color, highly saturated color palette, and inky black shadows. Outdoor photographers loved it. Seemingly overnight, VELVIA quickly became the favorite film of landscape, nature, travel, and adventure shooters everywhere.

A contraction of the words "Velvet Media," VELVIA means "vivid." It was my favorite slide film, and it's my favorite Film Simulation because it delivers colors that are larger than life. It's not always accurate nor is it *true to life*, but for general outdoor photography, it delivers the intended emotion and confidence of your scenes with a bang.

In fact, when designing the original VELVIA color profile, the Fuji color engineers actually added a bit of magenta to the blue tones, which added additional depth and flavor to blue skies in order to make them more "memorable."

The human brain often remembers events, interactions, and colors as being more "enhanced" than they really were in real life. That's just how we work. In fact, if we were to look at a truly accurate photo of a memorable scene, we would think it's "missing something." VELVIA plays on this psychological aspect of human memory and helps us photographers create images that resonate and play strong in the memories of our viewers.

**2.4**

If you love bold colors and rich shadows, then VELVIA is the film sim for you, at least on bright, sunny days. Under these conditions, it can't be beat, and it's ideal for just about any kind of outdoor or nature scene with vibrant blue skies, glorious green grass or foliage, and rich red and orange flowers, backpacks, tents, bicycles, jackets... you name it. (See Figures 2.5–2.10.)

However, for as good as it is in the sunshine, VELVIA often looks horrible under overcast skies, unless you're shooting up close. It has too much tonality and contrast to handle cloudy skies and dark landscapes. It also doesn't do well with darker skin tones.

2.5

2.6

2.7

2.8

2.9

2.10

## ASTIA/SOFT

ASTIA has a similar color palette to PROVIA but with slightly lower tonality. Based on Fuji's professional ISO 100 color reversal portrait and fashion film, ASTIA does great with skin tones and clothing, which makes it ideal for photographing people outside under natural light. That said, it looks great on any kind of subject, inside and out, because it has great color that doesn't block up when the contrast of your scene increases.

For this reason, ASTIA is my preferred film sim on cloudy days when VELVIA is too contrasty. It's one of my favorite film sims, and I find it incredibly useful for a variety of subject matter and lighting conditions. See Figures 2.11–2.13.

Don't be misled by the word "SOFT" in the title of the film sim. While ASTIA is designed to soften skin tones slightly, it actually adds a slight degree of hardness to shadow tones in order to counter that softness and make your photos appear nice and sharp.

2.11

2.12

2.13

## CLASSIC CHROME

Although the Fuji people can't officially call it as such, CLASSIC CHROME was designed to emulate Kodachrome, the most classic of all film stocks. With the lowest saturation of any of the other film sims, CLASSIC CHROME produces softer colors and gives a wonderful muted look to your images.

At first, CLASSIC CHROME might seem a bit boring, especially when compared to VELVIA, but when you realize what it's doing, you'll find that it produces a very pleasing, almost monochromatic look, but in color (see Figures 2.14–2.17).

The tonality of CLASSIC CHROME is interesting; it's relatively soft in the highlights and harder in the shadows. This makes it quite usable for shooting under overcast skies. Shadows become a bit more rich, but your bright tones don't blow out so easily. You can use this to your advantage in a wide variety of situations.

When you want your story to be about the subject and not the colors, CLASSIC CHROME is a great choice. Think photojournalism, environmental portraiture, or street photography. It's even great for certain landscapes, because when you take away bright color, you force your viewer to concentrate on shape and tone, and to imagine the colors that were present. In that sense, it's like VELVIA in reverse.

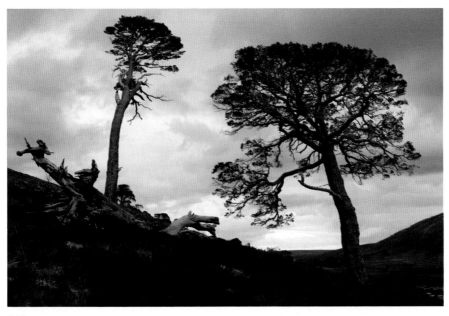

2.14

2.15

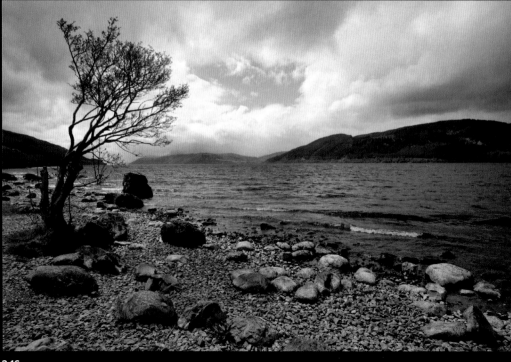

2.16

2.17

## PRO Neg Hi and Std

The two PRO Neg film sims are patterned after Fuji's popular NPS 160 print film, which was the go-to choice for wedding and portrait photographers. They're also the oldest Film Simulations in the bunch. First introduced in 2004 inside the FinePix 700 digital camera, they were created for photographers who craved a digital version of NPS 160. Think soft tones and muted colors. Again, great for photographing people. The two flavors of PRO Neg are Hi and Std.

PRO Neg Hi has slightly more tonality than Std, which gives it a little more contrast. It's ideal for portraits outside or street photography.

PRO Neg Std has the lowest tonality of any of the film sims, and it produces images with minimal contrast and soft, muted colors but with slightly enhanced skin tones. It's designed to give the best results when photographing portraits inside under studio lighting and flash.

I actually love shooting with these two sims, and I use them quite often.

2.17

2.19

2.20

2.21

## CLASSIC Neg.

Fuji's new CLASSIC Neg. film sim was introduced in the X-Pro. Built to replicate the look of the old FUJICOLOR SUPERIA color print film introduced in the late 1990s, it's designed to give you the look of consumer color negative film that was so prevalent in the days and decades before digital photography took over. In a sense, it's designed to look like snapshots of old.

With CLASSIC Neg., Fujifilm digs into its eighty-five-year history with film and color, and gives us a unique but familiar look. This new film sim taps into our color memories with a bold and unique expression that plays nicely with the already rich set of color choices we have in the X Series.

The color palette of CLASSIC Neg. is interesting. It has a strong tonality, similar to CLASSIC CHROME, but with slightly richer "Fuji-style" colors that you see in the PRO

Neg. film sims. The effect is a slightly muted but high-contrast look that, again, is reminiscent of the matte finish prints that so many of us grew up with.

This gives it a very representational look, and I find it to be a highly versatile film sim. It seems to work with just about every kind of subject and it produces a very cool and timeless look with a great deal of style. CLASSIC Neg. is a great addition to the X100 series, and I'm sure that it will quickly become a favorite for many shooters.

CLASSIC Neg. is already one of my favorite film sims. In my mind, the addition of CLASSIC Neg. might just be the strongest reason to upgrade.

2.22

2.23

2.24

## NOSTALGIC Neg.

Coming over from the GFX, NOSTALGIC Neg. is the first new film simulation to be introduced in the fifth-generation models. It's inspired by classic color prints and photo albums of the 1970s.

NOSTALGIC Neg. has rich colors in the shadows and a softer tonality through the midtones and highlights. With a somewhat similar palette to CLASSIC Neg., it has warmer hues, more vibrant reds, and slightly less contrast that gives you more shadow details.

## ETERNA/CINEMA

ETERNA is based on Fujifilm's motion picture film of the same name, which was first introduced in 2004. With a very muted palette, it's designed to give a cinematic look to your videos. It has a very soft tonality and a specifically engineered color balance to complement the differences in how we respond visually to film as opposed to still images.

**2.25** NOSTALGIC Neg.

Where photographs must deliver an entire message within a single, two-dimensional, motionless space, movies and videos are able to complement the visual aspect of the story with camera and subject movements and the added dimension of sound. For this reason, the visual impact of the space doesn't need to be as prominent as it does in an image. The same amount of color that works in a photograph might overwhelm or overshadow the other elements in a motion picture.

ETERNA delivers color with very low saturation and a wide dynamic range, similar to the look of Pro Neg. STD. The low contrast levels also make it a perfect base if you intend to do further color grading on your project.

You can certainly shoot still images with ETERNA, treating it like an even softer Pro Neg. STD. It might be a good solution for portraits used for editorial purposes or when you want to present the subject with a soft look. In addition, the low tonality can work well for images printed on matte paper.

**2.26** ETERNA Film Sim

**2.27** ETERNA/CINEMA

**2.28** NOSTALGIC Neg.

## ETERNA BLEACH BYPASS

With the X-T4, Fujifilm introduced a new Film Simulation called ETERNA BLEACH BYPASS. This all-new color palette creates a high-contrast look with very low color saturation. It's designed to reproduce the developing technique of skipping the bleaching step, which was sometimes used by photographers in the days of analog film, and in Nik Software's Bleach Bypass filter, found in their Color Efex collection.

With its edgy, bleached look, ETERNA BLEACH BYPASS film sim adds a new level of style and cinematic drama to your photos. Its specially tuned recipe accentuates details and contrast in the darker tones, but reduces contrast and overall tonality in the lighter tones of your image. It's akin to shooting monochrome in color. In Fuji's own words, this new film simulation "delivers hard, serious images that—apart from being in color—resemble black-and-white photographs."

Think ETERNA with increased SHADOW TONE and a decrease in the COLOR setting. Of course, the exact recipe is not that simple, but this will at least give you an idea of what it looks like and how you might try to achieve a similar look if you don't have this option.

As of this writing, the only cameras to feature the new ETERNA BLEACH BYPASS Film Simulation are the X-T4 and later.

2.29

2.30

2.31

## ACROS

ACROS is a black-and-white Film Simulation with an exceptional level of tonality and a very complex grain structure. It requires a higher degree of processing than regular Monochrome sims, so it's not found on the first- and second-generation Fujis.

With a tonality curve that's capable of holding detail in both bright whites and dark shadows, ACROS produces an exceptional level of depth and tonal gradation across the entire image.

It also produces a wonderful, characteristic level of grain that very closely mimics actual film grain. Just like you would see in a black-and-white print, ACROS has more grain in the darker areas and almost none in the highlights, and it increases in strength as you move up the ISO dial.

At ISO 3200, ACROS looks incredible, with superb tonality and gorgeous, film-like grain. At ISO 12800, images still hold up with a surprising amount of detail, and the grain looks just like what you'd see on a print made from Kodak T-MAX 3200.

I absolutely love ACROS. You will, too. If you have a newer Fuji, definitely shoot with the ACROS film sim, and don't be afraid to shoot it at any ISO setting. I'll often shoot

2.32

2.33

2.34

**2.35** X-T2 image, shot at ISO 3200

**2.36** X-T2 image, shot at ISO 3200, cropped to 100%

ISO 3200 in broad daylight, just so I can get that awesome grain (see Figures 2.35 and 2.36). Remember, photography is all about representation, and a little bit—or a lot—of grain never hurt anyone.

You can also use ACROS with the three color filter settings. The Yellow (**Ye**) filter deepens purples and blues. The Red (**R**) filter deepens blues and greens, which increases contrast and darkens skies, making it great for shooting dramatic land-scapes. The Green (**G**) filter deepens reds and browns, including skin tones, which makes it a good choice for portraits.

2.37

2.38

## MONOCHROME

MONOCHROME is the default black-and-white Film Simulation, and it's found on all the X Series cameras. Before I had the X-T2, I shot in MONOCHROME all the time and I loved it (see Figures 2.38–2.40). If your camera doesn't have ACROS, then this will be your choice for black-and-white photography.

Don't worry about what you might be missing if you don't have ACROS; MONOCHROME is a gorgeous film sim, and I guarantee you'll have fun with it. You can even apply the same **Ye**, **R**, and **G** color filter settings as discussed above.

2.39

2.40

## SEPIA

Self-explanatory. Old timey. Black and white, only warmer, with a pronounced brownish-yellow tint (see Figure 2.41). Just like really old pictures.

You won't use it very often, but in the right situation, it can be fun.

**2.41**

# B&W ADJ. (WARM/COOL)

Found only on the X-T3 and X-T30, the B&W ADJ. menu lets you customize your black-and-white film simulations by adding a warm or cool tint to your ACROS or MONO-CHROME photos.

By scrolling either up or down on the color bar indicator, you can adjust the amount of tint applied to your images with nine steps of adjustment in either the yellow or blue spectrum.

This is yet another way to add style to your images right inside the camera, without needing to resort to further processing. It's another tool in your creative bag of tricks that lets you explore your creativity right there in the moment.

If you're shooting in JPEG, the new color tint will be permanently fixed into your image. With RAW, it's the same as with the other film simulations: The color profile is tagged in the file, but if you open the image in an external processor like Photoshop or Luminar, your software will discard the Fuji film sim profile and display the image with the default color profile. Your BW tint will be gone.

2.42

2.43

2.44

# MONOCHROMATIC COLOR

Most newer models have this instead of the B&W ADJ. (WARM/COOL) setting. It gives you even more creative control by allowing you to not only push the image toward the warm and cool side, but also push it toward the green or magenta side.

Instead of a single up/down option for WARM/COOL adjustments, you now have a full white balance graph that lets you adjust the X-Axis (warm/cool) and Y-Axis (magenta/green) in any combination you want. This allows you to further customize your monochrome images in a much wider array of tones and color shifts, and your changes are shown as value. For examples, five clicks up and two clicks right will be shown as WC+5 MG-2.

When you see various examples together, the color shift stands out like a sore thumb (Figures 2.45–2.51). However, when you view a shifted image on its own, the effect appears much more subtle and intriguing, and it lets you add a high degree of style to photographs that you shoot in any of the Monochrome film simulations.

**2.45** ACROS with WC -6 (WARM/COOL) and MG +2 (MAGENTA/GREEN)

**2.46** ACROS with WC -6 and MG +9

**2.47** ACROS with WC +3 and MG -6

**2.48** ACROS with WC -7 and MG -2

**2.49** ACROS with WC +8 and MG -7

**2.50** ACROS with WC +8 and MG -7

**2.50** ACROS with WC +3 and MG -2

# COLOR CHROME EFFECT

First introduced in the GFX system, COLOR CHROME EFFECT replicates the look of Fuji's Fortia film, which was a brand of slide film from the early 2000s. Fortia was touted as having even more contrast and vibrancy than Velvia. Essentially, the film increased the tonality without oversaturating the colors.

You can apply COLOR CHROME EFFECT to any of the color film simulations, with either a STRONG or WEAK setting. The effect adds a bit more richness to your images, although it's very subtle. It can be hard to see when you're shooting, but when you compare images side-by-side, you can definitely see the bump in tonality.

**2.52** Velvia with COLOR CHROME EFFECT – OFF

**2.53** Velvia with COLOR CHROME EFFECT – STRONG

# COLOR CHROME FX BLUE

Found on the X-Pro 3, X-T4, X-S10, and X100V and fifth-generation models, this adds a different take on Fuji's existing Color Chrome Effect that boosts the tones in your images to produce deeper colors and gradation in subjects that already have a high degree of saturation.

COLOR CHROME FX BLUE boosts only the blue colors of your scene, and you can apply it with a STRONG, WEAK, or OFF setting. The effect is like using a polarizing filter on the sky, and it also deepens shadows. I find that it adds a nice touch to certain imagery, and I especially love using it with the CLASSIC Neg. sim. It's subtle, but it's there.

**2.54** COLOR CHROME FX BLUE – STRONG

**2.55** COLOR CHROME FX BLUE – OFF

**2.56** COLOR CHROME FX BLUE – STRONG

## SMOOTH SKIN EFFECT

Brand-new and exclusive to fifth-generation models, this setting allows the camera's image-processing engine to create smoother skin complexions for portraits shot in JPEG or HIEF mode. Like the GRAIN EFFECT, you have three choices: STRONG, WEAK, and OFF.

## GRAIN EFFECT

This setting adds a "film grain" effect to your photos. It has three options: STRONG, WEAK, and OFF.

I realize that some (serious) photographers will hate this setting, but it can be fun. Remember how I keep saying that good photography is representational? For many of us, our memory of the symbolic nature of photography is closely tied to a certain legacy of grain that was often present in our pictures.

As I said above, **a little grain never hurt anyone**, and in some cases, it might even add a special something to the occasional photo that might appeal to you. That's where this setting comes in.

Okay, I know what you're thinking: Can't I just get grain by cranking up the ISO dial?

Yes, you can. That works, and it works exceedingly well with the ACROS Film Simulation at high ISO settings. However, high ISO in color never looks quite as good, and the GRAIN EFFECT setting will add a more defined grain overlay that looks more like film than high ISO images in color.

**2.57** Shot at ISO 12800

**2.58** Close-up at 100% of Figure 2.57

Also, if you apply grain at low ISO settings, your details will hold up a little better than they would at very high ISO settings. For example, at ISO 200, your details will be nice and crisp with an overlay of smooth grain, while at ISO 6400 and 12800, details won't be quite as strong, and the grain (noise) will be a little bit mushier.

So that's GRAIN EFFECT. Use it or don't. You might like it, you might not, but if you want it, you know where to find it.

# DYNAMIC RANGE (DR)

The DYNAMIC RANGE setting allows you to control contrast when shooting JPEGs. X Series cameras feature four settings: **AUTO**, **100%**, **200%**, and **400%**.

The lower values increase contrast when shooting in low-contrast situations, while higher values rescue certain amounts of highlight and shadow detail when photographing high-contrast scenes.

Higher values are recommended for scenes that include both sunlight and shadowed areas—high-contrast scenes like sunlight on water, brightly lit autumn foliage, portraits taken against a blue sky, and white objects or fair-skinned people wearing white. Note, however, that slight mottling may appear in pictures taken at higher values.

## How Does This Work?

It's all pixel-wrangling magic done inside the camera's processor. Essentially, when you shoot at the higher DR settings of 200% and 400%, the camera underexposes the scene, then selectively brightens the darker regions of your image. The algorithms allow you to retain your shadows without blowing out the highlights.

However, due to the way this setting functions, 200% only works at ISO 400 and above, and 400% only works at ISO 800 and above. When set to AUTO, the camera automatically selects either 100% or 200%. 400% can only be set manually.

## So, Which Setting Should You Use?

Good question. This is a setting I've never worried about on the X Series cameras. I've always kept mine on either 100% (which is essentially off) or AUTO and forgotten about it. Honestly, if you were to ask me right now where mine is set, I probably wouldn't remember.

If you're happy with the way your Fuji JPEGs look, I recommend doing the same. If you're curious about how this works, then go ahead and experiment with the different settings and see how they affect your images. However, if you're not really into doing careful experiments on a wide variety of scenes and subject matter, then just leave it at AUTO. Or on 100%. I promise you, you'll still get great images.

## D RANGE PRIORITY

This setting is designed to reduce contrast in high-contrast scenes by automatically adjusting your HIGHLIGHT/SHADOW TONE and DYNAMIC RANGE.

- **AUTO:** Contrast is automatically adjusted based on your current lighting conditions.

- **STRONG:** Dramatically reduces contrast in your scene. This setting would ideally be used to control the tones in very high-contrast scenes. It's only available at ISO settings 800 (640 on the X-T3/4) and higher.

- **WEAK:** Adjusts overall contrast by a small amount. You probably won't see much difference between WEAK and AUTO. It's only available at ISO settings 400 (320 on the X-T3) and higher.

- **OFF:** Contrast reduction is turned off.

Note, that when any of the D RANGE PRIORITY settings are engaged, the DYNAMIC RANGE, HIGHLIGHT TONE, and SHADOW TONE menu items are automatically disabled and are grayed out with a "DR-P" symbol. If you wish to make manual adjustments to any of these settings, D RANGE PRIORITY will need to be set to OFF.

## WHITE BALANCE

Every light source has a different color temperature based on the Kelvin scale. 5,000 degrees K is considered white light, which is what we see in pure daylight and with electronic flash. Higher temperatures lie along the blue spectrum, while lower temps signify warmer colors. For example, the light from an orange sunset might be around 2,900 degrees Kelvin.

In addition, certain types of artificial lighting add specific color casts. Many fluorescent lights have a green cast, while sodium vapor lamps emit a distinct yellow color. Incandescent lights are orange.

We don't notice this much with our eyes, as our brains automatically "correct" the light's color so that it looks relatively neutral. This is an evolutionary process that helps us see and determine accurate colors in our surroundings, no matter what kind of light we're in.

Digital sensors don't make this correction, so the camera's brain takes up the task in order to make the scene look "natural." Most cameras, including the X Series models, have a variety of WHITE BALANCE (WB) presets, as well as AUTO white balance. They also allow for a manual adjustment.

Here's a list of all the white balance settings you'll find on your Fuji. Remember, if you're shooting JPEG, then your chosen white balance will be written permanently into the file. If you're shooting RAW, the white balance will be tagged, but you can always change it in your photo software.

## Auto

The AUTO setting adjusts white balance automatically, and it usually does a great job with most scenes. This is pretty remarkable when you think about it.

Let's say you're shooting a gorgeous sunset scene with rich orange light. Technically, the white balance for this kind of scene would be fairly warm, but if the camera corrected for this warmth, it wouldn't look right; you want to preserve that nice orange light for your picture. **With AUTO white balance, the camera's WB light meter and algorithms keep the scene looking normal.**

Sometimes the WB will make slight adjustments on the fly, even when the light doesn't change. I've seen this happen at sunset. If this happens, **don't worry about what's *right*, worry about what looks good in your viewfinder**. I've shot sunset scenes where the WB changes with slight camera movements.

In these cases, I'll just shift the camera around until I get the look I want, then lock my exposure by pressing the shutter halfway down and recomposing.

One of my favorite images from the Great Smoky Mountains happened like this. You can see the slightly different looks in Figures 2.59 and 2.60. Merely shifting the camera slightly caused the white balance to shift enough to alter the look of the shots and give the second one a very different look from the first.

2.59                                    2.60

For any white balance setting, including AUTO, **you can adjust the white balance by simply pressing OK.** This will bring up the WB SHIFT color grid, where you can move the cursor with either the joystick or the thumb pad buttons to shift along the Red, Green, and Blue axes and fine-tune your scene to any color you wish.

Once you have a look you want, press OK again.

**Note: Your camera will keep this WB setting until you change it back.** If your pictures ever have a strange color cast, this is usually the culprit. Check and see if you have an altered WB setting.

**I keep my cameras on AUTO white balance most of the time** and I'm usually happy with the results.

## Custom 1, 2, and 3

All the X Series cameras give you the option to store three custom WB settings. Select the slot you want and press **OK** (or press the joystick). This will give you the option to shoot a photo and automatically set a new white balance to match the ambient light of your current scene.

After you shoot the photo, it will say, **"Completed!"** You can either press **OK** to accept the new WB, or press **BACK** to cancel. Instead of shooting a photo, you can press **OK** again to bring up the RGB WB SHIFT option. Set the color you want, then press OK again, and it will save to that slot.

This is a great option if you find yourself wishing the camera would render a certain scene or lighting type a little bit differently. Perhaps you find shaded scenes to be a little bit blue, or night scenes to be too green, or you want a tiny bit of magenta in your scenes to give them extra life. (Remember what I said earlier in the chapter? The actual color recipe of VELVIA has a little bit of extra magenta in there to help enhance the blues.) Or maybe you often shoot under a specific kind of artificial lighting; you could save a custom WB to correct specifically for that.

You could use one of the other WB settings, like SHADE or CLOUDY, or you could tweak the WB to your exact desires and save that as a custom preset. I've occasionally used this option to create a slightly warmer WB for shaded scenes.

## K (Kelvin)

With this white balance setting, you can choose your own specific color temperature as measured in degrees Kelvin. If your lighting is exceptionally cool, the higher degree settings add warmth to correct for the blue. Likewise, if your scene is exceptionally warm, the lower settings will cool the scene off.

Let's say you're shooting a portrait under artificial lighting and AUTO isn't quite getting there. You could use the K setting and dial in the exact color temperature in order to get the skin tones you want. Don't be afraid to get creative with this setting. If you *want* a warmer or cooler picture, even though it might not look accurate, you can adjust the K scale to your liking.

## Daylight

This setting is balanced for normal daylight scenes. I know photographers who prefer this over AUTO for shooting bright, sunny scenes. The WB is usually very close. In certain types of light, AUTO will look a tiny bit different. For example, under overcast light, it adds a tiny bit of magenta.

I recommend experimenting with this one and see what you prefer.

## Shade

Shaded scenes have a distinct blue color cast, so this setting will add yellow in order to warm up the scene to create normal daylight colors. I definitely use the SHADE setting when I'm shooting in the shadows or under overcast light and AUTO isn't quite getting me there.

Figure 2.61 shows a scene shot with AUTO white balance, while Figure 2.62 shows the same scene using the SHADE setting. Side by side, they look dramatically different, with the first having a distinct blue cast. The second one almost looks brownish.

However, if you were to view them separately, Figure 2.62 would actually appear to have a much more neutral color cast. See what I mean? Color can be deceiving, especially when you compare images side by side.

2.61                    2.62

## Fluorescent 1, 2, and 3

Fluorescent light does not have a standard color temperature; there are many different color casts, depending on the bulb type. This WB setting corrects for the three most common types of color casts that fluorescent light typically emits.

## Incandescent

The INCANDESCENT white balance setting corrects for the overly warm color temperature of regular light bulbs. You would also use this setting if you're doing the Joe McNally trick where you shoot with an orange CTO gel on the flash while using the INCANDESCENT white balance setting.

This makes the entire scene dark, blueish, and moody, while the WB will cancel out the orange of the flash and make your flash-lit subjects look normal.

It's a pretty cool effect. Here's how it looks. Figure 2.63 shows the scene with a "normal" DAYLIGHT white balance, while the white balance in Figure 2.64 is set to INCANDESCENT.

2.63

2.64

You can have a lot of fun with a flash and a CTO gel. I talk about this more in my *Going Fast With Light* ebook[9], and you can read how Joe does it in his awesome book *The Hot Shoe Diaries*.

## Underwater

This one is self-explanatory. It reduces the overly blue cast you'll typically find down in the depths. I've never used it, mostly because I spend very little (i.e., no) time underwater with my Fuji cameras. However, if you have an underwater housing, this is the WB you'd want to use.

## White Balance in Use

By default, WB is assigned to the right thumb pad button on the X-T2 and X-Pro2. (It's right "flick" on the X-E3.) All cameras have WB in the Q menu, and you can assign WB to a Fn button.

I like having it set to a Fn button because it allows for lightning-quick adjustments in the field. As I said above, I keep my camera on AUTO WB, and if I need to make corrections, it's right there at my fingertips—or rather, my thumb tip.

Remember, you can always set WB to any Fn button by holding down the DISP/BACK button and choosing from the menu. If you don't want to spare a Fn button, then get to know where WB is located in your Q menu. (Remember, you can customize your Q menu by holding down the Q menu button.)

I'll stress this again: unless you're shooting a commercial job where colors have to be 100% accurate across the entire job, then there is no perfect WB. It can be whatever you want, depending on how you want your pictures to look. If you prefer a little bit of magenta or blue in your photos, then that's your decision. If you like to warm up your shade shots more than normal, then that's fine, too.

I'll say it again—photography is all about fun. There is no perfect. There is only you and your creative ideas.

Don't be afraid to experiment and even make drastic changes if you like the way it looks. You could shift your scene with a heavy yellow/orange cast to make your images look like old prints. If you want to make pictures that resemble old slides, you could give them a slight green or blue shift.

When shooting a recent bike race, I decided to use a custom white balance, just to shake things up and go for a different look. Pulling up the WB menu, I hit OK and then went five or six clicks down and right on the graph, which gave a sort of "bronze" hue to my photos. The result can be seen in Figures 2.65 and 2.66.

## HIGHLIGHT TONE AND SHADOW TONE

You already know how good the X Series JPEGs look straight out of camera, right? This is one of the things we all love about the Fuji cameras. You can choose your desired Film Simulation, adjust your exposure, check the LCD screen, and pretty much be assured that you'll get a great-looking photo with wonderfully rich colors

**2.65** My "Bronze" custom white balance in action      **2.66** My "Bronze" custom white balance in action

and a high degree of tonal depth. The in-camera image processor does such a killer job with most scenes, **you can get by with shooting JPEG in a wide variety of lighting conditions.**

But what about when you're shooting in really tricky light? You could shoot RAW. The Fuji RAW files contain an enormous amount of information, but shooting RAW means you have to spend time processing your photos later, at a time when you're removed from the experience you were having when you took the original shot.

This isn't a bad thing, but there's something nice about being able to pick a film look you like, snap the photo, and walk away with a great shot.

If only there was a way you could deal with tricky light when shooting in JPEG mode....

Thankfully, there is. You can use the HIGHLIGHT TONE and SHADOW TONE controls found in the Q menu. (They're notated as **H TONE** and **S TONE**.) Many Fuji shooters I talk to have never messed with these controls, but they're quite useful.

With HIGHLIGHT TONE and SHADOW TONE, you can increase or decrease your lights and darks just as if you had post-processing capabilities built right into the camera. Instead of sliders, though, you control them with the command dial. And instead of tweaking the image after you take the shot, you can make your changes beforehand and view the results in the viewfinder or LCD.

The adjustments with these controls go from +4 to –2, with "+" adding contrast and "–" reducing contrast. This gives you a convenient way to rescue your really bright tones and either open up the shadows a little bit or make them even darker.

Here's a basic primer on how to use these controls. I talk more in depth about how I use them in the "Shooting Like Film" section of *Chapter 1: The Really Important Stuff.*

## Highlight Tone

Highlights are tricky. Unlike shadows, you don't usually want too many blown highlights in your photos. Most of us base our entire exposure calculation on trying to preserve the highlights, because once you blow them out and send them tumbling over the right edge of the histogram, you can't get them back.

It's the same with shadows, but we usually don't care. As I often like to say, shadows are your best friend in photography.[10] Shadows represent mystery, and they often work as dramatic shapes in your photos.

But blown highlights usually don't do anything for us. We hate to see large areas of blown-out sky or water in a photo—that just looks yucky—so we try hard to get rid of them or at least wrangle them under control. Using the HIGHLIGHT TONE control allows you to tone down the super-bright areas in your photo (see Figures 2.67 and 2.68).

If your highlights are totally blown, you won't be able to rescue them completely, but you can still dial them down a bit to make them less intrusive.

With this in mind, the HIGHLIGHT TONE control probably isn't quite as useful as the SHADOW TONE control, but it can still be a valuable and viable option if you're shooting JPEGs and you're faced with an exceedingly high level of contrast.

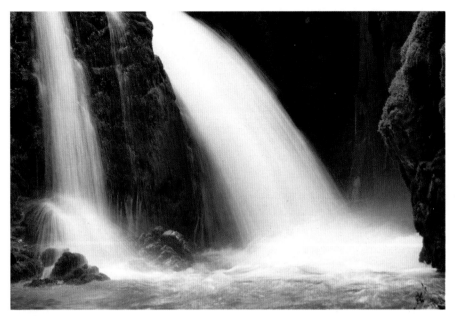

**2.67** HIGHLIGHT TONE set to 0

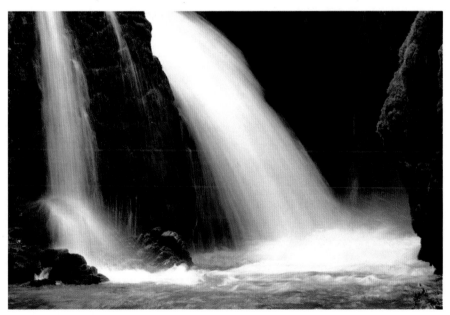

**2.68** HIGHLIGHT TONE set to −2

## Shadow Tone

The SHADOW TONE control can be used in a number of ways. As I mentioned above, I'll often use this control to tweak my chosen film sim and adjust my contrast levels.

I'll also use it to bring up darker tones and alleviate contrast problems. It's great for this.

Here's an example: Let's say you want to increase the level of your blacks for more drama and harder contrast. Go a couple notches in the "+" side of SHADOW TONE and you'll watch your shadows get darker. What if you already have a high-contrast scene and you'd like to show a little more depth and detail in the shadows? Pull back to −2 and you'll open up your image. Take a look at Figures 2.69–2.72.

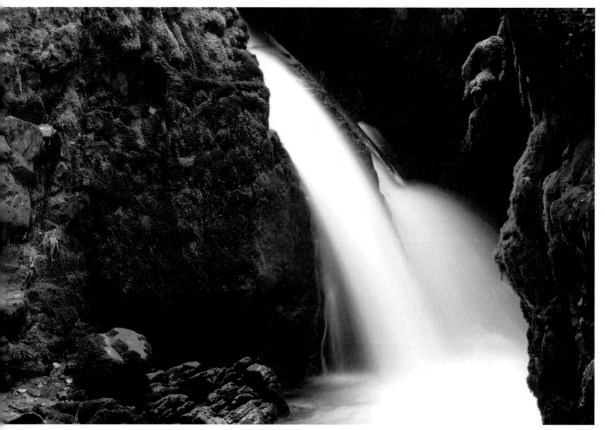

**2.69** SHADOW TONE set to 0

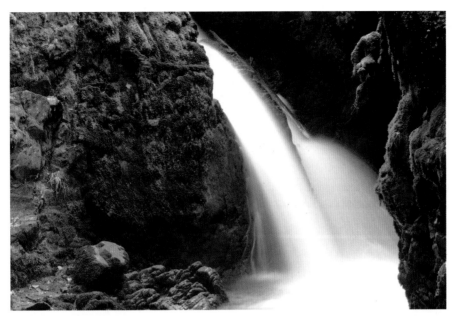

**2.70** SHADOW TONE set to −2

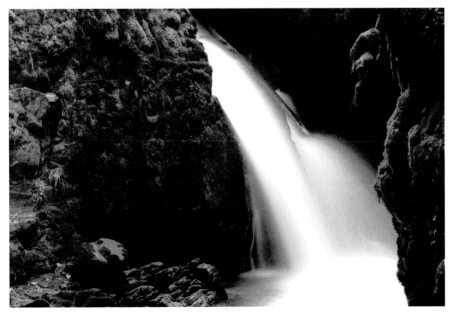

**2.71** SHADOW TONE set to +2

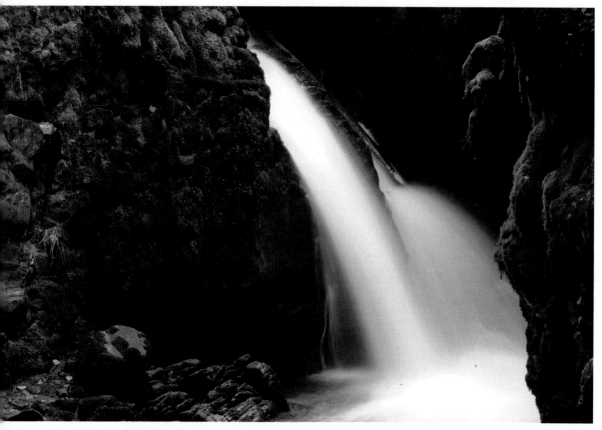

**2.72** SHADOW TONE set to +4

Here's another example: a forest scene shot under bright skies. This kind of scene normally presents problems with contrast, and it's the kind of situation when you'd often revert to shooting RAW. See Figures 2.73 and 2.74.

Figure 2.73 was shot straight with the VELVIA film sim, which already has a higher level of contrast. For Figure 2.74, I opened up the shadows by adjusting the SHADOW TONE to –2. Suddenly, I have more depth without sacrificing any of the highlights.

It's as simple as that. And the nice thing is that there's no price to pay; you hardly see any noise or grain increase, especially at lower ISO settings. It's essentially a free bump in your shadows.

**2.73** SHADOW TONE set to 0

**2.74** SHADOW TONE set to −2

# TONE CURVE

The most recent X Series models don't have separate Highlight/Shadow Tone menu items. Going forward, Fujiflim has combined them into one setting. Here, you can adjust your Highlights and Shadows with the standard +4 to −2 configuration in one place. At the same time, you can see the effect of your changes on a tone curve graph, similar to what you might see when adjusting curves in Photoshop.

As with all of the other models, you can still adjust either your Highlight or Shadow tones in the Q Menu as well.

# COLOR

The COLOR control works just like the HIGHLIGHT TONE and SHADOW TONE controls, although you have two additional values (−4 to +4). Adjustments on the "plus" side increase color saturation and contrast, while "minus" adjustments do the opposite.

The nice thing is that the effects are pretty subtle, way more subtle than what you get by going +4 on the SHADOW TONE. Nothing you do here will be too obvious to anyone, and chances are, your viewer probably won't even notice. See Figure 2.75.

Again, this only works on your JPEGs; it won't affect the look of your RAW files, except for what you see in the JPEG preview on the back of the camera.

## When Would You Use This Control?

That's a good question, and my best answer is that **it's entirely up to you**. The way I see this setting, it's less about fine-tuning your exposure and more about providing you with additional creative options. Given that it doesn't paint in broad strokes, it can actually be a very useful effect.

I use it to "color grade" my Film Simulations. Sometimes I'll bump up the vibrancy of a certain scene in order to make it pop even more, other times I'll use it to detune the colors and create a more subtle and subdued palette. You could make your VELVIA shot even more vibrant, or you could dial down your CLASSIC CHROME or PRO Neg images and make them even softer.

**2.75** VELVIA Film Simulation with COLOR set to +4

Perhaps you really want the VELVIA look, but your reds are just a little too hot and they're blowing out the histogram. You could use this control to pull them back into a more earthly gamut range.

Again, you could easily make these adjustments at the computer, but the beauty of the X Series is that you can get gorgeous images right out of the camera. These on-board controls give you that much more flexibility for refining and creating the exact look you want based on your subject matter, creative ideas, and mood in that particular moment.

**2.76** CLASSIC CHROME Film Simulation with COLOR set to −2

## SHARPNESS

The last control in this category, SHARPNESS adjusts the overall sharpness of your JPEGs with an adjustment range of +4 to −4. Although the image processor on your Fuji will already apply some sharpening to the file, this control lets you refine how crisp and tight your images look.

Like the other three adjustments (HIGHLIGHT TONE, SHADOW TONE, and COLOR), you'll probably keep this on the default setting most of the time. You may never end up using it, but if you ever want to add an extra level of grit, contrast, or softness to your pictures, you know that it's there.

Maybe you'd want to use a softer setting when shooting certain low-contrast portraits. For action, street, and other subjects, where you may want a slightly harder edge, you could bump up this setting a little bit—or a lot!

Again, it's all about choice. **How do you want *your* pictures to look?** There's no right answer, and there's no right setting. Some of the best photographs in the world have technical qualities that would certainly open the floodgates of negative comments in certain camera forums.

If you capture a compelling subject in great light and freeze the right moment, who cares if you make some slight tweaks to the tones, color, or sharpness of the image? If you like the results, then that's all that matters. The reality is that nearly all great photos have been tweaked, at least a little bit.

You can save your HIGHLIGHT TONE, SHADOW TONE, COLOR, and SHARPNESS adjustments as a preset in the EDIT/SAVE CUSTOM SETTING menu option. With the X-T2 and X-Pro2, you can even rename them, so if you come up with a fun combination that speaks to your style, you can give it a special designation and set it up for quick recall in the Q menu.

## NOISE REDUCTION

This control reduces digital noise in pictures taken at high ISO settings. The adjustment goes from +4 to −4, with 0 being the default. "Plus" gives you more noise reduction and "minus" gives less.

In other words, a setting of +4 will give you smoother pictures with less grain, but also with a slight loss in sharpness. Images with that setting will be a tiny bit softer. A −4 setting will give you more grain, but your picture will be sharper.

This is totally a preference setting. It depends on what you're going for. I usually just leave it at the default setting. A little grain won't hurt anyone, but then again, neither will a slight softening effect.

If you're shooting brides at ISO 12800, you probably want to go a little bit plus on the NOISE REDUCTION. Conversely, if you're shooting gritty street scenes, you might want to drop into minus territory. Or leave it at 0 and forget about it.

# CLARITY

The CLARITY adjustment setting is similar to the HIGHLIGHT and SHADOW TONE and COLOR controls, and it works much like the CLARITY slider in Lightroom. It's found on all of the current camera models, except for the X-T3 and X-T30.

This control lets you render your subject with added contrast and definition at the edges, or reduce definition and create softer looking scenes. Adjustment levels run in steps from −5 to +5. Portrait shooters will love having the option to make negative CLARITY adjustments, while street and action shooters might like to add clarity to their scenes.

Here's what the new CLARITY effect looks like in action (see Figures 2.77–2.80).

**2.77** Normal—No Clarity Adjustment

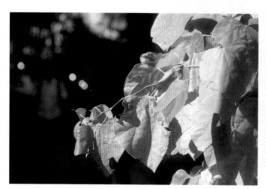

**2.78** Using a −5 CLARITY setting

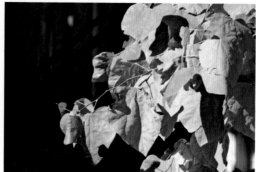

**2.79** Using a +5 CLARITY setting

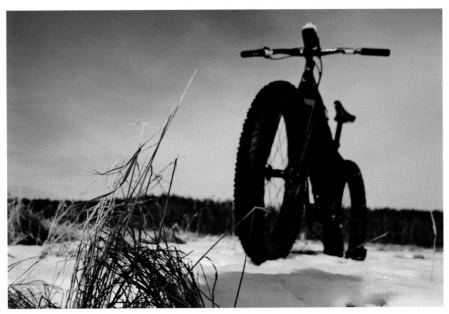

**2.80** CLASSIC NEG. with +2 SHADOW TONE, +4 COLOR, and +5 CLARITY

**2.81** CLASSIC NEG. with −2 SHADOW TONE, +4 COLOR, and −3 CLARITY

## LONG EXPOSURE NR (NOISE REDUCTION)

This camera setting reduces mottling-type noise in long exposures. It works by secretly taking a second exposure with the shutter closed, then comparing the two frames and subtracting the noise on the secret frame from your original shot. This helps to optimize the noise from the real exposure.

The result is that turning this setting **ON** almost always produces higher-quality images. Sometimes the difference is quite dramatic.

In order for this to work, the camera takes twice as long to process your image after the shutter closes. Depending on your camera and aperture setting, it doesn't work for every long exposure time. LONG EXPOSURE NR seems to kick in on exposures of about one minute and longer, although using smaller apertures like f/16 seems to activate it with shorter exposure times.

However, no one really knows for sure. Only the Fuji engineers know exactly what's going on under the hood, and they're not talking. Maybe I can try to bribe them....

So, to recap, it will take twice as long to take long-exposure pictures with this setting **ON**, but your pictures will look a whole lot better. If you don't like waiting, then bring along a book or a few beers to keep you busy while you're shooting long-exposure pictures.

## LENS MODULATION OPTIMIZER

Since the FUJIFILM lenses are designed in conjunction with the cameras and sensors, they're built for optimum performance when used with X Series cameras. However, due to limitations of glass and optics, even with the highest-quality lenses there's always a certain (very small) degree of imperfection that can occur.

The LENS MODULATION OPTIMIZER (LMO) uses software inside the camera to adjust and correct for certain types of diffraction and a slight loss of edge sharpness when the camera converts the RAW data into a JPEG image.

**For this reason, you should always leave this setting ON.** If you shoot RAW, you can also apply or disable LMO when doing your RAW conversions in-camera. This is an easy way to compare and see what the LMO actually does to your image. In some cases, the effects will be very subtle, while in others you'll clearly see what's being changed.

# COLOR SPACE

A color space in photography is a measure of the range of colors present or available in a particular device or medium. Since different mediums and even different electronic devices reproduce color in unique ways, a series of standard color spaces was designed to achieve close color matching between cameras, computers, monitors, and different kinds of paper.

In digital photography, the two most common color spaces are **sRGB** and **Adobe RGB**. Most electronic devices use the sRGB color space, while Adobe RGB is the standard color space for commercial printing.

While Adobe RGB has a wider gamut of colors than sRGB, most displays and devices can't reproduce all of the colors it contains. For practical purposes, this means when you upload an Adobe RGB image to the web, the colors might look a little different from your original image.

If you shoot in the sRGB color space, your uploaded images will look just like the originals. However, if you print your images, you may find that you lose some of your color brilliance.

So which color space should you use? The easy answer is that if you're mostly shooting for the web and you mostly display your images on electronic devices, then go ahead and shoot in sRGB. This is the preferred setting for general use in most situations.

If you shoot professionally or if you tend to print your work, then I recommend shooting in Adobe RGB. You'll have the most amount of color information in your image, and you can always convert your images to sRGB before you upload them to the web. You can even do this conversion using the RAW CONVERSION option when playing back RAW files.

# PIXEL MAPPING

The newer FUJIFILM cameras have this option, and it's used to combat the occasional "hot pixel." If you start to notice white spots in your viewfinder or on your pictures, it could mean that one of the pixels on the sensor is malfunctioning. Running the PIXEL MAPPING function might solve your problem. Basically, the camera takes a dark exposure and then re-calibrates the output of each pixel.

Experiencing a hot pixel is pretty rare, so you may find that you never have to use this feature. I've never had any hot pixels on any of my Fuji cameras. However, if you find one, now you know how to fix it.

## CUSTOM SETTINGS

All X Series cameras have seven slots where you can assign and recall custom shooting presets. By default, they're called C1–C7, and they can be selected either in the SELECT CUSTOM SETTING menu or as the top left item in the Q menu. On the X-H2 and X-H2S, you can also access your C1–C7 settings on the camera's Mode Dial.

Whenever you turn the camera on, it will retain all of the settings you had previously set before you turned it off. (Except for the self-timer; this will always revert to OFF.)

In the Q Menu, whatever custom setting you currently have or had selected will be called BASE. On some cameras, it will be called BASE plus your C settings number, e.g., BASE/C1. Note: Any changes you make to your BASE setting will not affect the original custom bank you have set or the default banks if you haven't changed any of them.

2.82

For example, if you're shooting in C2 (let's say it's set to VELVIA with no adjustments), and then you adjust your SHADOW TONE to +3, your current bank will now be called BASE/C2, or just BASE.

If you turn the camera off and back on again, it will default to BASE/C2 and your settings will be VELVIA with SHADOW TONE +3. However, if you scroll away from BASE, you'll start at C1 again and move up through the banks. When you reach C2, it will still be VELVIA because that was your default C2 setting. But the SHADOW TONE will be set to 0.

If you keep scrolling, you'll eventually get back to BASE, or BASE/C2, which will have remained unchanged from VELVIA and ST+3. So, any changes you make to the IMAGE QUALITY settings will remain set in your BASE setting until you change them again. In that way, just think of BASE as your current settings.

## Edit/Save Custom Setting

What if you want to change your custom settings? Using the EDIT/SAVE CUSTOM SETTING menu item, you can do exactly that and design your own custom banks for C1–7.

To change any one of the C1–7 banks, press **MENU/OK** in shooting mode to display the shooting menu. Select the **IMAGE QUALITY SETTING** tab, then scroll down, highlight **EDIT/SAVE CUSTOM SETTING**, and press **MENU/OK**.

Then, choose any one of your seven banks and either scroll right or press **OK** again. You can now adjust any of the available settings by selecting that setting, clicking right or hitting **OK**, and then adjusting the values as desired. Note: On the fifth-generation models, you have a greater number of available settings you can save into a C1–7 bank from the IQ, AF/MF, and SHOOTING SETTINGS Menus.

When you're done with each setting, press **OK**, then go back and adjust the next one, etc. Or, if you've already made some adjustments to your image quality settings and you'd like to save those to the bank, then hit **SAVE CURRENT SETTINGS** at the top of the menu. This will write all of your current camera settings to that bank.

Either way, when you're finished, hit the **BACK** button to confirm your save and press **OK**. I'll repeat: Make sure you hit **BACK** and select **OK**, then hit the **OK** button.

## Edit Custom Name

Another one of my favorite settings, this was added in a recent firmware update.

It's fun to tweak image quality settings such as HIGHLIGHT TONE, SHADOW TONE, COLOR, WHITE BALANCE, SHARPNESS, and NOISE REDUCTION to suit different subject matter and shooting styles. Combining these settings with different Film Simulations can give you some unique and personal looks for your imagery.

With most recent X Series models, you can name your custom settings and make them even more personal. The names can match your current mood, your subject matter, or whatever.

Maybe you'll call them things like GRIT, AIR, DENSE, MUSH, COOL, CLASSY, BREEZE, VIBRANT, YUMMY, GORILLA, SO LONG, TAKE OUT THE TRASH, SHOW ME THE MONEY, VSCO, BBDO, or WICKED COOL PRESET.

Or perhaps you'll come up with even cooler names. You have 25 character spaces to work with, so have fun (see Figure 2.83).

**2.83** My "DARK & DIRTY" custom preset: CLASSIC CHROME with SHADOW TONE +3, COLOR –2, and SHARPNESS +1

# AUTO UPDATE CUSTOM SETTING

The X-H2 and X-H2S let you choose whether changes to your saved custom settings are automatically applied.

**ENABLE:** Changes to Custom Setting banks C1–C7 apply automatically.

**DISABLE:** Changes you make to your custom settings do not apply automatically. You must apply them manually in the Edit/Save Custom Setting Menu.

2.84

# FOCUS MENUS— AF/MF SETTINGS

The FUJIFILM cameras use a specially designed hybrid autofocus that incorporates both contrast and phase detection sensors, as well as intelligent, predictive algorithms. The result is an extremely capable focus system that offers a high degree of speed and accuracy. They can even be set up to function with back-button focus.

Nearly all of the Fuji cameras acquire focus on subjects quickly and are able to track moving subjects and shoot fast action, even at high frame rates. They also have great Face Detection systems that let you shoot portraits and scenes with people without having to move the little focus zone around.

The fourth- and fifth-generation X Series cameras have incredibly fast performance. With an increased number of phase detect pixels that cover over 100% of the frame, faster processors, custom AF settings, and new algorithms, these cameras are now in the same category as some of the highest-level DSLR cameras when it comes to autofocus.

**3.1**

**3.2**

I'm utterly amazed at how fast and accurate the focus is on the modern Fujis, even when tracking quick subjects with long lenses. Having used many cameras in my over-twenty-five-year career, I can say with confidence that the X-T4 has the best AF system of any camera I've ever owned. It has kept up and done everything I've asked of it… and with the new sensor and Subject Detection Setting, the new fifth-generation cameras are even faster and more precise!

That said, even the previous-generation X Series cameras outperform many comparable DSLRs in this area. While they aren't as fast as the newer models, these cameras are still quite fast and are perfectly suitable for shooting a wide variety of action and fast-moving subjects.

The original X Series camera, like the X-Pro1, X-E1, X-E2, and X100 were built before Fuji really started ramping up their focus technology, so these models aren't nearly as fast when it comes to AF performance.

3.3

However, with good technique and practice, you can still get good action shots with an older Fuji. Figure 3.4 on the following page is from an X70.

The X Series cameras also have some great manual focus features, like AF+MF, FOCUS PEAKING, FOCUS CHECK, a DEPTH-OF-FIELD SCALE, and a special DUAL DISPLAY SETTING.

On the RED/BLUE menu cameras, most of the options covered below will be found in AUTOFOCUS SETTINGS, which you'll find in the RED MENUS.

**3.4** Shot with the X70

# FOCUS AREA

This item lets you select your FOCUS AREA, although you should *never* use this menu item to select your FOCUS AREA.

Simply pressing the AF Joystick brings up the green AF box, and then you move it around the frame with the joystick as needed. (On RED/BLUE models, by default, FOCUS AREA is already assigned to your bottom THUMB PAD button).

If you're using autofocus, chances are you need to act quickly, so you might as well make this action as quick as possible.

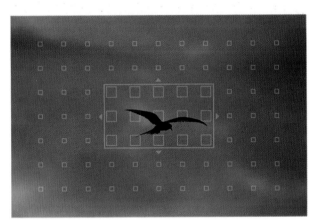

3.5

# AF MODE

The X Series cameras have three autofocus modes: SINGLE AF, ZONE AF, and WIDE/ TRACKING. These options give you three distinct tools to let you frame and track your subject with precise accuracy, speed, and effective ergonomics. (First-generation X Series cameras don't have all three modes.) All recent models have a fourth setting called AF ALL, which allows for seamless transition between these three modes.

To select/move your focus points, activate your FOCUS AREA. (Press the "down" button on the thumb pad or press the AF joystick.) Once you see the green AF box, you can move it around using the directional buttons or the AF joystick. With touch screen models, you can either use the joystick or tap the corresponding area of the screen to select your focus point.

## SINGLE AF

SINGLE AF is simple; it's one point that you select from any one of the AF points in your viewfinder, using the focus point selector on the back of the camera.

Older models have a 77 AF point grid; with the newest models, you can choose either 425 or 117 AF points.

You can use SINGLE AF mode in either AF-S, if you're shooting still subjects, or in AF-C, if you're tracking moving subjects that remain in a relative position within the frame, i.e., straight toward or away from you. In either case, simply place the AF box on your subject and adjust the size of the box to match your subject via the rear command dial. See Figures 3.6–3.8.

The larger, 425-point grid is great for precise focusing of still subjects. The downside to using the larger grid is that it takes longer to move your AF box around the viewfinder. If pinpoint accuracy is not needed, then I recommend using the smaller, 117-point grid.

The beauty of SINGLE AF is that you can select a focus point in any area of the frame, even out at the extreme edges. Most DSLR cameras limit your focus selection to the central area of the frame, but the Fujis let you focus anywhere. This gives you the ultimate freedom with which to compose your imagery.

Again, when focusing, as long as you have the little green focus box showing in the viewfinder, **you change the size of the selected point via the rear command dial and the position of the selected point within your frame via the directional thumb tab buttons, or with the AF joystick.**

You can also select the AF point position by tapping a specific area of the LCD touch screen. This method works extremely well, and once you get used to this gesture, it can be even faster than using the joystick.

I use SINGLE AF mode when I need to be very precise and ensure that the camera is focusing on the exact right piece of subject matter. An example would be when focusing on something relatively small inside the frame or on a subject that lacks a significant amount of contrast compared to the rest of the scene.

In AF-C mode, I might use SINGLE AF if I'm sure that my subject won't move too much from side to side within the frame. However, if I'm using SINGLE AF, I'm usually using AF-S mode.

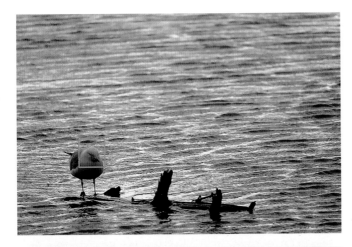

**3.6** SINGLE AF

**3.7** SINGLE AF: very small AF area for precise focusing of still subjects

**3.8** SINGLE AF with AF-C for tracking moving subjects

## ZONE AF

Instead of using a single AF point, ZONE AF gives you a group of points. You can change the size and shape of the group to match the size and position of your subject matter within the frame.

With the older models, your options are a 3 x 3, 3 x 5, or 5 x 5 grid. With the X-T2, X-Pro2, X100F, and X-T20, you can also use an additional 7 x 7 grid. This 7 x 7 grid covers nearly 40% of the frame, which allows it to track moving subjects all the way across the frame. **Note: In ZONE AF, you're always limited to the 117 AF point grid; you can't use the 425 AF point option.**

**Once you select the size of your focus zone, you can move the entire grid around the frame via the focus point selector.** The advantage of using ZONE AF is that the camera will automatically choose which AF point or points to use when focusing on your subject, even if your subject is moving. See Figure 3.9. It works in both AF-S mode, for still or slowly moving subjects, and AF-C mode, for subjects that move more quickly.

**3.9** ZONE AF: useful for tracking moving subjects through the frame

ZONE AF is my preferred setting, and I use it with both AF-S and AF-C modes. With AF-S mode, I'll use ZONE AF to focus on stationary or slowly moving subjects that are hard to pinpoint with SINGLE AF.

In AF-C mode, I'll use ZONE AF to track any kind of motion and subjects that move quickly around different areas of the frame. It's the ideal mode for shooting any kind of action: birds, bikes, runners, motorcycles, skiers, golden retrievers, and hyperactive children/grandchildren. See Figure 3.10.

**3.10**

With AF-C, I keep my cameras set to ZONE AF so that when I turn them on, I'm ready to shoot anything. ZONE AF is the most versatile AF mode because you don't have to be as precise when you initially select your focus point, and it will continue to track subjects as they move across different AF points through the frame.

As with SINGLE AF, when shooting in Continuous High, your zone is limited to the Phase Detect pixel grid in the central area of your viewfinder. See Figure 3.11.

When using ZONE AF, I set the size of my zone based on where my subject is in the frame, how likely it is to move across the frame, how large my subject is, and whether or not there are other things in the frame that might accidentally confuse the focus of a large zone.

**3.11** X-T1/X-T10/X-E2S          X-T2 and later

## WIDE/TRACKING AF

This mode basically drops the AF system into Full Auto. It's great for complicated scenes, unpredictable subject matter, or situations where you're shooting multiple moving subjects. If you're unsure about which focus point to set, or if you'd rather not worry about AF and just shoot, WIDE/TRACKING usually does a very good job.

WIDE/TRACKING works in both AF-S and AF-C modes. On Fuji cameras that have Full Auto mode, when you flip that switch, the camera automatically defaults to WIDE/TRACKING. (On fifth-generation models, it's just called WIDE.)

I'll use this setting when I'm confident the camera can handle my focus duties: if there are people in the frame; if things aren't moving very fast or erratically; or if my subject is clear, unobstructed, and not competing in space with other things that might distract the focus system. It doesn't happen very often, but when I want to outsource my focus duties, it's there if I need it.

**3.12** WIDE/TRACKING AF: useful for unpredictable subject matter and moving subjects

## AF ALL

All models X-T2 and later have a fourth setting called AF ALL. This setting simply lets you scroll seamlessly through all of the different sizes of your AF points and through all of the three main focus modes.

When you have a green focus box selected in AF ALL mode, simply turn the rear command dial and you'll see it change in size. When it reaches the last available size in that mode, the camera will automatically jump to the next AF mode. After WIDE/TRACKING, it will switch back to SINGLE AF with the smallest point.

This is great if you're dealing with a variety of subject types, relative sizes, and movements.

Let's say you're shooting a person standing still and you've got them locked on with SINGLE AF. If they start moving or taking up more space in the frame, you don't have to use the Fn button to switch between modes; just keep turning the rear command dial. Even though changing modes via the Fn buttons requires only two or three presses, AF ALL gives you that seamless transition, which makes your shooting workflow even faster.

## Face Detection

FACE DETECTION on the X Series cameras (covered in more depth later in this chapter) works extremely well, and I usually just leave it on all the time, with the **Eye Detection AF setting on Auto**. Note: Eye Detection doesn't work in AF-C mode.

**3.13** FACE DETECTION AF

# AF-C CUSTOM SETTINGS

With the development and introduction of the X-T2, FUJIFILM brought mirrorless cameras into the realm of performance previously ruled by DSLRs. One of the main advancements of the camera was a fast, highly predictive 325-point autofocus system that's able to track moving subjects with a high degree of speed and accuracy.

This is further enhanced by the new AF-C CUSTOM SETTINGS menu, which gives you five autofocus presets, as well as the ability to adjust three different AF parameters and save your own custom configuration to the sixth slot.

As an action and sports photographer, I find this to be an incredibly useful tool, one which clearly demonstrates FUJIFILM's dedication to making high-performance cameras that are suitable for handling the fastest action and sports shooting tasks.

AF-C CUSTOM SETTINGS are used in all of the new Fujis, although some models contain only the five standard presets; you can't customize and save your own configurations.

I've experimented with the new AF-C CUSTOM SETTINGS quite a bit, and I've been highly impressed with how well the system works. Each setting has a distinct performance behavior, which helps the camera lock and stay locked onto subjects with a variety of movement types.

Here's a quick primer on how the system works. It can be a little bit confusing at first, so I'll try to explain it in straightforward terms.

## AF-C Custom Parameters

There are three separate AF parameters that determine how the camera behaves with regard to acquiring subjects, tracking movement across the frame, and handing off the subject to the next AF zone.

### Tracking Sensitivity

**TRACKING SENSITIVITY determines how quickly the camera should switch to a different AF zone if the subject disappears for a brief period of time.** For example, if the subject passes behind a tree, if something else passes in front of the subject, or if the subject momentarily leaves the frame.

A setting of 0 tells the camera to immediately switch to a different zone to try and reacquire the subject. Settings 1–4 progressively lengthen the time the system will remain locked on the current zone.

You might use setting 0 when the subject is moving extremely fast around the frame, and you might employ one of the higher settings when your subject disappears behind another object, but you know it will soon reappear.

## Speed Tracking Sensitivity

**SPEED TRACKING SENSITIVITY sets the camera's tracking characteristics based on whether the subject is moving at a constant speed or if it's changing speeds.**

This is an important parameter because the AF tracking system leans heavily on predictive algorithms that tell the camera where the subject is likely to appear.

In addition, there's a slight lag between when the subject is locked in focus and when you actually press the shutter, so the camera has to compensate for this.

Setting 0 is for subjects that move at a steady speed, while setting 2 is for subjects that have more erratic speeds or are accelerating or decelerating. Setting 1 offers a balance for subjects that move with a combination of speeds. Setting 0 might be good when shooting things like road biking and flying birds, while 2 might be useful when shooting sports like soccer or when photographing toddlers.

## Zone Area Switching

**ZONE AREA SWITCHING is only available if you're using ZONE AF, and it lets you control which part of your selected focus zone should be given focusing priority.**

CENTER keeps your point of focus in the middle of the zone. FRONT tells the camera to focus on a subject inside the zone that's closest to the camera during times when your main subject disappears from the frame.

AUTO continues to track the subject, or part of the subject, you first focused on.

In shooting situations, using CENTER would be great for tracking a moving subject that temporarily passes behind other things in the frame, like another bike rider or an animal that passes behind a tree. FRONT is ideal for subjects that appear suddenly, or when you don't know exactly where they will enter the frame. AUTO is the default mode for a variety of subjects and action.

## AF-C Custom Presets

To make the system much easier to use in real-life situations, Fuji has included five AF-C Custom Presets that cover a wide array of subjects and different types of motion. Each type shows you the specific parameter settings used. You can also modify these parameters in order to create your own custom setting and store it in Set 6.

### SET 1: Multi Purpose

MULTI PURPOSE is the default AF-C setting. With Tracking Sensitivity set in the middle, Speed Tracking at 0, and Zone Area Switching at AUTO, **this is great for a wide variety of action, especially when your subjects are moving at a constant speed.**

As shown in Figure 3.14, you might use this for shooting races, animals that are moving at a regular rate of speed, or if there's a chance your subject might temporarily disappear.

When I first got the X-T2, I kept it on this setting for a while until I started learning more about how the system works. It does have limitations with certain types of action, and if you find that you're having trouble tracking subjects or getting sharp focus, switch to a different mode and see if that helps.

**3.14** AF-C Custom Setting: MULTI PURPOSE

## SET 2: Ignore Obstacles

**The IGNORE OBSTACLES preset is ideal when your subjects are temporarily going outside of the frame (or your selected focus zone) or when they're moving behind things like trees and other subject matter.** See Figure 3.15.

**3.15** AF-C Custom Setting: IGNORE OBSTACLES

With a slightly higher Tracking Sensitivity, it will wait a little bit longer before switching to a different zone. With Zone Area Switching set to CENTER, it will keep the focus set to the middle of the zone and it won't grab a stray object at the edge of the zone.

If I'm not getting sharp focus on my subjects, I'll often switch to this mode. For the types of subjects I usually photograph, **I find this setting to be one of my two favorites.**

It keeps tracking and doesn't hand off focus too quickly to another zone, which allows you some pretty tight tolerances and creativity when it comes to retaining a good lock on your main subject, even when it's fighting for space in the frame or looking through a field of subject matter that you want to be out of focus.

I often like to place my sharp subject pretty far back in the frame behind other elements, and this mode helps you maintain your lock in this type of situation.

**3.16**

Examples might be a cyclist who's coming up behind another racer (see Figure 3.16), or keeping the focus locked when they're in a large pack, shooting action in a tight forest, or photographing wildlife out in busy wilderness settings—like cheetahs.

### SET 3: Accelerating/Decelerating Subject

With Speed Tracking Sensitivity set to 2 and Zone Area Switching set to AUTO, **this is an ideal mode when photographing subjects with erratic motion and a high degree of change in their speed.**

It will keep the point of focus on the front of the frame (closest to the camera) and use predictive algorithms that are geared toward irregular motion. This makes it an ideal choice for shooting certain types of sports and wildlife where your subject is speeding up and slowing down on a regular basis (see Figure 3.17).

Fujifilm specifies that this setting is highly effective when using high-speed tracking with their LM lenses that use the Linear AF Motor, like the 90mm, 50–140mm, 100–400mm, 16–55mm, 55–200mm, 18–55mm, 18–135mm, 70–300mm, and 150–600mm.

**3.17** AF-C Custom Setting: ACCELERATING/DECELERATING SUBJECT

## SET 4: Suddenly Appearing Subject

**This is my other favorite AF-C Custom Setting.** With Tracking Sensitivity at the lowest setting and Zone Area Switching set to FRONT, this sets the camera up so that **it can focus instantly on subject matter that enters the frame quickly.**

Focus priority is set to the closest object in the frame and the low Tracking Sensitivity allows the camera to immediately switch to the right zone.

**This is an extremely useful and highly effective setting for a variety of action, sports, and wildlife photography.** It allows you to compose your desired scene and then quickly acquire subjects as they appear inside the frame (see Figure 3.18).

If you're having a hard time acquiring and achieving a good lock on your subject matter, and it's not an "obstacle issue," try this mode. For best results, select the AF Zone that's closest to where you think the subject will enter your frame.

**3.18** AF-C Custom Setting: SUDDENLY APPEARING SUBJECT

## SET 5: Erratically Moving Subject

With increased Tracking Sensitivity, this setting keeps the camera locked onto your subject, while a Speed Tracking Sensitivity of 2 causes the AF system to use predictive algorithms that are **suited for irregularly moving subjects.**

Zone Area Switching is set to AUTO, which means that it will acquire and hold your lock right where you set it, even if the subject is not the closest thing to the camera or if the subject goes in and out of the focus zone.

This is obviously the best mode for shooting **highly erratic motion and sports with quickly changing speeds and directions**, like soccer, lacrosse, and football. And it's great for puppies, children, and grandchildren.

This would also be a good setting to use for photographing birds that fly with quick, darting motions or other wildlife with "skittish" or hyperactive movement tendencies (see Figure 3.19).

**3.19** AF-C Custom Setting: ERRATICALLY MOVING SUBJECT

### SET 6: Custom

The CUSTOM bank allows you to tweak a setting or manually adjust the three AF parameters and save them as a custom preset.

In other words, you can optimize your AF-C Custom Settings for the type of movement your subject displays and then have it ready to bring up at a moment's notice.

Let's say you like to shoot a sport or subject that's passing behind some obstacles, and you want a slightly higher Tracking Sensitivity so that it holds focus for as long as possible. Or maybe you're shooting a wide variety of action, but you want the camera to grab subjects a little more quickly. You could decrease the Tracking Sensitivity.

What about quickly appearing subjects that have highly irregular motion? You might want to set the Speed Tracking Sensitivity to 2, or set the Zone Area Switching to AUTO. Perhaps you find yourself shooting a specific type of subject quite often. You can play around with the settings until you find the optimal combination, and then save it for future use.

Either way, the AF-C CUSTOM SETTINGS menu is a very powerful tool that can help you increase the performance of your camera and tweak the camera to fit your shooting style.

Bottom line, the modern X Series cameras have amazingly powerful AF systems, but if you're having trouble with your autofocus or you're having a hard time getting perfectly sharp photos, this is the first place you should go. **You may find that switching to a different custom setting will make a huge difference.**

## STORE AF MODE BY ORIENTATION

The camera automatically knows whether you're holding it horizontally or vertically, and there are a number of menu items that take advantage of this knowledge. Added in a recent firmware update, STORE AF MODE BY ORIENTATION is one of the most useful settings in the entire focus menu, and it's certainly one of my favorite settings. It's found on the X-T2 and later models.

In the default **OFF** mode, the same AF MODE and AF AREA position are used whether you're shooting in horizontal or vertical orientation. For example, let's say you're shooting horizontally and you select your AF point to cover the upper right corner of the frame. If you turn the camera vertically, the same point will be selected, but it will now appear in the upper left corner of your vertical frame.

If you were shooting and trying to focus on a subject placed in the right side of your frame while alternating between capturing horizontal and vertical shots, you would have to move your focus point across the frame each time you moved the camera.

Of course, it takes time to move your AF point, and if you're shooting a fast subject, or if you're going back and forth between horizontal and vertical orientations, it can become a real pain to keep moving the focus points back and forth each time you rotate the camera.

That's where this feature comes in so handy. By switching this menu item to **FOCUS AREA ONLY**, the camera will remember where you placed your focus point and store the location separately for each orientation. When you rotate the camera, you will only have to set the new AF point location once. Then, when you turn the camera back, it will automatically recall your AF point and you won't have to reselect it.

**3.20**

With this parameter set to **ON,** the camera will not only store and recall the location of your focus area, **it will store your AF MODE as well**. This means you can select a different area in the frame *and* you can use a different focus mode for horizontal and vertical framing. Maybe you're using SINGLE POINT AF for your horizontal compositions and ZONE or WIDE/TRACKING for your verticals. See Figures 3.20 and 3.21.

For maximum control, **I leave this ON all the time**. I can't think of any shooting situation where I would need to turn it off.

**3.21**

I was extremely pleased when they added this setting, and I make use of it all the time. It's a very useful feature for shooting sports and action, portraits, or any subject matter where you're shooting quickly and varying between horizontals and verticals.

## WRAP FOCUS POINT

This new setting, introduced with the X-T5, allows you to choose whether your green focus box is bound by the edges of the frame when you move it with the AF Joystick, or if you can "wrap" it continuously back around from one edge to the other. This feature operates in both still and movie mode.

## AF POINT DISPLAY

This setting allows you to choose whether you see the individual focus frames inside your viewfinder when you're using AF ZONE or WIDE/TRACKING focus mode. The frames appear as a translucent grid, and it lets you know where your focus frames are located inside your viewfinder.

This could help you compose your images, since you'll be able to see the exact dimensions and points of your AF zone. It's certainly not obtrusive, but if you prefer a clear, bright viewfinder with no grids or guidelines, you'll probably want to leave this off.

That said, if you're new to the X Series, you might find it helpful to see the grid, especially when shooting moving subjects or if you find yourself using different-sized zones.

## NUMBER OF FOCUS POINTS

As I mentioned in the "AF Mode" section earlier in this chapter, the latest generation of X Series cameras have two options for selectable focus points when using SINGLE AF: either 117 points (9 x 13 grid) or 425 AF points (17 x 25 grid). See Figures 3.22 and 3.23.

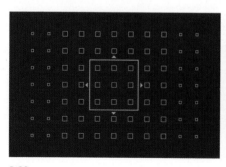

3.22

3.23

Using 425 AF points is great for very precise focusing of still subjects. I'll use this setting if I'm shooting flowers, macro, foliage, or other highly detailed subject matter, close or far, where critical and accurate focus is a must. The downside to this option is that it's a bit slower to move the AF point around the 425-point grid, since you have more points to navigate.

In many cases, you may find the 117-point grid to be perfectly adequate for your needs. Remember, you're always in the 117-point grid when using ZONE AF or WIDE/TRACKING so if you usually use one of these modes, it might not even be an issue. Perhaps you'll keep it on 117 all the time.

However, for the most accurate, pinpoint focusing performance when shooting still subjects, I recommend keeping the camera set to 425 points.

## PRE-AF

Turning PRE-AF to **ON** activates full-time, non-stop autofocus. The camera will continually adjust focus even when the shutter button is not pressed halfway. As you can imagine, this setting dramatically increases the drain on the battery, since the AF motor is in constant motion.

Theoretically, this mode could increase autofocus performance. But I have not found that it really makes any difference. Given that it reduces battery life, **I recommend leaving this setting OFF.**

## AF ILLUMINATOR

With this setting **ON**, the camera automatically turns on the AF ILLUMINATOR when you're trying to focus in the dark. The LED light will help create additional contrast on your subject, which may increase the camera's focusing capabilities in very low light.

Keep in mind, the light has limited range, so it won't work with distant subjects. Also, you probably don't want the light to activate if you're shooting clandestinely or in places where the light would interrupt your subjects. In cases like this, you're probably better off trying to use manual focus anyway.

I leave my cameras set to **ON**, because I rarely shoot in those types of situations.

# FACE/EYE DETECTION SETTING

The FACE/EYE DETECTION SETTING on the X Series cameras works extremely well, and I usually leave it on all the time. (Note: The X-Pro1, X-E1, and X100 do not have this feature.) You can set it to one of five options:

- **Face On/Eye Off:** Face Detection Only
- **Face On/Eye Auto:** The camera locks focus on one of the eyes
- **Face On/Right Eye Priority:** The camera focuses on the right eye, if it's visible
- **Face On/Left Eye Priority:** The camera focuses on the left eye, if it's visible
- **Face Off/Eye Off:** Face Detection Off

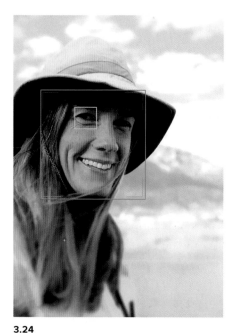

3.24

I usually leave my cameras set to **Face On/Eye Auto**. I'm often photographing people, and this setting allows the camera to quickly acquire focus on them, which saves me from having to manually move the focus point around the frame for each shot (see Figure 3.24).

However, there are times when I don't necessarily want it to grab people in my frame. For this reason, I have the FACE/EYE DETECTION SETTING set to one of my Fn buttons. The default setting on most X-T models is the Fn button on the top deck of the camera.

Note: On some models, Eye Detection doesn't work in AF-C mode, and on some models, Face Detection doesn't work in Continuous High.

If you like to photograph people, I highly recommend using Face Detection and experimenting with the different eye settings.

# SUBJECT DETECTION SETTING

The new fifth-generation X Series models have a powerful new Subject Detection Autofocus feature that automatically detects a wide range of subjects. This helps the camera acquire and track moving subjects with a higher degree of speed and accuracy.

In this menu, you can choose whether the camera prioritizes subjects of a certain type when analyzing the scene, or if it uses the standard AF-C algorithms.

**SUBJECT DETECTION ON:** Choose one of the subject types below to enable:

- **ANIMAL:** The camera detects and tracks focus on dogs, cats, and similar creatures

- **BIRD:** The camera detects and tracks focus on birds and insects.

- **AUTOMOBILE:** Looks for the body and front end of cars—think motorsports.

- **MOTORCYCLE & BIKE:** Looks for people riding bikes and motorcycles.

- **AIRPLANE:** Looks for and specifically detects airplanes and drones.

- **TRAIN:** Looks for the shape of trains.

**OFF:** Subject Detection is off. The camera will track with the default AF system.

When this setting is enabled and a subject is found, the camera will mark it with a white frame. If the camera detects multiple subjects of the same type, then it will automatically choose one to track. You can change to a different subject by tapping the display to reposition the focus area, or by using the Focus Joystick, if the camera is set to WIDE. If the subject temporarily leaves the frame, the camera will wait a set amount of time for its return.

Note: When Subject Detection is **ON**, Face/Eye Detection is automatically disabled.

# AF+MF

AF+MF is an extremely powerful and useful feature. With this setting **ON**, you gain a huge perk when focusing: If you keep the shutter pressed halfway down with your finger after autofocusing, you can then manually fine-tune your focus by turning the focus ring.

As good as modern AF systems are, they can be fooled. Say you're trying to photograph a subject situated within dense foliage, like a bird or flower. The camera's AF system might grab the branches in front of your subject, but that's not what you want. With the AF+MF option, you can get 90% there with the AF, then go the last 10% by focusing manually.

If you also have the FOCUS CHECK feature set to ON, when you're using SINGLE AF and AF-S, and you're doing the above action, the viewfinder will also zoom in to your selected focus area. This helps you even more when trying to focus critically. By rotating the rear command dial, you can change the zoom ratio from 6x to 2.5x. (You'll read about FOCUS CHECK in just a moment.)

Here's an example: In Figure 3.25, the autofocus system was fooled and it actually grabbed the rippled water just behind the rear duck. This makes the ducks slightly out of focus, which is clearly not what I want.

With AF+MF on, I could have grabbed the focus ring and dialed it back just a bit until the FOCUS PEAKING highlights landed on the ducks.

Given that there are numerous situations where this could come in handy, **I recommend keeping AF+MF set to ON all the time.**

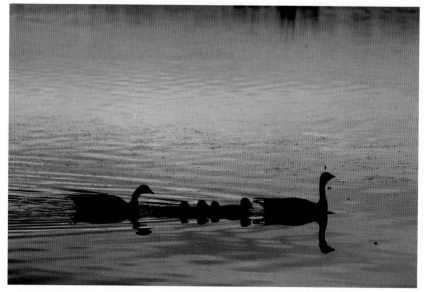

**3.25**

## MF ASSIST

In addition to the robust autofocus system, the X Series cameras also have a full-featured manual focus system. Some photographers prefer using manual focus because they feel more in control or because it feels more intuitive.

All of the cameras have bright viewfinders, which helps you focus more easily. Turn PREVIEW PIC EFFECT OFF (found in the SCREEN SETTING menu) and you might even forget that you're actually looking through a tiny TV screen instead of a ground glass pentaprism.

Also, with the right adaptor, you can even use old manual focus lenses from other camera systems with excellent results. Even though I sold all of my Nikon DSLR gear, I kept my old manual 105mm f/2.5 and 50mm f/1.8 lenses and bought a Nikon-to-Fuji adaptor.

The three most popular adaptor brands are Metabones, Novoflex, and Fotodiox. I have a Fotodiox adapter and it works fine. However, I've heard from other users that the Novoflex adaptors seem to offer the highest quality and performance.

A friend of mine has an old Canon FD 200mm f/4 that he uses on his X-T1. Not only is it incredibly sharp, it's quite small for a 200mm lens. Effectively, considering the crop sensor, this gives him a 300mm f/4 manual focus lens that's very compact and a lot of fun to use.

It can be hard to focus manually since we don't have the fresnel/split-image focusing screens that were used in old SLR cameras. Thankfully, mirrorless technology allows for some very useful tools that help you in this area. The Fuji X Series cameras have three MF ASSIST options: Standard, Digital Split Image, and Focus Peak Highlight. There is also the Focus Assist Button/Menu option.

Whether you're shooting low-contrast subjects that are difficult to acquire or track; you just feel more "in control" using manual focus; or you simply like using manual focus because it's fun and it reminds you of your "old" camera, you should get to know these settings.

Note: These settings also apply if you're using the AF+MF feature outlined in the previous section.

## Standard

This is the default mode. It's simply manual focus through the viewfinder, as if you were using a standard bright SLR screen. This is the most basic focusing mode; what you see is what you get. If you need help focusing, you can always crank up the brightness level in your EVF or LCD, or turn PREVIEW PIC EFFECT OFF.

## Digital Split Image

With a nod back to the old split-image screens found on most SLR cameras, this mode displays a small black-and-white or color split image over the phase detect array in the middle of your viewfinder. This makes it very easy to determine exactly when your subject is in focus. It even replicates the classic fresnel effect when you're getting close.

## Focus Peak Highlight

Autofocus systems work by detecting edge contrast on your subject matter. When the greatest amount of contrast is detected, the camera determines that the subject is in focus.

FOCUS PEAK HIGHLIGHT essentially does the same thing for manual focus. It creates a highlight of clearly visible pixels around your edges that adjusts in intensity depending on how close you are to achieving sharp focus. You can also change the color of the peaking highlights. Your choices are white, red, and blue.

Being the most "digital" of the three modes, FOCUS PEAK HIGHLIGHT is an acquired taste with some photographers, but it's worth using. While it may be a little distracting at first, once you get used to it, you'll see that it works extremely well when you need to focus quickly, and it's very effective in low-light situations.

I often use this mode when trying to focus in dim conditions, and I find the colored highlights tend to stand out a little better than white. I usually go with the RED HIGH setting.

## FOCUS CHECK

Whenever you're focusing manually, you can press the rear command dial (or the FOCUS ASSIST button on the X-T1) and the camera will zoom in to give you a closer look at your subject in order to help you achieve sharp focus.

There's also a menu item called FOCUS CHECK. With this option turned **ON**, the viewfinder/LCD will automatically zoom in on the selected focus area when you grab and rotate the focus in manual focus mode. (On the older Fuji cameras, FOCUS CHECK is found in the SCREEN SET-UP menu inside one of the BLUE MENUS.)

As I mentioned in the previous section, the FOCUS CHECK feature also works in conjunction with the AF+MF settings when shooting in AF-S autofocus mode. Again, I usually keep my MF ASSIST menu set to FOCUS PEAK HIGHLIGHT (RED HIGH). This gives me the easiest and fastest way to gauge my focus.

Although I consider the AF+MF setting to be an essential feature, FOCUS CHECK can be a mixed bag. Sometimes it works perfectly and is exactly what you need to achieve precise focus. Other times, you may find it distracting because suddenly you're not seeing the entire frame.

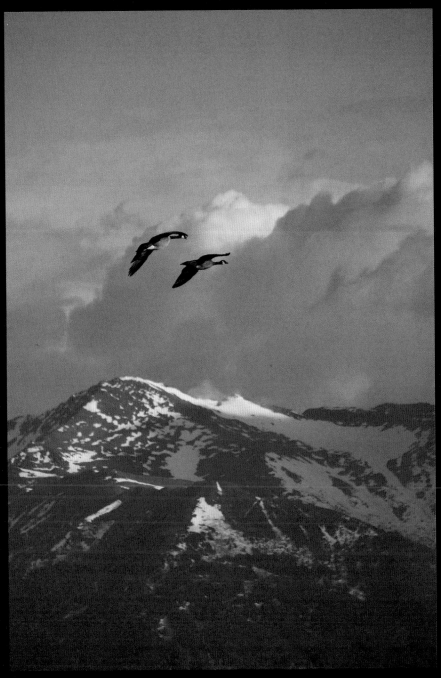

3.26

If you have a MY MENU camera, you might consider putting FOCUS CHECK in your MY MENU or assigning it to a Fn button so you can turn it on and off quickly as needed.

## INTERLOCK SPOT AE & FOCUS AREA

This is pretty straightforward. When you turn this feature **ON**, your exposure meter becomes tied to your selected focus zone if you're using SINGLE AF mode, and the Spot Meter is selected as your metering option.

To me, this is a no-brainer. If you're using the Spot Meter, there's a pretty good chance you'll want to base your meter reading on your selected focus point. For this reason **I keep this setting ON at all times.**

## INSTANT AF SETTING

There are a few different ways to configure the FUJIFILM cameras for back-button focus; this is one of them.

If your AF-L button is set to **AF LOCK** or **AF/AE LOCK** and the camera is set to manual focus, pressing this button activates autofocus. Using the INSTANT AF SETTING, you can choose whether the camera focuses using Single AF (**AF-S**) or Continuous AF (**AF-C**) when the **AF-L** button is pressed in manual focus mode.

I'm not a back-button focus guy, so I don't use this setting. In fact, I find it quite useful to assign the AF-L button to operate any number of other functions.

## DEPTH-OF-FIELD SCALE

The XF14mm f/2.8, 16mm f/1.4, and the 23mm f/1.4 lenses all have depth-of-field (DOF) scales on the front of the lens barrel. If you don't have one of these lenses, you can use the electronic DEPTH-OF-FIELD SCALE.

There are two options and, as the manual states, **FILM FORMAT BASIS** is the recommended choice for assessing depth of field for pictures that will be viewed as prints. If you intend to view your images at high resolution on electronic displays, then you should use **PIXEL BASIS**.

3.27

The science behind this is actually quite impressive. It's based on the difference in how we perceive sharpness between the perfectly sized/spaced pixels found on electronic displays and the liquid ink dots that spread when they're dropped onto paper.

Even though ink on paper is technically "more blurry," when we stand back and look at a print, this slightly softer look actually fools us into thinking that we see a greater level of sharpness than actually exists in the print. (This effect is slightly enhanced with a print that was made from an image originally shot on film.)

The result is that the **FILM FORMAT BASIS** DOF scale indicates a much wider depth of field than the **PIXEL BASIS** scale.

I wouldn't worry too much about this setting, though. Just keep it on **PIXEL BASIS** and forget about it. Pretend it's not even there. The reality is that even though we might print a few of our images, we see all of our images on the screen. I don't think it makes much of a difference, but then again, I'm not an intense pixel peeper.

Thanks to FUJIFILM Training Manager Michael Bulbenko for explaining this one to me.

## RELEASE/FOCUS PRIORITY

This setting controls how the camera operates in **AF-S** and **AF-C**.

In **RELEASE PRIORITY,** the shutter will fire whether the scene is locked in focus or not, whereas in **FOCUS PRIORITY,** the shutter will not fire unless the camera has achieved focus.

Using this menu item, you can assign a separate setting for both **AF-S** and **AF-C,** you can swap them, or you can assign the same setting to both.

For all the years I've been using cameras, AF-S has always been set to FOCUS PRIORITY, and AF-C has always been assigned to RELEASE PRIORITY. I see no reason to change this, and so I recommend you leave these at the default settings.

## AF RANGE LIMITER

Found only on the X-Pro 3, X-T4, X-S10, X100V, and fifth-generation models, this feature lets you manually limit the range of available focus distance on your lens. By limiting the range, you increase AF performance and speed, because if the lens gets confused, it won't travel as far as it tries to reacquire the subject. This can be

very useful if you're shooting a scene and focusing on two different subjects, or when shooting within a specific range of distances. You have four settings:

**OFF:** Focus Limiting is disabled. Use this for general photography and when you're shooting a variety of subjects at different distances.

**CUSTOM:** You can limit your focus range and define a specific minimum and maximum distance. To set, press SET, and then either turn the focus ring manually or tap the screen to focus on your "A" (close) distance. When the camera is locked on, press OK. Then set your "B" (far) distance and press the DISP/BACK Button. Don't accidentally hit OK again, or you'll start over back at A.

Once your focus range is selected, the next time you return to this menu, you can either hit OK to activate the currently selected range, or hit SET again to change.

**PRESET 1/2:** You can select from two different distance ranges. PRESET 1 is 2.0 meters to infinity, PRESET 2 is 5.0 meters to infinity.

## CORRECTED AF FRAME

This setting is found on the higher-end rangefinder cameras, the X-Pro and X100 models. When you turn this setting **ON**, a second focus frame is added to the optical viewfinder display. This second frame is used for focusing at very close distances of about 1.6 feet (50 cm). This compensates for the difference in viewpoint between the optical viewfinder and the lens.

# SHOOTING SETTINGS

The SHOOTING SETTING menu is where you'll find your shooting and camera options. It's a relatively short list, only eight items. In my mind, the first three are the most important, and all of them can easily be assigned to a Fn button, the MY MENU, or a Q menu slot. The fourth item, INTERVAL TIMER SHOOTING, is what you use to shoot time-lapse imagery.

If you own a RED/BLUE camera, you'll find most of these options in your RED MENUS.

## SCENE POSITION

This menu item is only found on theX-T10/20/30, X-E3/4, and X70, or when the mode dial is set to SR+ on the X-T200 and X10/20/30. It's where you select a SCENE POSITION mode when the AUTO switch is engaged. You can read more about this in the section "Full Auto Switch & Scene Modes" in *Chapter 1: The Really Important Stuff.*

(Note: The AUTO switch must be engaged and the Drive dial/menu must be set to S or STILL IMAGE for this mode to work.)

Here are all the different options for shooting in SCENE POSITION mode:

- **ADVANCED SR AUTO:** Full auto mode. The camera evaluates the light and chooses whatever SCENE mode it thinks is right.
- **PORTRAIT:** For shooting pictures of people, whether they're wearing hats or not.

- **PORTRAIT ENHANCER:** This mode applies special processing to portraits to give the subject a smoother complexion. Use this mode when taking pictures of pretty girls.

- **LANDSCAPE:** For shooting landscapes and urban mountains (also called "buildings").

- **SPORT:** For photographing people (or animals) who are running. Also used for sports or any type of quickly moving subject matter.

- **NIGHT:** For shooting at night or during twilight when it's getting pretty dark.

- **NIGHT (TRIPOD):** Ideal for using slow shutter speeds when shooting at night on a tripod.

- **FIREWORKS:** Ideal for photographing fireworks or any other subjects that happen to be exploding.

- **SUNSET:** Use this mode when shooting at magic hour.

- **SNOW:** Ski resort mode. Also called Snowman mode.

- **BEACH:** Vacation resort mode. Also called Caribbean mode.

- **UNDERWATER:** Remember, no X Series camera is waterproof!

- **PARTY:** Woohoo! Party time! Dim rooms, bright lights, and mixed drinks.

- **FLOWER:** Make beautiful flowers look even more vivid and beautiful.

- **TEXT:** For taking clear pictures of text or drawings in print. Also known as Espionage mode.

## DRIVE SETTING

DRIVE SETTING is one of those menu items that's often overlooked, but it's actually a very important control. It's where you set the parameters for the following drive modes:

- **FRAME RATE for CL and CH**
- **BRACKETING SETTINGS**
- **ADV MODE FILTER SELECTION**
- **MULTIPLE EXPOSURE** (models with DRIVE buttons only)
- **PANORAMA** (models with DRIVE buttons only)
- **HDR** (X-T4, X-Pro 3, X100V, X-S10, and fifth-generation models only)

Note that the exact layout of the DRIVE SETTING menu varies by camera.

## Models with a Drive Dial

The DRIVE SETTING menu on the X-T2/3/4/5 and X-H1 is found in the SHOOTING SETTING menu. Here you control the following settings, which become active when you turn the Drive dial to the corresponding setting:

- **BKT SETTING:** Go **one click right** to adjust your BKT SETTING, **two clicks right** to adjust your BKT SELECT. (Choose from AE BKT, ISO BKT, FILM SIMULATION BKT, WHITE BALANCE BKT, and DYNAMIC RANGE BKT.)

- **CH HIGH SPEED BURST:** Choose your desired frame rate, up to 15 fps for the mechanical shutter, and up to 40 fps for the electronic shutter.

- **CH LOW SPEED BURST:** Choose your desired frame rate up to 8 fps.

- **ADV FILTER SETTING:** Choose from any of the ADV filters.

- **HDR:** The latest models have a new **HDR MODE**, in which the camera takes three shots and combines them into a single, high-dynamic-range photograph. HDR setting options are **AUTO, 200%, 400%, 800%, 800%+,** and **HDR PLUS.** With the **AUTO** and **%** settings, you'll see slight differences in dynamic range, whereas the **800%+/HDR PLUS** settings will produce classic, HDR-style photos with an extremely wide dynamic range.

The DRIVE SETTING menu can also be assigned to a Fn button. (By default, it's set to the front Fn button on some models.) Pressing the button brings up the appropriate menu, **as long as the Drive dial is set to either BKT, CH, CL, ADV, or HDR.** If it's on any other setting, nothing will happen.

4.1

## X-T1

On the X-T1, RED MENU 1 is BKT/Adv. SETTING. This is where you can select your BRACKETING type and settings, and select your Adv. FILTER type.

You can assign BKT/Adv. SETTING to a Fn button. Like the X-T2, the default button for this option is the front Fn button, and it will only function if the Drive dial is set to either BKT or ADV. If it's set to any other option, nothing will happen.

By default, the X-T1 has fixed frame rate settings for the CH (8 fps) and CL (3 fps) options on the Drive dial, so there is no menu setting to change this.

## X-T10

The X-T10 has a different type of Drive dial, which features two BKT settings and two Adv. settings. You can store a different setting for each one for quick recall.

The X-T10 BKT/Adv. SETTING menu items are found at the top of RED MENU 5. This is where you can set the BKT1 and BK1 settings, and also the Adv. FILTER 1 SELECT and Adv. 2 FILTER 2 SELECT for the corresponding BKT and Adv. settings on the Drive dial.

Like the X-T1, both CH and CL have fixed settings, with 8 fps and 3 fps, respectively.

## X-T20/30

The X-T20 has the same Drive dial layout as the X-T10, with two BKT and two ADV settings. However, being a MY MENU camera, the X-T20 has a DRIVE SETTING menu in the SHOOTING SETTING menu. You can also set the DRIVE SETTING option as a Fn button. By default, this is set to the Fn button on the top deck.

- **BKT 1 SETTING/BKT 2 SETTING**: Select the BKT type and setting for the BKT 1 and BKT 2 settings on the Drive dial.

- **CH HIGH SPEED BURST:** Select the frame rate used for the CH setting. Choose either 8 fps, 11 fps, or 14 fps. (Note: 11 fps and 14 fps are only available when the camera is set to ELECTRONIC SHUTTER.)

- **CL LOW SPEED BURST:** Select the frame rate used for the CL setting. Choose either 3 fps, 4 fps, or 5 fps.

- **Adv. FILTER 1 SELECT/Adv. FILTER 2 SELECT:** Select the ADV FILTER setting for the ADV 1 and ADV 2 settings on the Drive dial.

4.2

### Models with a DRIVE Button

For all X Series cameras that have a dedicated DRIVE button, you select all BRACK-ETING, CL/CH and ADV FILTER SETTINGS, as well as MULTIPLE EXPOSURE, HDR, PANORAMA, and MOVIE MODE by pressing the DRIVE button and scrolling down to the appropriate item in the menu.

Note: The X-H2 and X-H2S do not allow you to change the ADV FILTER SETTINGS via the DRIVE button. You must go into the SHOOTING SETTINGS - FILTER SETTING.

On the X-H2, the new PIXEL SHIFT MULTI-SHOT feature is found in this menu.

## FILTER SETTING

**This setting is found on the X-H2 and X-H2S only.** This is where you select your ADV Filter mode settings. On most other models, you select this inside DRIVE SETTINGS.

## SPORTS FINDER MODE

When engaged, this new setting found on the fourth- and fifth-generation cameras creates a 1.25X or 1.29X crop view, depending on the camera. Effectively switching to a medium-sized image, this allows the camera to shoot in burst mode at very high frame rates of up to 30 fps (40 fps on the X-H2S).

Note: Using higher ES shutter speed settings will automatically put the camera into SPORTS FINDER MODE.

## PRE SHOT ES

This very powerful setting is designed for shooting fast action, and it only works when you are using the Electronic Shutter and CH mode. It helps compensate for the lag time between when you "see" your ideal shot, and when you press the shutter button. When shooting extremely fast action, that delay can easily cause you to miss the shot.

By enabling PRE SHOT ES, the camera will lock onto the subject and begin tracking at high speed as soon as you press the shutter button halfway down. In addition,

the camera starts recording images into the buffer while you're still at "half press." As long as you keep the shutter button halfway down, the camera will continue to refresh so that you always have up to twenty frames stored in the buffer.

Then, when you press the shutter button all the way down, the camera will write those buffer images onto the memory card, essentially saving those frames that were recorded during the period of "half press." If you hold the shutter button down, the camera will begin to capture and write new images onto the card as well.

In effect, PRE SHOT ES allows you to nail the sequence and capture the entire series, including those initial fleeting moments, even if you end up pressing the shutter button a little bit late. It's a little confusing at first, but once you understand how it works, you'll see that it's a very useful tool for shooting extremely fast-breaking action scenes. (This setting is found on all fourth- and fifth-generation models, except the X100V.)

## SELF-TIMER

SELF-TIMER is obvious. You can set it to **2 SEC., 10 SEC.,** or **OFF.** When you press the shutter, you'll see the little light blink on the front of the camera as it counts down.

This setting is also found in the default Q menu on all cameras. This means **you should never have to go into the menus to set the self-timer.** I'll repeat: Don't ever scroll around the menus looking for your self-timer. It's right there in the Q menu.

Some models even allow you to save your self-timer settings.

## INTERVAL TIMER SHOOTING

INTERVAL TIMER SHOOTING is the option you want for doing time-lapse photography with the X Series cameras. In this menu, you set the **SHOOTING INTERVAL,** the **NUMBER OF FRAMES,** and the **STARTING TIME.** If you want the camera to keep shooting until your memory card is full, set the number of frames to **INFINITY.**

Obviously, you want to have your camera on a tripod or a track when shooting intervals. Unfortunately, there is currently no way to export your interval to movie format right inside the camera. This is something I've been requesting Fuji add for a while; hopefully, they'll include it in a future firmware update.

For maximum performance when shooting intervals, you should check your battery level and either start with a full charge, use the battery grip, or keep your camera plugged into a power source.

Note: The display turns off between shots and turns on right before the next shot. You can press the shutter button at any time to turn it back on. Some models have a setting called INTERVAL TIMER SHOOTING EXPOSURE SMOOTHING. When enabled, it automatically adjusts exposure during interval-timer shooting to prevent it from changing dramatically between shots.

## AE BKT SETTING

This setting is found on the fourth- and fifth-generation models that don't have a Drive dial or DRIVE SETTINGS menu item. When you're using the BKT shooting mode (accessible via the DRIVE button), you can choose between AE BKT, Film Simulation BKT, Dynamic Range BKT, and Focus BKT, and the AE BKT Setting is where you configure the parameters for Auto-Exposure Bracketing.

**FRAMES/SET SETTINGS:** Here, you choose the number of shots in your bracketing sequence (FRAMES) and the amount of exposure variation in each shot. With STEPS, you can choose to bracket up to 3 frames overexposure, up to 3 frames underexposure, or you can bracket 3, 5, 7, or 9 shots over- and underexposure, in 1/3-stop variations, up to three full stops both ways.

**1 FRAME/CONTINUOUS:** This gives you the option to fire the shots in your bracketing sequence one frame at a time or as a continuous burst.

**SEQUENCE SETTING:** You can choose the order in which your shots are taken. You have four options.

Note: With X Series models that have a Drive dial on the left side of the top deck, you'll use the DRIVE settings menu (or the DRIVE SETTINGS Fn button) to set up these parameters when the Drive dial is set to BKT.

## FILM SIMULATION BKT

As with the AE BKT Setting, this option allows you to set up the parameters for Film Simulation Bracketing and choose your three different film sims if you don't have a Drive dial and DRIVE SETTINGS menu.

# MULTIPLE EXPOSURE CTRL

This all-new setting, currently found on most fourth- and fifth-generation models, allows you to choose how the camera combines images to create a multiple-exposure image. You have four options, and with all of these, you can combine up to nine exposures to create your final shot.

**ADDITIVE:** With this default setting, the camera simply adds the exposures together. Keep in mind that your final composite image will inherently become brighter as you add more exposures. With most scenes, if you're using more than three different shots, you may need to reduce your camera exposure to keep things from blowing out.

**AVERAGE:** With this option, the camera will automatically optimize the exposure in the final composited image so that nothing becomes too bright. If you want to preserve the background, then this is probably the best choice.

**BRIGHT:** Things start to get a little weird here. With this option, when you shoot each additional exposure, the camera will compare the original image to the new frame, and only the brightest pixel that's present in the current frame will be shown in the composited image. Any dark areas in the original frame will be replaced by whatever new subject matter shows up there in the new frame, if that new subject matter is brighter than the original image.

**4.3** "Bright Mode"

**DARK:** Same as above, but in reverse. When you shoot each additional exposure, the camera will compare the original image to the new frame and only the darkest pixel that's present in the current frame will be shown in the composited image. Any bright areas in the original frame will be replaced by whatever new subject matter shows up there in the new frame, if that new subject matter is darker than it was in the original image.

I know this sounds very confusing, so here's what it looks like in practice. From a creative standpoint, the BRIGHT and DARK settings allow you to create some cool "knockout" and "fill" effects.

**4.4** "Dark Mode"

# SHUTTER TYPE

The X Series cameras are designed with a traditional focal plane **MECHANICAL SHUTTER (MS)**, just like those found on many other cameras.

They also have an **ELECTRONIC SHUTTER (ES)**, which essentially just turns the sensor on and off **rather than having curtains actually open and close**. (First-generation models do not have the electronic shutter.) This allows for extremely high shutter speeds of up to 1/32,000 second (1/180,000 sec on the X-H2 and X-T5), and totally silent operation. This is what you want to use while shooting at the theater, on a film set, or on clandestine photo shoots where secrecy is of the utmost importance.

The ES also allows you to shoot with wide-open apertures and thus get extremely shallow depths of field in super-bright light, which you would normally not be able to do with a mechanical shutter. I've shot in full sun in snowy landscapes with my 56mm lens at f/1.2 and gotten some interesting effects. I'll also use the ES when shooting straight toward the sun (see Figure 4.5).

(**Warning:** Please don't burn your retinas or damage your camera sensor. Never shoot toward the sun at midday, only when the sun is extremely low in the sky.)

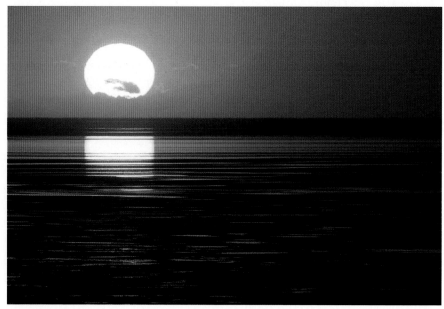

**4.5** Shot at 1/10,000 second

In the past, electronic shutter readout speeds were much slower, so they were not ideal for shooting fast action (see Figure 4.6). **However, with the latest generation of sensors, this is no longer an issue.** They're fast enough for shooting action.

**4.6** Distortion caused by an earlier-version electronic shutter

**You can choose MS only, ES only, or MS+ES.** In MS+ES, the camera will fire the mechanical shutter until the maximum mechanical shutter speed on your camera is attained. Above that, it will seamlessly switch to the ES. At the very least, **you should assign SHUTTER TYPE as one of the items in your MY MENU.**

For maximum versatility, you might want to keep your camera set to MS+ES, unless you use flash. Note: Having the camera set to ES will disable the hot shoe.

All of the latest X Series models have an additional shutter type called **EF**, or **ELECTRONIC FRONT CURTAIN**, which is designed to reduce "shutter shake" and blackout time.

When using **EF**, the camera starts the exposure by using the electronic shutter, then finishes it by closing the mechanical shutter. You'll get less vibration when using slower shutter speeds, and reduced lag-time between pressing the shutter button and when the camera starts making the exposure.

Here are the different shutter options you'll find on all recent X Series models:

- **MS:** Mechanical Shutter, goes up to 1/8000 sec.
- **ES:** Electronic Shutter.
- **EF-E:** Front Curtain Shutter. Shortest blackout time. Higher IQ when slower than 1/2000 sec.

- **M+E:** Mechanical + Electronic. MS up to 1/8000 sec., then switches to ES above 1/8000 sec.

- **EF+M:** Front Curtain + Mechanical. EF until 1/2000 sec., MS above 1/2000 sec.

- **EF+M+E:** EF up to 1/2000 sec., MS above 1/2000 sec., ES above 1/8000 sec.

## FLICKER REDUCTION

Reduces the occasional "flicker" when shooting under fluorescent lights. On some models, this is called FLICKERLESS S.S. SETTING.

## IS MODE

IS MODE helps reduce blur due to camera shake when shooting handheld at lower shutter speeds. This option is available only with lenses that support optical image stabilization (OIS). If you don't have an OIS-capable lens attached, this menu item will be grayed out.

The OIS on the Fuji lenses is outstanding, and you'll be amazed at how low you can handhold your shots, even with long lenses. Here are the IS Mode options:

- **CONTINUOUS:** Image stabilization is on. This setting will draw more battery power.

- **SHOOTING ONLY:** Image stabilization is enabled only when the shutter button is pressed halfway or the shutter is released.

- **OFF:** Image stabilization is off. The little "shaking hand with the line through it" icon appears in the display. This is the recommended mode when using a tripod (see Figure 4.7).

The **X-S10** has two additional modes:

- **CONTINUOUS+MOTION:** The same as **CONTINUOUS**. Image stabilization on. If the +**MOTION** option is selected, the camera will adjust shutter speed accordingly to reduce motion blur when moving objects are detected in the viewfinder.

- **SHOOTING+MOTION:** Same as **SHOOTING ONLY**. Image stabilization enabled only when the shutter button is pressed halfway or the shutter is released. If the +**MOTION** option is selected, the camera will adjust shutter speed accordingly to reduce motion blur when moving objects are detected in the viewfinder.

Note: The +**MOTION** option has no effect when ISO is set to a fixed value; it works only in conjunction with the ISO AUTO Setting.

4.7

## ISO AUTO SETTING

When shooting with FUJIFILM cameras, you can select the ISO manually by turning those nice metal dials, or you can set it to AUTO ISO.

When configuring your AUTO ISO settings, you select your base ISO sensitivity, the maximum sensitivity, and the minimum shutter speed for the **A** (AUTO ISO) position on the ISO dial. You can save up to three different settings, which can be assigned to **AUTO 1**, **AUTO 2**, and **AUTO 3.** These settings can be quickly recalled for different types of lighting conditions or shooting situations.

- **DEFAULT SENSITIVITY** refers to the lowest ISO setting you want the camera to use, provided there's enough light in the scene. Your options start at ISO 200 and go all the way up to the maximum ISO setting for your camera.

- **MAX SENSITIVITY** is the highest ISO setting you want the camera to use when your ambient light levels drop. Your options start at ISO 400 and go all the way up to the maximum ISO setting for your camera.

- **MIN SHUTTER SPEED** refers to the lowest possible shutter speed you want your camera to use if the light drops. Your options are 1/500–1/4 sec. In AUTO, the camera will automatically select a shutter speed base that is roughly equal to the inverse of your current focal length. For example, if you're using a 60mm lens, your camera will choose a speed no lower than 1/60 sec. Keep in mind that the camera may select a shutter speed lower than this speed if your scene will be underexposed at MAX SENSITIVITY.

**I usually prefer setting my ISO manually.** This is mostly because I have that awesome ISO dial on the top deck of my X-T5. It's easy to reach, and I can wrangle that thing around to whatever ISO setting I want in about one second. A quick spin will take me from ISO 200 all the way up to 3200 or even 12800 and back down to 1600 before anyone can even notice what I'm doing.

Sometimes when the light is dim and I desperately need a higher shutter speed, I'll just grab it and give it a spin without even looking at where it stops. I know that my images will look great at just about any ISO.

Also, setting it manually gives me maximum control over my shutter speed. This is nice when shooting action or moving subjects in dim light. In addition, keeping it in manual makes it easier to take advantage of the excellent optical image stabilization on the Fuji lenses and shoot at ridiculously low shutter speeds.

## So, Why Use ISO Auto?

**Reason #1:** Because it's easy. You don't have to worry about anything. You just set it and forget it, and let the camera do all the work. One less thing to think about.

**Reason #2:** You don't have an ISO dial on your camera. You could assign ISO to a Fn button, but if the light's changing quickly and you're a little bit unsure what you're doing, or if you just don't want to think about it, AUTO ISO can be pretty nice. **Note: You probably don't want to use AUTO ISO when doing flash photography.**

Some newer models allow you to toggle and spin the front command dial when you're in A mode so that you can change the ISO with the command dial. You'll find this setting in the ISO DIAL SETTING A menu inside the BUTTON/DIAL SETTING menu.

On RED/BLUE models, ISO AUTO SETTING is found in the RED MENUS.

# CONVERSION LENS

The X100 and X70 allow the use of the optional FUJIFILM conversion lenses. These special lenses screw onto the front of the fixed lens and give you a different focal length.

When using either the WCL-X100 or TCL-X100 conversion lens, select the appropriate **CONVERSION LENS** setting. Chose **WIDE** for the WCL-X100 and **TELE** for the TCL-X100.

(Note: The camera selects the correct option automatically when the WCL-X100II or TCL-X100II is used.)

# DIGITAL TELECONVERTER

Found on the X100F and X70, the DIGITAL TELE-CONV is one of the settings that can be assigned to the Control Ring. By rotating the ring when you have this feature set, the camera performs a digital zoom function, letting you shoot with two more view angles in addition to the native focal length of the lens.

Essentially, it's just digital zoom, but the camera's processor optimizes the image for the best reproduction quality. Given the sharpness of the X-Trans sensor and the capabilities of the image processor, you'll find the results to be very good. There will be a slight loss in quality, but you may find the loss negligible for general use. This setting only works when shooting JPEG.

Here are the different view angle options for the X100F and X70. Note: These focal lengths correspond to the effective focal length when compared to a 35mm film camera.

## X100F

- 35mm (native)
- 50mm
- 70mm

## X70

- 28mm (native)
- 35mm
- 50mm

# ND FILTER

All X100 models have a three-stop neutral-density (ND) filter built right into the camera. This unique tool automatically reduces exposure by 3 EV, which allows you to use slower shutter speeds and/or wider apertures than would normally be possible without overexposing your image.

You could use the ND FILTER to blur motion, or you could use it to reduce depth of field by using wider aperture settings in bright light or when using flash.

# MOUNT ADAPTOR SETTING

Using the FUJIFILM M Mount Adaptor, you can use a wide range of legendary Leica, Voigtländer, Carl Zeiss, and Ricoh M Mount lenses on your X Series camera. Use this menu item to adjust settings for M Mount lenses connected with the adaptor.

If your lens has a focal length of 21mm, 24mm, 28mm, or 35mm, choose the matching **FOCAL LENGTH** option, or use option 5 or 6 if your focal length isn't present.

- **DISTORTION CORRECTION:** Select to correct for **BARREL** or **PINCUSHION** distortion. Choose from **STRONG**, **MEDIUM**, or **WEAK**.

- **COLOR SHADING CORRECTION:** Corrects for variations between the center and edges of the frame. Different color corrections can be set separately for each corner.

- Rotate the rear command dial to choose a corner and use the selector to adjust the shading until there is no visible difference in color between the selected corner and the center of the image. Press the selector left or right to adjust colors on the cyan/red axis, and go up or down to adjust the blue/yellow axis. Then select your next corner with the command dial and repeat.

- To ensure accuracy, perform your color shading corrections while shooting a blue sky or a solid gray background, paper, or gray card.

- **PERIPHERAL ILLUMINATION CORRECTION (also known as vignetting):** To correct, choose values between −5 and +5; positive values make the corners lighter, negative values make the corners darker. Positive correction is recommended when using vintage lenses. Negative correction creates the classic vignetting effect of images taken with an antique lens or a pinhole camera.

Please note that the above correction settings only work when shooting JPEG.

# WIRELESS COMMUNICATION

This setting allows you to connect your camera to smartphones and tablets running the FUJIFILM Camera Remote app. Once connected, your mobile device can be used to browse the images on the camera, download selected images, control the camera remotely, and upload location data to the camera for geotagging your images.

This function is also found in the PLAYBACK MENU. However, many X Series cameras have a dedicated Wi-Fi button or Fn button to which this function is assigned, and which can be accessed when you're playing back images.

With the latest version of the Camera Remote app and all Bluetooth-enabled models, you don't need to use this menu item to connect; the app will automatically find your camera and connect. For older models, assign this to a Fn button or stick it in your MY MENU. That way, when you just shot a super-awesome image and can't wait to share it, you don't have to go looking for this item in the menu system.

**4.8**

# FLASH SETTINGS

There are a number of dedicated FUJIFILM-brand and third-party flash units that pair with the X Series cameras, including the tiny EF-20, the mid-range EF-X42, the high end EF-X500, and the wireless radio EF-60, which works with the EF-W1 Wireless Commander. In addition, the X-T10/20/30 have on-board pop-up flashes; the X100 and X70 have them built in; and both the X-T1 and X-T2 came with the tiny EF-X8 flash.

The X Series cameras also work quite well with a variety of other flash units, including those from Nikon and Canon, and there are great units made by both Nissin and Godox. These days, I'm using the Fujifilm EF-60 and EF-W1 Wireless Commander.

Most third-party flashes that are not specifically designed for Fuji won't perform TTL or high-speed sync (HSS) functions. Some Fuji-compatible flashes like Nissin and Godox will, and Profoto has their Air Remote TTL-F wireless radio unit, which allows TTL and HSS flash capabilities between FUJIFILM cameras and Profoto flash units.

If you shoot manual flash and you have some old Nikon or Canon speedlights left over from your DSLR days, rest assured, you can still use them with your Fuji. (Note: If you want to shoot off-camera TTL with dedicated Fuji flashes, you'll need a Canon-compatible sync cord for your TTL pins to line up.)

You can also do off-camera flash with X Series cameras using the PocketWizard Plus models, as well as the Cactus V6 triggers.

**Note: The X100 and X10/20/30/70 models all use leaf shutters and will do flash sync at any shutter speed.**

For RED/BLUE menu cameras, the only flash settings available are FLASH FUNCTION SETTINGS and TTL-LOCK, both found in one of the RED MENUS. You can also access your flash settings in the Q menu.

The MY MENU cameras have increased flash capabilities and feature a brand-new dedicated FLASH SETTING menu. While the exact options available depend on what flash unit you attach to the camera, it's a pretty straightforward process to control your flash from the camera's FLASH SETTING menu.

Basically, if you stick a flash on your Fuji and bring up the FLASH FUNCTION SETTING options, you'll see pretty quickly what you can control. With a TTL-compatible unit, you'll be able to turn the flash on and off, change the flash mode, set either normal or slow sync, set front or rear curtain sync, and adjust the flash output compensation, all right from the camera.

With a dedicated Fuji flash like the EF-X500 and EF-60, you'll have even more options, including wireless remote control, flash commander settings, and even high-speed sync.

If you use an X100 and X70, you can either use the built-in flash or use a flash in the hot shoe. You can turn the built-in flash ON or OFF in the flash menu.

Here are the items you'll find in the FLASH SETTING menu of most cameras. I'll just cover the basics here. If you want more detailed reading, please refer to the FUJIFILM External Flash Units web page.[11]

# FLASH FUNCTION SETTING

As discussed above, this setting lets you select your flash control mode, flash mode, sync mode, and flash output power/compensation level. The exact options available are determined by what flash you're using, but it's pretty straightforward.

**5.1**

With a little trial and error, you should be able to figure it out pretty quickly.

- **FLASH CONTROL MODE:** Choose between TTL, Manual, Commander, or OFF. Commander mode is for when you're using the on-camera flash to control other off-camera remote flash units.

- **FLASH COMPENSATION/OUTPUT:** Adjusts your light output level.

- **FLASH MODE (TTL):** Select a flash mode for TTL control. Options vary with your exposure shooting mode (P, S, A, M).

- **FLASH AUTO:** The flash fires only as required with the light level adjusted according to subject brightness. When you press the shutter halfway down and you see the little "lightning bolt" icon appear in your viewfinder, this indicates that the flash is about to fire.

- **STANDARD:** The flash will fire with every shot if possible. The flash level is adjusted according to the scene's brightness. The only way the flash will not fire is if it's not fully charged when you press the shutter.

- **SLOW SYNC:** This lets you use slow shutter speeds with the flash, which produces that highly appealing motion-blur flash effect. Slow-shutter flash is awesome. Try it. I know you'll like it. I use slow shutter sync flash all the time. Most pros do.

- **SYNC:** This controls when the flash will fire.

- **FRONT/1st CURTAIN:** The flash fires immediately after the shutter opens.

- **REAR/2nd CURTAIN:** The flash fires right before the shutter closes. In almost every single type of flash shot, this is the preferred and recommended method. It looks especially cool when combined with SLOW SYNC flash.

**I recommend keeping your flash set to REAR CURTAIN.**

## RED EYE REMOVAL

We all know what this does, right? The X Series RED EYE REMOVAL menu has four options:

- **FLASH+REMOVAL:** A red-eye reduction pre-flash is combined with digital red-eye removal.

- **FLASH:** Red-eye reduction is performed by the pre-flash only.

- **REMOVAL:** Digital red-eye removal is performed by the image processor only.

- **OFF:** No red-eye removal.

Note: Digital red-eye reduction is only performed when a face is detected and you're not shooting in RAW.

## TTL-LOCK MODE

Instead of adjusting the flash level with each shot, TTL flash control can be locked for consistent results across a series of photographs. There are two options here:

- **LOCK WITH LAST FLASH:** The lighting value as measured by your most recent photo will be saved and used for subsequent images.

- **LOCK WITH METERING FLASH:** The lighting value metered with the next series of TTL pre-flashes will be used for subsequent photos.

This is a pretty handy setting, as it keeps your lighting levels consistent between shots, and it probably conserves battery power on your flash. Use TTL-LOCK if your lighting doesn't change.

Note: You can assign TTL-LOCK to a Fn button and use the button to toggle it on or off.

## LED LIGHT SETTING

Some flash units have an LED video light. This setting lets you choose whether to use the LED light as a CATCHLIGHT or an AF-ASSIST ILLUMINATOR. You can also set it to perform both functions (AF ASSIST+CATCHLIGHT) or turn it off entirely (OFF).

## MASTER SETTING

When using a FUJIFILM flash with wireless optical flash control, you can select a flash group (A, B, or C) for the flash mounted on the camera hot shoe when it functions as a master flash commander.

Or you can choose **OFF** to limit master flash output to a level that does not affect the final picture. This way, it controls the other units but does not contribute to the light in the photo or function as one of the group lights.

## CH (CHANNEL) SETTING

When using a FUJIFILM flash with optical wireless flash control, you can select one of four channels for your flash systems to operate when communicating between the master and the remote units. Use this setting when you're using multiple lighting systems or to prevent interference when other compatible flash systems are operating nearby.

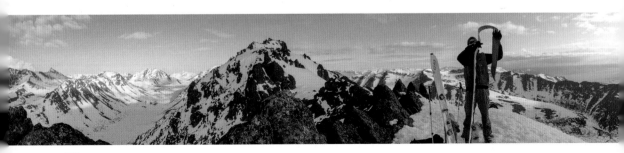

5.2

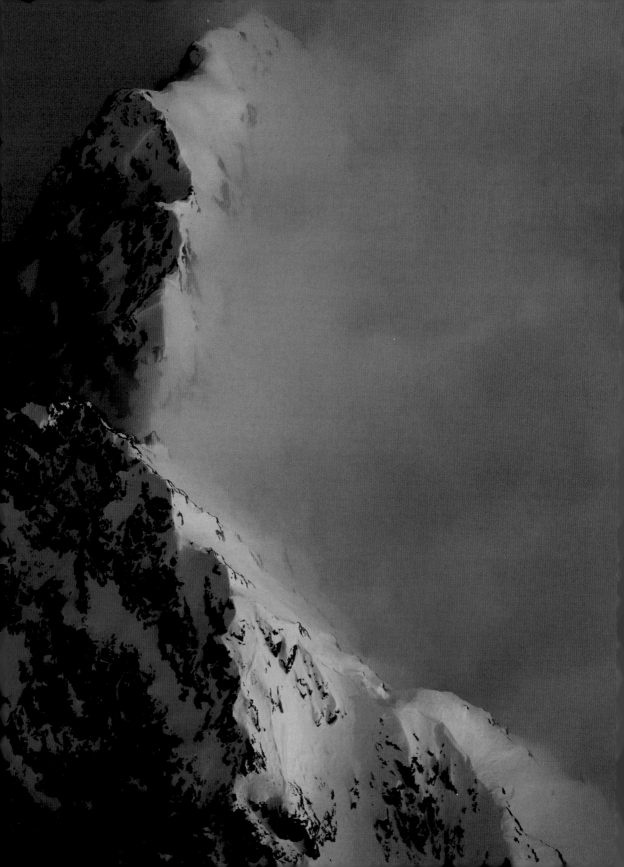

# MOVIE SETTINGS

All of the current and recent X Series models feature expanded video capabilities, with up to 4K capture. The new fifth-generation models can shoot up to 6.2K or 8K. In addition, all recent models have dedicated menu items for shooting video. This allows you to apply any number of camera settings separate from your regular still-shooting options.

The X-H2 and X-H2S offer the highest level of video performance, with ultra-high-speed recording, ultra-high resolution, and optional cooling fans that allow longer periods of non-stop movie recording.

If you have a RED/BLUE menu camera, you'll find the MOVIE SET-UP menu in one of the RED MENUS.

**Note on MOVIE Settings:** Since many of the video settings on the newer X Series models have the exact same function as the I.Q. and AF/MF settings of the same name, I will not list them all again here. If you see a particular setting in your camera's MOVIE SETTINGS menu that is not listed in this chapter, simply refer to the IMAGE QUALITY or FOCUS MENUS chapters to read what they do.

If you have specific I.Q. or AF settings—such as Film Simulation, Highlight/Shadow Tone, White Balance, Focus Mode, etc.—assigned to Fn buttons or the Q menu, you can apply those when shooting in Movie Mode as well, and they will stay separate. So, if you're shooting stills with the ASTIA film sim, and you switch to shooting video with PROVIA, then later switch back to shooting stills, ASTIA will still be the active film sim.

**6.1** X-H2S with optional cooling fan accessory

## FILM SIMULATION ON VIDEO RECORDING (ALL CAMERAS)

All of the FILM SIMULATION options are available during video recording right in-camera, just as if you were shooting stills. This allows you to get great-looking, stylized footage right out of the camera, without having to do any color grading or video post-processing.

You can even shoot in ACROS/black-and-white mode, and you can also apply tonal and color adjustments using tools like HIGHLIGHT TONE and SHADOW TONE. And you can adjust aperture, shutter speed, and EV +/–2 stops on the fly.

## SIMULTANEOUS HDMI OUTPUT TO EXTERNAL MONITOR

The latest models can output video to an HDMI device during recording. This allows you to simultaneously check footage on the camera's LCD/EVF and on an external monitor. The video data can even be recorded onto an external recorder in real time in uncompressed format.

In addition, when shooting 4K movies, you can choose log gamma "F-Log" to record a wider dynamic range than normal video mode.

(The fifth-generation models also have F-Log2, which offers an even larger dynamic range of 13+ stops.)

Check out the link in the *Online References* section at the end of the book to see a mountain-bike-racing video I shot this past summer with the X-T4.[12] I mostly used the

XF100–400mm lens, and XF16mm f/2.8 lens, and CLASSIC Neg. Film Simulation with a SHADOW TONE adjustment of +2 to increase contrast and give the video a muted, hard-edged, gritty look.

Rather than try to manually select an AF point, which would have been extremely difficult with some of these clips, I just put the camera on **MOVIE AF MODE—MULTI** and let it find and acquire subjects on its own.

Even if you don't have one of the higher-end models, you can still shoot video, and you can make it as fun as you want it to be.

## MOVIE MODE

All of the X Series cameras can shoot video at a number of sizes and frame rates. In this menu, you choose the **aspect ratio** for your video, an appropriate **frame rate**, and your desired **bitrate**. Not all of these setting options will be available on all cameras. If a setting is missing or grayed out, it means your camera doesn't have that particular option available.

6.2

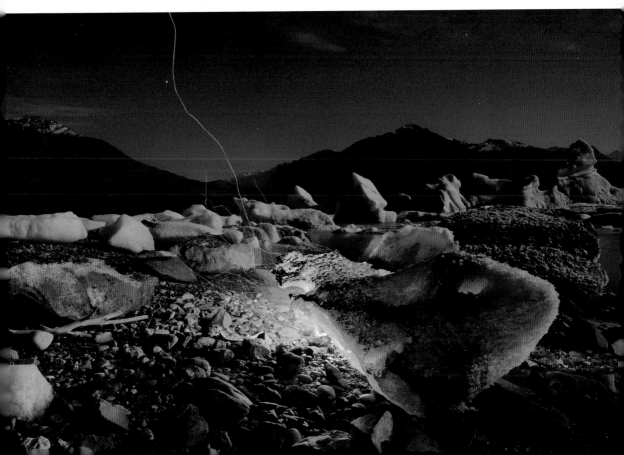

## Choosing Your Aspect Ratio

The aspect ratio determines resolution and size of your video. The larger the aspect ratio, the bigger your video will be on the screen, the higher the resolution, and the more room the video file will take up on your memory card and hard drive. Larger video files also require more processing power to play and edit on your computer.

| | |
|---|---|
| 8K | **(16:9) 7890 x 4330** |
| 6.2K | **(3:2) 6240 x 4160** |
| 6.2K | **(16:9) 6420 x 3510** |
| DCI 4K | **(17:9) 4096 x 2160** |
| 4K | **(16:9) 3840 x 2160** |
| Full HD | **(17:9) 2048 x 1080** |
| Full HD | **(16:9) 1920 x 1080** |
| HD | **(16:9) 1280 x 720** (Older X Series models) |

## Choosing Your Frame Rate

Depending on the camera and your chosen aspect ratio, you can choose from the following worldwide standard motion picture format frame rates:

- **60p (59.97p):** Suited for fast-paced action and gives crisp resolution and details.

- **50p:** Works well for faster motion when you still want some blur.

- **30p (29.97p):** The standard format for digital home movies of normal scenes.

- **25p:** Similar to 24p, but is based on UK, EU, and Australian PAL format.

- **24p (23.97p):** The standard motion picture format. Gives a pleasing, cinematic effect.

## Choosing Your Bitrate

Bitrate is basically how fast your video information is processed/transferred during playback. It's measured in megabits per second. The higher the bitrate, the higher the quality of your video, but at the cost of larger file sizes.

**720Mbps** (X-H2 and X-H2S only)
**400Mbps** (X-T3/4, X-H2, and X-H2S only)
**360Mbps**
**200Mbps**
**100Mbps**
**50Mbps**

For shooting things like interviews, vlogs, "Talking Head" YouTube videos, or other static or slow-moving subjects in bright light, lower bit rates of **50Mbps** and **100Mbps** will be fine, and this will create smaller video files. For fast-moving subjects or if you're shooting in lower light, **200Mbps** and up will produce higher-quality video and lower noise, but your files will be much larger.

The X-H2 and X-H2S can shoot at up to **720Mbps**, which gives an astoundingly high level of quality and crispness to the video, even with very fast motion.

**6.3** X-H2S with optional battery grip

# FILE FORMAT/MEDIA REC SETTING

This is where you choose a video codec for movie recording. On the fifth-generation models, this menu is called MEDIA REC SETTING, and it has a lot more options.

**H.265(HVEC):** This format gives you higher-quality footage with a higher compression ratio. However, video shot with this mode can only be viewed on devices that support H.265(HVEC). This format is only supported on the fourth- and fifth-generation X Series cameras.

**H.264:** This is the most widely supported video codec and can be viewed on most devices. It's available in two formats: **MOV/LPCM**, which gives high-quality picture and sound, and **MP4/AAC**, which is suitable for movies that will be uploaded to the web.

Fifth-generation X Series models can also support Apple's ProRes video format, **but only when movies are saved to a Type B CFexpress memory card or recorded to external HDMI. ProRes video cannot be recorded internally to an SD card.**

**MOV/ProRes 422 HQ:** This high-quality format has widespread adoption across the video post-production industry and offers high-quality, full-width video with 10-bit 4:2:2 color and virtually lossless reproduction.

**MOV/ProRes 422:** This high-quality codec offers nearly all the benefits of 422 HQ, but at a smaller data rate for better streaming and real-time editing performance.

**MOV/ProRes 422LT:** This is a more highly compressed video codec that produces full-resolution video at much smaller file sizes. Ideal when storage capacity is limited.

### ProRes PROXY SETTING

When shooting movies in ProRes format, you can choose to simultaneously record a duplicate "proxy" version of your video at the same time. You have three options:

**ON (H264):** The camera will record proxy videos in H.264 format.

**ON (ProRes Proxy):** The camera records videos in the highly compressed ProRes Proxy format.

**OFF:** Proxy recording is disabled.

## MOVIE COMPRESSION

This is where you choose a compression ratio for your video footage. This menu is found only on the X-T3 and X-T4. For compression options on the new X-H models, see the File Format menu.

**ALL-Intra:** Each frame is compressed separately. This results in larger video files, but it's an ideal choice if you intend to further process your movie footage. When shooting in 4K mode, max frame rate is reduced to 29.97P and 25P.

**Long GOP:** This setting gives you a tradeoff between good image quality and high compression. Files are much smaller, which makes this an ideal setting for longer movies.

## FULL HD HIGH SPEED REC

Most newer-model X Series cameras allow you to record Full HD movies at high frame rates, which are then played back in **slow motion**. (The X-H2S can record 4K video at high speed.) Footage is recorded at frame rates of 100p, 120p, 200p, or 240p, and played back at either 1/2, 1/4, or 1/5 speed. Choose your desired frame rate and play speed, and have fun!

## INTERFRAME NR

On some 4K-compatible models, this is called 4K Interframe NR. Choose **ON** or **OFF** to enable Interframe Noise Reduction. I have no experience with this setting, but from what I've read, it's used when shooting video of things that aren't moving. With subject or camera movement, you may experience ghosting.

# F-LOG RECORDING

This is found on the X-T30, X-Pro 3, X100V, X-E4, X-S10, and X-H1 only. Use this option to apply a soft gamma curve to your movie recordings. This gives you a low-contrast profile that's highly suitable for further processing and color grading.

# F-LOG/HLG RECORDING

This is found on X-T3/X-T4 and fifth-generation models only. Similar to the previous menu item, this setting lets you choose a destination for shooting F-Log/HLG (Hybrid Log-Gamma) movies when the camera is connected to an HDMI device.

Basically, you can choose to save raw footage, footage that's processed with a film simulation, or footage recorded in F-Log/F-Log2/HLG format to both the memory card and to an HDMI device, or save different formats to different destinations. Depending on the model, you could send straight film-simulation footage or an F-Log output of your movie to either the memory card or an HDMI device, or send F-Log footage to the card and film sim video to HDMI, etc. The icons in the menu tell you what goes where.

With F-Log/F-Log2 selected, a low-contrast color space with a wide gamut is applied to the files. This helps make the most of the X-Trans sensor's great dynamic range and allows for a wider range of color grading and processing options in post. Also, when shooting in this mode, your minimum ISO is ISO 640.

If you're shooting professional or high-quality video and intend to post-process your files with color grading or other tonal adjustments, you'll probably want to output to F-Log/F-Log2. You'll need this file to get started: https://fujifilm-x.com/global/support/download/lut/.

# DATA LEVEL ADJUSTMENT

This brand-new fifth-generation setting allows you to choose a standard signal range, which is the range of values the camera records when shooting movies. You have two choices: **VIDEO RANGE** and **FULL RANGE**.

Essentially, this determines the bit values and grayscale range of your content when viewed on a calibrated display. **FULL RANGE** gives you slightly more information in the extreme whites and blacks, but only if your device is capable of rendering this information.

Unless you're experienced with this terminology, I would recommend leaving the camera set to **VIDEO RANGE**. You'll get great results. If you want to learn more about this aspect of video post-production, I recommend reading this highly informative article: https://www.thepostprocess.com/2019/09/24/how-to-deal-with-levels-full-vs-video/.

## PERIPHERAL LIGHT CORRECTION

This is found on the X-T3, X-T4, X-T30, X-Pro 3, X100V, and X-H1 only. With some lenses, you may experience light falloff in the corners. This option lets you correct this. Note, if you're using a non-Fuji lens, or any lens that doesn't transmit data to the camera, you'll have to correct for this in the Mount Adaptor Settings menu.

## MOVIE AF MODE

You can choose how the camera selects the focus point when shooting video. You have two options:

- **MULTI:** Automatic AF-point selection. Like WIDE/TRACKING AF, but for video.
- **AREA:** The camera will focus on the subject in your selected focus area.

Which mode you use will depend on your subject type and movement, and how comfortable and adept you are with selecting and moving your AF points around the frame.

## FOCUS CHECK LOCK

This option lets you choose whether the focus zoom remains in effect once movie recording begins. It's found only on the newer models.

## HDMI OUTPUT INFO DISPLAY

By setting this to **ON**, your connected HDMI devices will mirror the information in the camera display. Most newer Fuji models have this setting.

# 4K HD MOVIE OUTPUT

This is actually two separate menu settings, one for 4K and one for Full HD. You can choose the destination for 4K and Full HD movies while the camera is connected to an HDMI recorder or other device that supports 4K/Full HD video.

Depending on your camera, you'll have different options for which formats get saved to which output destination. If you look at the menu, it's pretty self-explanatory. You'll have either two options to choose from, SD CARD and HDMI, or a host of detailed output choices. There's also an option that sends 4K to the HDMI port, but not to the memory card. This allows you to send your video files straight to an HDMI recorder.

- **SD CARD:** When shooting in 4K, your movie files are saved to the camera's memory cards in 4K format and to your HDMI device in Full HD format.

- **HDMI:** Your 4K movies are sent to the HDMI device as 4K video. If the SD option has a dash symbol by it, then no video files are saved to your memory card.

- **HDMI F-LOG (X-T2/3/4 and fifth-generation models only):** 4K movies are sent to the HDMI device without recording them to the memory card. A special, flat, low-contrast color space with a wide gamut is applied to the files. This helps make the most of the X-Trans sensor's great dynamic range and allows for a wider range of color grading and processing options in post. Also, when shooting in this mode, your minimum ISO is set to ISO 800. Note: On the new fifth-generation models, you specify all movie output destinations in the MEDIA REC SETTING menu.

If you're shooting professional or high-quality video and intend to post-process your files with color grading or other tonal adjustments, you'll probably want to output to F-Log. Visit the FUJIFILM website to download the necessary LUT file for editing 4K movie data.[13]

## 4K HDMI STANDBY QUALITY

This is found on the X-T3/4 and X-H1 only. This lets you choose whether the connected HDMI output device switches from 4K to Full HD during standby. Switching to Full HD reduces battery drain.

## HDMI REC CONTROL

You can choose whether the camera sends movie "Start" and "Stop" signals to your HDMI device when you press the shutter button.

## IS MODE (MOVIE)

The X-T4 and new fifth-generation models have an additional IS (Image Stabilization) setting in the main MOVIE SETTINGS menu that allows for dedicated optimization of the IBIS and OIS systems when shooting video.

- **IBIS/OIS:** Enables both the camera's in-body image stabilization (IBIS) and optical lens image stabilization (OIS). If your current lens does not have OIS, then only IBIS will be used.

- **IBIS/OIS + DIS:** Enables in-body (IBIS), lens (OIS), and digital image stabilization (DIS) to achieve maximum image stabilization when shooting movies.

- **OFF:** Image stabilization is turned off. The hand icon appears on the display. This is the recommended mode when using a tripod or when the camera is mounted on a fixed support.

## IS MODE BOOST

This control, found only on the X-T4, X-S10, and fifth-generation models with IBIS, allows for optimized stabilization for performing panning motions when shooting video. It is an additional IS setting in the main MOVIE SETTINGS menu that allows for dedicated optimization of the IBIS and OIS systems when shooting video. For general movie shooting, keep this setting **ON**, unless you're doing hand-held panning, in which case, turn this setting **OFF**.

## ZEBRA SETTING/ZEBRA LEVEL

**ZEBRA SETTING** shows highlights that might be overexposed during video shooting. Here, you can choose the direction of the stripes—slanting right or left—or turn the zebra OFF.

**ZEBRA LEVEL** allows you to choose the brightness threshold for displaying the Zebra stripes, from 50 to 100. At 50, the camera is more sensitive, and you'll see the zebra stripes in a broader level of exposure. At 100, they'll only display on the brightest subject matter.

## TIME CODE SETTING

Here you can adjust the time code display settings for video recording. Time code is used to sync different video devices, most commonly linking the video footage with your sound recording/playback device.

- **TIME CODE DISPLAY:** Turns the time code display on and off.

- **START TIME SETTING:** Select your time code start time.

- **MANUAL INPUT:** Choose this option to start the time code manually.

- **CURRENT TIME:** Sets the start time to the current time.

- **RESET:** Sets the start time to 00:00:00.

- **COUNT UP SETTING:** Select whether the time code runs continuously or only during recording.

- **REC RUN:** Time is only clocked while you're recording video.

- **FREE RUN:** Time is clocked continuously, whether you're shooting or not.

- **DROP FRAME:** At certain frame rates (59.94 and 27.97) there's a discrepancy between the time code, which is measured in seconds, and the actual recording time, which is measured in fractions of a second. Enabling DROP FRAME by selecting ON will allow the camera to drop occasional frames as necessary in order to match the time code. You can also turn this OFF.

- **TIME CODE OUTPUT:** This lets you choose whether time code is set to your HDMI devices.

## TALLY LIGHT

Choose whether the Indicator Lamp and/or AF-Assist Light displays during movie recording, and how each light behaves. Each one can be set to blink, stay on, or be turned off.

## MOVIE OPTIMIZED CONTROL

This control allows you to disable the camera dials so that you can only adjust movie settings via the touch screen controls. This allows for silent operation, so you won't hear those noisy clicks when you turn the dials. Note: On some models, this is called MOVIE SILENT CONTROL.

When you turn this setting ON, you'll see an additional "Movie Set" icon on the touch screen. When you tap this, you'll be able to adjust the parameters listed below via touch control. Simply tap and swipe up, down, right, or left on the screen to choose and set your desired controls.

- SHUTTER SPEED
- APERTURE
- EV +/−
- ISO
- INTERNAL/EXTERNAL MIC LEVEL ADJUSTMENTS
- WIND FILTER
- HEADPHONES VOLUME
- FILM SIMULATION
- WHITE BALANCE

## MIC LEVEL ADJUSTMENT (INTERNAL/EXTERNAL)

Here you have control over your internal and external mic levels. You can set this to **AUTO**; **MANUAL**, and adjust accordingly; or turn it **OFF** to disable the microphone.

On RED/BLUE cameras, you'll find this in one of the RED MENUS.

# MIC JACK SETTING

This is where you specify what type of audio device is connected to the microphone jack. You can choose either MIC, for an external microphone, or LINE, for an external audio device with a line output, like a keyboard or mixer.

# MIC LEVEL LIMITER

This setting allows you to add an automatic limiter to reduce distortion caused by sudden mic input signals that are too loud. It's either ON or OFF. It's better to set your Mic Level Adjustment to a workable level than to rely on this setting, but sometimes loud noises can get through and this option can help.

# WIND FILTER

Wind noise is the bane of videographers who work outside, and by enabling this setting, you can reduce it during movie recording.

# LOW CUT FILTER

This enables a low-cut or high-pass filter that can reduce rumbling, low-frequency noises that may occur during recording. It's either ON or OFF.

# HEADPHONE VOLUME

This allows you to adjust the headphone volume level on a scale of 1–10, or mute it entirely with the 0 setting.

# MIC/REMOTE RELEASE

This item lets you specify whether the device connected to the microphone/remote release connector is a microphone or a remote release.

# XLR MIC ADAPTER SETTING

The higher-end X Series models allow you to use XLR microphone adapters to expand the capabilities of your audio recording when shooting movies.

## MIC INPUT CHANNEL

This feature allows you to record four-channel quadraphonic sound (**4ch XLR+CAMERA**) with the help of the camera's built-in microphone, or two-channel stereo sound (**2ch XLR ONLY**) by using only an XLR mic that's connected via XLR mic adapters and interfaces like those made by IK Multimedia and TASCAM.

## 4ch AUDIO MONITORING

This allows you to choose the sound source that's output to headphones or other audio monitors during movie recording.

- **XLR:** Monitor sound from external mics connected to the XLR mic adapter.

- **CAMERA:** Monitor the sound from the camera's built-in microphone.

## HDMI 4ch AUDIO OUTPUT

This allows you to choose the source of audio that's sent to the HDMI device.

- **XLR:** Audio from external microphones that are connected via the XLR mic adapter are output to the HDMI port.

- **CAMERA:** Audio from the camera's built-in microphone is output to the HDMI port.

Note: Four-channel audio recording is only available when **MOV/H.264 (HVEC)** or **MOV/H.264 LPCM** is selected in the Movie File Format menu.

6.4

# SET UP MENUS

The Set Up section includes the following menus:

- User Setting
- Sound Setting
- Screen Setting
- Button/Dial Setting

- Power Management
- Save Data Setting
- Connection Setting

Let's dive in!

## USER SETTING MENU

In this section, we'll cover formatting your memory card, setting the date and time, setting up your MY MENU, and more.

## FORMAT

To format a memory card, scroll to this setting, choose your card slot (if applicable), and press OK.

**Shortcut:** The MY MENU cameras have a great shortcut that saves you about six button presses.

Press and hold the TRASH button for about 2.5–3 seconds. Then, while holding the button down, press the rear command dial. This will bring you right to the Format option (or the Card Slot Selection option, if applicable).

**I always recommend formatting your memory cards each time you put a new one in the camera.** This cleans the card off and reduces the chance of card errors. It's just a good habit to get into because you start fresh every time.

What if you put in a card that was half full—with room for, say, 200 frames—and you shot 200 photos? You'd either have to take that card out and waste half the space, or else you could start doing the "delete image" dance a couple hundred times to get rid of the old images.

Or worse (this has happened to me), you put an almost full card in and shoot 10 killer images before you realize that you forgot to format the card. Maybe you run out of room. What if it's the only card you happened to be carrying at the time?

Yeah, you can see where this is going. You don't want to find yourself in this boat. Believe me.

Format your cards.

On RED/BLUE cameras, FORMAT is your last item in BLUE3. In other words, it's the very last item in the entire menu. Instead of scrolling all the way down through all of the menus to get there, try hitting MENU and scrolling "up." This will bring you right to SET-UP Menu 3, where FORMAT lives.

## DATE/TIME

Usually, you should only have to set the date and time when you first use a brand-new camera, or when installing certain firmware updates. (Not every firmware update forces you to reset the date/time.)

## TIME DIFFERENCE

This option lets you switch the camera clock from your normal HOME time zone to a second time zone, called LOCAL. You specify the difference between your LOCAL time zone and your HOME time when choosing that menu item. This is a good thing to do when traveling, because it adjusts your capture times to reflect the actual time at your destination.

**7.1**

**7.2**

Otherwise, if you shoot photos at noon when you're six time zones ahead, your capture times will show image creation at 6:00 a.m. You can always change your capture time metadata in applications like Lightroom and Photo Mechanic, but if you use this option, you won't have to.

One nice feature is that if LOCAL is selected, every time you turn the camera on, the date and time will be displayed in yellow for a few seconds. This is a nice warning to let you know which time zone you're currently using, and it will help you remember to change it back when you get home.

I often forget about this menu item, so maybe writing it down here in this book will help me remember to use it for my next trip. Now if you'll excuse me, I have to go adjust my capture times for all of my Scotland images. Fortunately, there's a batch command, so it doesn't take very long.

## LANGUAGE

Which language do you want to use for all your Fuji menus? You have 32 choices.

## MY MENU SETTING

The MY MENU is a great new addition to the menu system. It's one more place where you can store often-used settings (you have 16 available slots), and as soon as you put anything in your MY MENU, **that item will be the very first thing to show up when you turn the camera on and hit the MENU/OK button.**

With regard to accessing camera settings and features, this is about as fast as you can get. **Put your very favorite setting at the top and it will take only one button press to get there.** That's as fast as any Fn button, and it's faster than the Q menu. From there, it's only a quick scroll down to the next few items.

Note: If you've been scrolling through or using items in your MY MENU, the next time you access your MY MENU, it will go straight to your last-used setting. It will perform this way until you turn the camera off and back on again.

You can add items, remove items, and rank items in the MY MENU panel in the USER SETTING section.

To add, simply hit **ADD ITEMS,** then select from any available item in the entire camera menu. (Available items are highlighted in blue, while items currently in your MY MENU appear with a checkmark.)

**7.3**

To reorder items, hit **RANK ITEMS**, then choose any of your current MY MENU items and press **OK**, or press the "right" button or move the joystick to the right.

It will now be highlighted in yellow, and you can use the up or down button or the joystick to move it to a new slot. When you're done, press **OK** or navigate back to the left with the buttons or joystick.

To remove an item, simply choose **REMOVE ITEMS**, navigate to the selected item, and hit **OK**.

## SENSOR CLEANING

This is where you set your preferences for sensor cleaning. A super-secret process of electromagnetism, vibration, subatomic energy, and tiny gnomes with brushes is activated either when the camera is turned on, turned off, or immediately when you press the OK button, depending on how you set the options in this menu.

**7.4**

If, after a few rounds of cleaning, the dust proves too troublesome (even for the gnomes), my advice is to use a blower brush. Beyond that, seek professional advice from someone other than me.

Sorry I can't be of more help here. I just don't feel like I'm the most qualified guy to tell anyone how to clean their sensor. I tried to clean my Nikon sensor with one of those fancy whirling static brushes one time and ended up with a scratched sensor. It cost me $700 to replace. Needless to say, I've never touched my sensor since then.

Also, I wouldn't advise blowing on your sensor either. Unless you have a serious case of cottonmouth, you could end up spitting on it. How do I know this? Don't ask.

Like I said, get a blower brush.

## BATTERY AGE

This setting allows you to check the age of your battery. The older the battery, the faster it will lose its charge. If your battery is below the middle mark, you should probably replace it.

## RESET

This resets all SHOOTING and SET UP menu options to their default settings.

Any custom white balance you have set, as well as custom settings banks created using **EDIT/SAVE CUSTOM SETTING, WIRELESS SETTINGS,** and your **DATE/TIME** and **TIME DIFFERENCE** options will not be affected. *Whew!*

In six years shooting with the X Series cameras, I've never found the need to use this function.

If you have a RED/BLUE model, all of the USER SETTINGS in this section (except for MY MENU and SENSOR CLEANING) are found in one of the BLUE MENUS.

## SOUND SETTING MENU

This is where you access all your sound settings, from the autofocus beep volume to the shutter sound, and more.

## AF BEEP VOLUME

By default, the camera makes a beep sound when the autofocus successfully acquires focus on your subject, and your selected AF points turn green.

You can select the volume level for this function, or you can turn it off so there is no beep.

Note: On the RED/BLUE cameras, your SOUND SET-UP menu is found in the BLUE MENU.

You also have a confusing function called SOUND & FLASH OFF. This setting **turns all camera sounds off, and it disables the hot shoe.** Your flash will not fire if this item is set to ON. You'll probably want to keep SOUND & FLASH OFF "off."

## SELF-TIMER BEEP VOLUME

Same thing as above, but for the Self-Timer. You have three volume level options, or you can turn the beep off.

## OPERATION VOLUME

This controls the sound level for menu navigation. By default, you'll hear "little clicks" when moving through the menus, kind of like typing on an iPhone when you have clicks enabled. You can set three levels of sound, or turn the clicks off.

I have all three of these settings OFF on my cameras. I shoot a lot and can only take so many beeps and clicks before they drive me crazy.

## HEADPHONES VOLUME

Choose the volume level if you're using headphones connected to the VPB-XT2 power booster grip—say, if you're shooting and previewing video clips.

It goes from 1 to 10, or you can choose OFF to mute the sound.

## SHUTTER VOLUME

These control the volume of your ELECTRONIC SHUTTER—which doesn't actually make any noise, but you can assign a pretend "shutter sound" to the ES or EF to make it a little more realistic, or at least a little more noisy.

7.5

7.6

7.7

You can also disable any sound so that your ES or EF is silent. You'd want this option if you're shooting on a movie set or inside a theater, or if you're doing clandestine photography and don't want anyone to know that you're taking pictures.

## SHUTTER SOUND

If you want your Electronic Shutter (ES or EF) to make noise, you have three different sound options.

- **SOUND 1** is a tiny "tick."

- **SOUND 2** is a slightly deeper "chick." Actually, it's more like a "chock" that sounds kind of like a tiny handclap from an old Roland drum machine.

- **SOUND 3** is a very fast "ca-chick!" It's supposed to sound like a real shutter firing at about 1/1,000 sec. It's kind of cute.

I think my favorite is 2, although I've used 1 as well. Maybe you'll like 3 best.

## PLAYBACK VOLUME

Set the volume for audio playback of movies and voice annotations, which you can read about in chapter 8.

## 4CH AUDIO PLAYBACK

The X-T4, X-T5, X-H2, and X-H2S allow you to adjust the audio settings when viewing movies that have four-channel audio.

- **XLR:** The camera plays audio that was recorded with the external microphone via the XLR microphone adapter.

- **CAMERA:** The camera plays back audio that was recorded with the camera's built-in microphone, or external microphones that were connected via the camera's mic jack.

## SCREEN SETTING MENU

I like the SCREEN SETTING menu. In addition to setting brightness and color on your viewfinder and LCD screen and setting up your display with things like framing guidelines, shooting info, histograms, and the electronic level, this menu also contains two of my favorite settings: PREVIEW EXP/WB IN MANUAL MODE and PREVIEW PIC EFFECT.

On the RED/BLUE cameras, your SCREEN SETTING options are found at the bottom, in the BLUE MENUS.

## VIEW MODE SETTING/EYE SENSOR SETTING

This is where you adjust the settings for the Eye Sensor and view modes for both the EVF and LCD. Not all cameras have this setting, and on some models, this is called EYE SENSOR SETTING. All X-T and X-H models have a VIEW MODE button on the right side of the EVF housing.

7.8

## EVF BRIGHTNESS

Here you can set the brightness level inside your electronic viewfinder.

**MANUAL** lets you choose a value, while **AUTO** automatically selects a brightness level for you. Note: The older X Series models don't have **AUTO.**

I usually leave mine set to Auto, or else at 0.

## EVF COLOR

This adjusts the hue of your electronic viewfinder. Basically, it does a subtle shift in saturation. I've never changed this setting from the default.

## LCD BRIGHTNESS

Same as above (EVF Brightness), but for the LCD screen.

## LCD COLOR

Same as above (EVF Color), but for the LCD screen. Again, I've never adjusted this. The LCD screen looks just fine to me. Some models also have an LCD COLOR ADJUSTMENT menu setting.

## IMAGE DISPLAY

This setting lets you choose how long images are displayed after capture.

- **CONTINUOUS:** Pictures are displayed on the LCD/EVF until you press either the **MENU/OK** button or the shutter button lightly. Remember, when reviewing images, **you can zoom to 100% by pressing the rear command dial**, or hitting the FOCUS ASSIST button on the X-T1.

- **1.5 SEC or 0.5 SEC:** Pictures are displayed for the selected time, or until you press the shutter button again.

- **OFF:** The camera does not display pictures after capture.

I keep my cameras set to **OFF**. I don't need to see every frame I shoot. Plus it saves battery power.

7.9

7.10

## AUTOROTATE DISPLAYS

If you set this function to **ON,** your shooting info and other indicators will rotate to the correct orientation if you turn the camera vertically. I leave this setting ON at all times.

## PREVIEW EXPOSURE/WHITE BALANCE IN MANUAL MODE

Now we're getting to the good stuff!

Selecting **PREVIEW EXP/WB IN MANUAL MODE** enables you to preview exposure and white balance settings and adjustments when shooting in Manual exposure mode. This is the default setting, and it's how you normally want the camera to operate.

Remember, one of the huge advantages of shooting with mirrorless cameras is that **you're able to view real-time changes to your exposure** in the LCD and EVF because you're drawing the view directly from the sensor. This means **what you see on the LCD is** *exactly* **what you'll get when you take the photo.** In most situations, you'll *want* to see this stuff, because it removes the uncertainty of what your image will look like, especially when shooting in tricky light.

Turning this setting **OFF** essentially makes your Fuji act more like a DSLR, where what you see may *not* be what you get. Unless you like the mystery of tricky exposures, you should keep this set to **PREVIEW EXP/WB.**

### So, When Might You Want This Setting Turned Off?

The answer is **when you're shooting with flash.** During these times, you might be using an ambient exposure setting that's simply too dark to see in the viewfinder. Say you're shooting an event in the dark and lighting the scene entirely with flash.

In this case, your exposure settings are something like 1/250 sec. at f/8, which, in a dark room, will be too dark to see anything through your viewfinder.

Turning the setting to **OFF** gives you a normal bright view in your EVF/LCD that's unaffected by exposure changes. This makes it easier to see and compose your subject matter.

In this kind of situation, you could choose to **PREVIEW WB** only, which will show you a preview of the white balance in your viewfinder, but not the exposure itself.

7.11

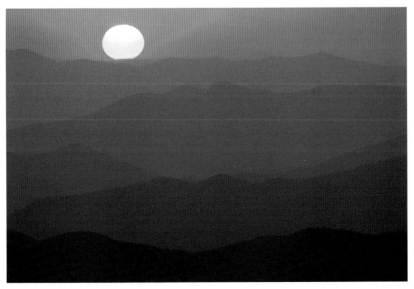

7.12

**7.13**

You might go with this option when shooting under multiple lights that have different color temperatures. Or if you're shooting in RAW and plan to tweak your WB settings at the computer later.

If you shoot with a flash quite often, I recommend putting this function into your MY MENU, or assigning it to a Fn button for quick access.

## NATURAL LIVE VIEW

My other favorite setting in this menu!

NATURAL LIVE VIEW (formerly called PREVIEW PIC. EFFECT) lets you preview the color and effects of your Film Simulation, white balance, and other exposure settings right in your viewfinder. The default setting is **OFF**, which gives you the *"what you see is what you get"* benefit, which makes shooting with mirrorless cameras so nice. The result is that you'll know exactly what your image will look like before you take the shot, because it will look just like what you see in the EVF/LCD.

Turning this setting **ON** turns the display totally neutral and **shows your scene without the effect of the film sim or white balance**. This gives you a much more

accurate view of the world in front of your camera, almost as if you were looking through an optical viewfinder. (On the the older X Series models, where this is called PREVIEW PIC. EFFECT, the controls are reversed. ON shows film sim effects, and OFF shows no effects.)

With the film sim applied, you don't always see how clear and bright the EVF actually is. Looking through the electronic viewfinder with this setting **ON** is almost like looking through a DSLR pentaprism. It also helps make dark, backlit, and other high-contrast scenes a little bit easier to see.

Setting this option to ON is extremely useful for situations when you want the most realism in your viewfinder, e.g., when photographing night skies or when shooting in RAW with the mindset that you'll do all of your own processing and color editing later at the computer.

It's also a good option if you're not really into the film sims, or if you shoot everything in RAW and do all your own processing anyway. You might as well give yourself the full benefit of a nice, bright EVF.

Note: Even if you select **OFF**, you'll still see the film sim effects if you're shooting with one of the black-and-white/monochrome or sepia simulations, or if you're using one of the ADV filters.

## F-LOG VIEW ASSIST

When you turn this setting on, you can display a tone-corrected preview of your movies when recording or viewing F-Log movies. It's found only on the X-T3/4 and fifth-generation models.

## FRAMING GUIDELINE

You can elect to show a framing guideline in your viewfinder and LCD to assist you with compositional decisions.

Your three choices are GRID 9, which helps you shoot according to the "rule of thirds"; a GRID 24, which is a 6 x 4 grid; and HD FRAMING, which gives you crop lines at the top and bottom of the frame that equate to standard HD format.

Note: Regardless of which option you select, it won't show until you check the FRAMING GUIDELINE option inside the DISPLAY CUSTOM SETTING menu, which is the last item in the SCREEN SETTING menu.

## AUTOROTATE PB (PLAYBACK)

Select **ON** to automatically rotate pictures shot in vertical/portrait orientation during playback. Otherwise, you have to turn the camera sideways to see your vertical shots right side up.

## FOCUS SCALE UNITS

You can choose which measurement units are used to display focus distance information inside the viewfinder—meters or feet. I'm hoping that in a future firmware update, they'll add smoots as a third option.[14]

## APERTURE UNIT FOR CINEMA LENS

X-T2, X-T3, and fifth-generation models only. If you're using a FUJINON MKX-series cinema lens, you can use this option to choose whether the camera displays aperture as a T-number, which is used for movie camera lenses and by professional cinematographers, or a standard f/-number.

T-numbers factor in actual lens transmission when calculating exposure to compensate for the fact that different lenses can produce slightly different exposure at the same aperture settings.

## DUAL DISPLAY MODE

This is another great feature. When shooting in manual focus, you have an additional viewing option when you press the DISP/BACK button: DUAL DISPLAY mode.

In this mode, the viewfinder shows you a split screen that lets you see both a regular, full view of the scene and the zoomed-in FOCUS ASSIST view at the same time on a smaller, secondary screen (when using FOCUS PEAKING and DIGITAL SPLIT IMAGE FOCUS). This helps make critical focusing adjustments even easier and more precise.

Adding to this function, most recent models have a special DUAL DISPLAY SETTING, which lets you swap views. You can either see the entire scene on the big screen and the close-up view on the small screen on the right, or the zoomed-in view on the big screen and the overall scene on the smaller one.

DUAL DISPLAY mode is a pretty cool feature, even if you don't have a newer camera.

# DISPLAY CUSTOM SETTING

This is another one of my favorite menu items. This lets you choose what you see in your standard display in the EVF/LCD. I just wish it weren't so far down the menu. It's located at the very bottom of the SCREEN SETTING menu inside the SET UP menu, which means you have to go a long way in order to get there. And you can't add it to your MY MENU either. *Sigh.*

It's actually faster to go to BUTTON DIAL SETTINGS, click RIGHT, and then scroll up through the bottom of the SCREEN SETTINGS Menu until you find it.

Anyway, once you bring up this menu, you can select all of the display items you wish to show by scrolling down and clicking on your desired options. Once you're done choosing, press **DISP/BACK** to save your changes, **then again to exit the menu**. Or just tap the shutter button.

Here's the full list of options, with an asterisk next to the items I currently display on my cameras:

- FRAMING GUIDELINE
- ELECTRONIC LEVEL *
- FOCUS FRAME *
- AF DISTANCE INDICATOR
- MF DISTANCE INDICATOR *
- HISTOGRAM *
- LIVE VIEW HIGHLIGHT ALERT (EVF)
- SHOOTING MODE *
- APERTURE/S-SPEED/ISO *
- INFORMATION BACKGROUND *
- EXPO. COMP. (DIGIT)
- EXPO. COMP. (SCALE) *
- FOCUS MODE *
- PHOTOMETRY *
- SHUTTER TYPE *

- FLASH *
- CONTINUOUS MODE *
- DUAL IS MODE *
- WHITE BALANCE *
- FILM SIMULATION *
- DYNAMIC RANGE *
- BOOST MODE *
- FRAMES REMAINING *
- IMAGE SIZE/QUALITY *
- MOVIE MODE & REC TIME *
- MIC LEVEL ADJUSTMENT *
- BATTERY LEVEL *
- GUIDANCE MESSAGE
- FRAMING OUTLINE

**7.14**

# LARGE INDICATORS MODE (EVF & LCD)

The X Series cameras now allow you the option to use enlarged indicator text to display camera info in the EVF and on the LCD. There's a separate menu item for each.

## LARGE INDICATORS DISP. SETTING

Use this setting to choose the indicators that are displayed in your EVF/LCD when LARGE INDICATORS MODE is turned on. There are four locations where the indicators are displayed, as shown in Figure 7.15.

1. **Expo. DISP.:** Choose which info is displayed at the bottom of the screen.

2. **+/- Scale:** Choose whether you want the EV+/- graph shown in your display.

3. **L1, L2, L3, L4:** Choose up to four camera setting icons on the left side of your screen.

4. **R1, R2, R3, R4:** Choose up to four camera setting icons on the right side of your screen.

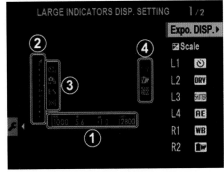

7.15

## LOCATION INFO

The fifth-generation models allow you to display your location info that's downloaded from a smartphone.

## SUB MONITOR SETTING

This is found on the X-H models only. Choose which camera settings you want to display on the secondary LCD monitor. You can select STILL MODE or MOVIE MODE and highlight which items you want to show.

## INFORMATION CONTRAST ADJ.

This setting allows you to change how the display looks on the LCD and EVF. You have four choices, HIGH CONTRAST, LOW CONTRAST, STANDARD, and DARK AMBIENT LIGHTING, which is red text on black. The DARK AMBIENT setting seems like a very good option for night photography and shooting concerts and dimly lit events.

## Q MENU BACKGROUND

Some X Series models give you the option to use either a black or transparent background in the Q Menu. On the X-Pro 3, this is found in BUTTON/DIAL SETTINGS.

## BUTTON/DIAL SETTING MENU

The X Series camera operation can be configured in a number of ways, and this menu controls how each button and dial acts, and in some cases, it assigns secondary functions to certain controls like the command dials.

For RED/BLUE menu cameras, you'll find most of the button/dial settings in the BLUE MENUS.

## FOCUS LEVER SETTING

With this function, you can lock the focus lever joystick. To lock the stick, **press and hold the stick for about two seconds** until you see the menu come up.

Select **LOCK (OFF)** to lock the joystick and prevent it from performing any focus functions. With this set, you will no longer be able to select or move your focus points. The current focus point will remain wherever you left it before you locked the lever. **You can still use the lever to navigate through menus and scroll through your photos.**

**To unlock, simply press and hold again, then select ON.** (The middle option unlocks it as well.) Now you're back in business.

If, for some strange reason, you find that the focus lever is stuck and it won't allow you to select or move focus points, it means your lever is locked. Again, just press and hold to bring up the unlock option.

This setting is obviously limited to the X-T2, X-Pro2, and X100F.

## EDIT/SAVE QUICK MENU

This is the official menu setting that allows you to configure your Q menu. However, you already know that you can simply press and hold the Q button in order to get there much more quickly. I don't ever want to see you going into the BUTTON/DIAL SETTING menu in order to add a setting to your Q menu. Got it?

7.16

At any rate, these are all of the settings you can add to the Q menu. The asterisk denotes settings that can be saved to your CUSTOM SETTINGS bank as well. On all current models after the X-T3/30, you can set up two different Q Menu layouts, one for still photography and one for movie mode.

- IMAGE SIZE
- IMAGE QUALITY
- FILM SIMULATION *
- GRAIN EFFECT *
- DYNAMIC RANGE *
- WHITE BALANCE *
- HIGHLIGHT TONE *
- SHADOW TONE *
- COLOR *
- SHARPNESS *
- NOISE REDUCTION *
- SELECT CUSTOM SETTING *

- AF MODE
- AF-C CUSTOM SETTINGS
- FACE/EYE DETECTION SETTING
- MF ASSIST
- SELF-TIMER
- SHUTTER TYPE
- FLASH FUNCTION SETTING
- FLASH COMPENSATION
- MOVIE MODE
- MIC LEVEL ADJUSTMENT
- EVF/LCD BRIGHTNESS
- EVF/LCD COLOR

# FUNCTION (FN) SETTING

This menu item allows you to set up all of your Fn buttons, as well as your AE-L and AF-L/AF-ON buttons. Again, you know a much faster way to assign your Fn buttons, so I don't ever want to catch you skulking around in this dark corner of the camera menu. Press and hold the DISP/BACK button instead. Note: On previous models this is called Fn/AE-L/AF-L BUTTON SETTINGS.

If **AF-ON** is assigned to a button, you can activate back-button autofocus by pressing that button instead of keeping the shutter button pressed halfway.

If **MODELING FLASH** is assigned, you can press that FN button to test-fire the flash.

If **TTL-LOCK** is assigned, you can press that button to lock flash output according to the option selected for **FLASH SETTING.** (Read more about TTL-LOCK MODE in *Chapter 5: Flash Settings*.)

The current X Series models all have over 70 possible Fn settings. Here's a partial list. Refer to your camera for an exact list.

- IMAGE SIZE
- IMAGE QUALITY
- RAW
- FILM SIMULATION
- GRAIN EFFECT
- COLOR CHROME EFFECT
- COLOR CHROME FX BLUE
- DYNAMIC RANGE
- D RANGE PRIORITY
- WHITE BALANCE
- CLARITY
- SELECT CUSTOM SETTING
- FOCUS AREA
- FOCUS CHECK
- AF MODE
- AF-C CUSTOM SETTINGS
- FACE SELECT EVF
- FACE DETECTION ON/OFF

- AF RANGE LIMITER
- FOCUS CHECK LOCK
- DRIVE SETTING
- SPORTS FINDER MODE
- PRE-SHOT ES
- SELF-TIMER
- PHOTOMETRY
- SHUTTER TYPE
- FLICKER REDUCTION
- ISO AUTO SETTING
- IS MODE
- CONVERSION LENS
- ND FILTER
- MULTI EXPOSURE
- WIRELESS COMMUNICATION
- FLASH FUNCTION SETTING
- TTL-LOCK
- MODELING FLASH

- FULL HD HIGH SPEED REC
- FIX MOVIE CROP MAGNIFICATION C
- IS MODE BOOST
- ZEBRA SETTING
- INTERNAL/EXTERNAL MIC LEVEL ADJUSTMENT
- MOVIE OPTIMIZED CONTROL
- PREVIEW DEPTH OF FIELD
- PREVIEW EXP./WB IN MANUAL MODE
- NATURAL LIVE VIEW
- HISTOGRAM
- ELECTRONIC LEVEL
- LARGE INDICATORS MODE
- F-Log VIEW ASSIST
- AE LOCK ONLY
- AF LOCK ONLY
- AE/AF LOCK
- AF-ON
- AWB LOCK ONLY
- APERTURE SETTING
- LOCK SETTING
- PERFORMANCE
- AUTO IMAGE TRANSFER
- SELECT PAIRING DESTINATION
- Bluetooth ON/OFF
- QUICK MENU
- PLAYBACK
- NONE (control disabled)

## SELECTOR BUTTON SETTING

This is an important setting for older cameras that don't have the AF/Selector Joystick. On those models, you might want to use the four thumb pad buttons as AF AREA selection buttons.

The default setting for the bottom thumb pad button is AF AREA, but some photographers prefer to have all four buttons operate as AF AREA buttons. With this in mind, Fuji gives you two options for assigning the four thumb pad buttons on the back of the camera:

- **Fn BUTTON:** This allows all four thumb pad buttons to operate as assignable Fn buttons. In this case, the bottom button still operates as the AF AREA selector button, although you can change this if you wish (not recommended).

- **FOCUS AREA:** This turns all four thumb pad buttons into Focus Area selection buttons. If you want the fastest, most intuitive method for selecting your AF area, you might consider this option. However, you will lose the ability to assign them as Fn buttons.

# COMMAND DIAL SETTING

This menu allows you to set up how your command dials operate. You can either set it so the front dial controls aperture while the rear dial controls shutter speed, or you can swap it and have the front dial control shutter speed with the rear controlling the aperture.

This is totally up to you. Whatever feels most comfortable or familiar. If you recently switched from another system like Nikon or Canon, you may already have a method that you're used to. In that case, you may want to set up your Fuji to match what you're used to for the most seamless transition.

**On all of the X-H models, this setting does something totally different.** These cameras all have fixed functions for the front and rear command dials that vary depending on which exposure mode you're using, and this setting allows you to customize and reverse the roles that the two dials control for each of the four modes.

**P:** Reverse the dials use for program shift and EV+/- when in Program mode.

**S:** Reverse the dials used for shutter speed and EV+/- when in Shutter Priority mode.

**A:** Reverse the dials used for aperture and EV+/- when in Aperture Priority mode.

**M:** Reverse the dials used for shutter speed and aperture when in Manual mode.

# SS OPERATION

This setting is used in MY MENU cameras only. When shooting in Program mode, you can use the shutter speed dial to fine-tune your settings.

For example, let's say you're in Program mode and you suddenly see an action scene unfolding in front of you; maybe it's a bald eagle about to take off, or your energetic kids or grandkids running around with a puppy. Putting the camera to your eye, you might notice that the camera is set with a shutter speed/aperture combination of 1/320 sec. at f/5.6.

You might decide that 1/320 sec. might not be fast enough to freeze the action, especially if you're using a long lens, which requires a higher shutter speed to ensure sharp images.

With this setting **ON**, you can simply grab whatever command dial you have set to control shutter speed and adjust to a more suitable combo, say, 1/1250 sec. at f/2.8. This will freeze the bird for sure. (I prefer to keep SS set to the rear dial.)

**7.18**

Keep in mind, your available shutter speeds in Program mode are limited by available light and your current ISO setting. You can only choose a range of shutter speeds that will still give you an acceptable exposure.

You can also turn this setting **OFF**, but given what it can do for you, I don't see why you would want to. **I recommend keeping it ON.**

## ISO DIAL SETTING H/L

This setting allows you to set the sensitivity of the H and L settings on the ISO dial. It's found on the X-T2 and X-Pro2 only. The X100F has ISO DIAL SETTING H only.

- For H, you have two choices: 25600 and 51200.
- For L, you have three choices: 100, 125, and 160.

# ISO DIAL SETTING A

Found only on the X-T2, this control determines how you select your ISO when the ISO dial is set to A. In the normal **AUTO** setting, the camera will choose the ISO automatically, based on your current Auto ISO setting.

However, if you switch to **COMMAND** and set the ISO dial to A, **you can now adjust ISO with your front command dial**. Press the dial to unlock this feature and rotate to scroll through your entire ISO range. Press again to lock the dial.

Note: In Program, Shutter Priority, or Manual mode, **pressing the command dial toggles between adjusting shutter speed and ISO.** If you're shooting in Manual using T mode, you can adjust shutter speed through the entire range.

I really like this feature because it allows an even greater amount of efficiency with the camera. With both shutter speed and ISO at your fingertips (and the aperture ring in the fingertips of your other hand), you can easily adjust any of your main exposure settings with ease...and without taking your eye away from the viewfinder.

To me, a setting like this clearly demonstrates Fuji's commitment to not only provide you with multiple ways of controlling your camera, but also to design the most ergonomically friendly cameras possible.

# SHUTTER AF/SHUTTER AE

This is another interesting setting, which was made even more powerful with one of the recent firmware updates. It's only available on the X-T2, X-T20, and X-E3.

Normally, when you press the shutter button halfway down, the camera automatically locks in exposure and focus. With the SHUTTER AF/AE settings, you can decouple one or both of these functions and even set different operational behavior for both AF-S and AF-C mode.

To clarify, in AF-S mode, the camera focuses when the shutter is pressed halfway and locks focus for as long as you hold the button in this position. In AF-C mode, focus is continually adjusted while the shutter button is pressed halfway.

## Shutter AF

Using this setting, you can keep the default **ON** setting for one or both, you can turn them both **OFF** and disable autofocus from the shutter button, or you can set a separate setting for AF-S and AF-C.

**7.19**

**7.20**

For example, if you set AF-S **ON** and AF-C **OFF**, the camera would focus and lock when you press the shutter in AF-S mode, but if you switch to AF-C mode and press the shutter, no focus operation would occur. (This is how you decouple the shutter button if you use back-button focus on the X-T2.)

## Shutter AE

Just as with SHUTTER AF, with SHUTTER AE you can assign different operational parameters for how and when the camera locks exposure when you're using AF-S/MF or AF-C mode.

Setting either to **ON** tells the camera to lock exposure when the shutter button is pressed halfway down. Setting one or both to **OFF** tells the camera to continually adjust exposure, even when the shutter button is pressed halfway.

Here's how I see this setting coming in handy in a real-life shooting situation. Let's say you and I are standing next to each other while shooting a peloton of bikers racing through

**7.21**

an area of both sunlight and shadow (see Figure 7.21). Or maybe we're out on the Serengeti shooting a dazzle of zebras. We're both shooting in Continuous and using AF-C so we can track the subjects' motion and ensure sharp focus.

I'm not a back-button focus guy, so I keep AF-C set to **ON** in SHUTTER AF. However, you're a back-button focus shooter, so you set AF-C to **OFF** in SHUTTER AF on your X-T2.

You've got your eye on a few key locations where you want to capture the subjects, and they all happen to be in the sunlight, while I'm grabbing shots left and right as they pass through the entire scene. (It sounds like you're a much more selective shooter than I am!)

Since you're not worried about locking exposure in one kind of light and then shooting in another, you keep your AF-C set to **ON** in SHUTTER AE. I, on the other hand, want to make sure my exposure doesn't lock on a sunny patch right before I shoot a burst as they bike from sun to shade. To prevent this from happening, I set my AF-C to **OFF** in SHUTTER AE mode.

These settings allow each of us to configure our X-T2s in the way that matches our own shooting styles, which, of course, helps us nail our shots. Great job!

## SHOOT WITHOUT LENS

This setting enables the shutter to release when there is no lens attached to the camera. Or rather, when there is no lens that contains electronic contacts that talk to your Fuji camera. Like a Lensbaby lens, or if you're using a Nikon, Canon, Leica, or any other third-party lens on your camera with an adaptor.

I've seen people use all kinds of lenses on their Fujis. Two years ago I met a portrait photographer in Little Rock, AR, who had a little leather bag full of archaic glass from the '70s and '80s; we're talking really obscure lenses made in Russia, Germany, and Japan. He used them on his X-T1 with a variety of adaptors and they worked great. His images were awesome and tack sharp.

My friend Josh uses an old manual-focus Canon 200mm f/4 FD lens on his X-T1 with excellent results. That lens is razor sharp, very fast, and quite small. I've used a couple different Lensbaby lenses on my Fuji, and they're a lot of fun.

If you've got an old lens and the right adaptor, just make sure you turn the SHOOT WITHOUT LENS option **ON** or it won't work.

RED/BLUE camera users will find this setting in the RED MENUS.

## SHOOT WITHOUT CARD

Sometimes you just want to test a camera or lens, or try out a new setting, but you don't have a memory card in the camera. (I'll just say right now that **you should always keep a memory card in the camera!**)

Should you find yourself sans card, you can turn this function **ON** to enable the shutter to release. In the default **OFF** mode, the shutter remains locked.

# FOCUS RING

If you're coming from another camera system where the focus rings turn the other way and you just can't get used to the direction the Fuji cameras use, or if you just want to swap to the other direction, you can use this setting to set whether your camera focuses near-to-far in clockwise or counterclockwise rotation.

I keep mine at the default setting.

# FOCUS RING OPERATION

This setting lets you choose how the focus ring operates when using manual focus.

**NONLINEAR** focusing changes focusing distance based on how fast you turn the focusing ring. This is the default mode with most X Series lenses, and with most digital photography lenses. Also called "Fly-by-wire" focusing, the movement of the focusing ring is measured electronically, and then the elements are moved by the internal motor.

**LINEAR** focusing feels more like you're using an old manual-focus lens. Focus distance changes according to how far you turn the ring, regardless of how fast you turn it.

Note: The three Fuji "Clutch Lenses"—the 14mm f/2.8, 16mm f/1.4, and 12mm f/1.4— all have fixed focus ranges, so they already feel somewhat like older manual lenses when using manual focus.

On the new fifth-generation models, this is called LENS ZOOM/FOCUS SETTING and it allows you to control the operation of both focus and zoom. You can also set the speed and direction of focus and zoom when using a compatible power zoom lens with an Fn button.

- **MF CONSTANT SPEED FOCUS (Fn):** Choose the rate of focus distance change when adjusted with Fn buttons during manual focus.

- **CONSTANT SPEED ZOOM (Fn):** Choose the rate of zoom when adjusting with an Fn button.

- **CONSTANT SPEED ZOOM/FOCUS (Fn) OPERATION:** Choose whether the Fn button needs to be pressed once or twice to start and stop focus or power zoom. With the START/STOP option, you press once to start focus/power zoom, and press again to stop. With PRESSING, press and hold the Fn button to start focus/power zoom, and release to stop.

- **ZOOM RING ROTATE:** Choose clockwise or counterclockwise for zoom ring rotation.

- **ZOOM/FOCUS CONTROL RING:** Choose the role played by the zoom/focus control ring on compatible power zoom lenses.

## CONTROL RING

Both the X100F/V and the X70 feature a Control Ring on the front of the camera, right in front of the aperture ring. This menu item controls the function of the Control Ring. For each setting, you simply scroll through your options, and once you land on your desired setting, just leave it there. You don't have to select it or do anything else.

Here are your options:

- **DEFAULT:** Changes based on which mode you're currently using.
- **WHITE BALANCE:** Scroll through the different WHITE BALANCE settings.
- **FILM SIMULATION:** Scroll through the different FILM SIMULATION choices.
- **DIGITAL TELE-CONV:** This gives you different view angles: 35mm, 50mm, and 70mm. Essentially, it's just cropping and enlarging the image, but there's some image optimizing going on as well. Given the sharpness of the X-Trans sensor and the capabilities of the image processor, you'll find the results to be very good.

## AE/AF-LOCK MODE/AWB-LOCK MODE

This is a very interesting setting, but I would imagine very few people even know it exists. I'll confess I just learned about it while writing this book and playing around with my X-T2, although it's found on most models. Keep in mind, you need to have your AE-L/AF-L buttons set to AE LOCK ONLY and AF LOCK ONLY for this to work.

If you set this function to **AE & AF ON WHEN PRESSING**, your exposure and/or focus will lock when you press the **AE-L** or **AF-L** button, and it will hold for as long as you keep pressing the button.

However, if you set the camera to **AE & AF ON/OFF SWITCH**, exposure and/or focus will lock when the **AE-L** or **AF-L** button is pressed and it will remain locked until you press the button again.

I see **SWITCH** mode as being a pretty handy setting. You could set up a Fn button as your AE LOCK ONLY control, and then meter on your subject. Once you dialed

**7.22**

in a good exposure, you could press AE-L to lock it in and then take your finger off the button.

This would free you to compose your scene, concentrate on the subject matter, and perform autofocus duties, all while not worrying about your exposure because it's locked in and hands-free. It stays locked, even after you press the shutter once or 100 times. As long as your light doesn't change, you're golden. If the light changes, press the button and take another meter reading, and you'll be golden once again.

Maybe you're shooting a static subject in changing light. You could do the same thing with AF-L instead of AE-L. Press to lock in focus, then constantly monitor exposure as you shoot.

**PRESSING** mode works the same way, only you have to keep holding the button down. Like many other settings, this comes down to personal preference. Get to know this setting and see if it might work for you. **NOTE:** Some models have a menu setting called AWB-LOCK MODE. If you have an Fn button set to AWB-LOCK, you can do the same thing with White Balance.

7.23

## APERTURE SETTING

Most but not all of the Fuji lenses have aperture rings. Here's how to adjust the aperture when your lens has no ring.

Since I own the little pancake 27mm f/2.8 lens, I know firsthand that it can be quite confusing to figure this out in all the shooting modes. On RED/BLUE cameras, this setting is found in one of the RED MENUS.

- **AUTO+MANUAL:** Choose the aperture via the front command dial. Rotate past your minimum (largest number) aperture to set the lens to A (Auto aperture).

- **AUTO:** The camera selects the aperture automatically. In this mode, the camera functions in **P** (Program) and **S** (Shutter Priority) modes only.

- **MANUAL:** Choose the aperture via the front command dial. In this mode, the camera functions in **A** (Aperture Priority) and **M** (Manual exposure) modes only.

# PLAYBACK ISO BUTTON SETTING

Found only on the X-H2 and X-H2S, this setting allows you choose the role for your ISO Button during Playback.

- **SMARTPHONE TRANSFER ORDER:** Select pictures for upload to your mobile device.

- **FTP TRANSFER ORDER:** Mark current picture for upload to an FTP server.

- **FTP PRIORITY TRANSFER ORDER:** Mark picture for priority upload to an FTP server.

- **WIRELESS COMMUNICATION:** Enable button for Wireless Communication.

Note: **FTP TRANSFER ORDER** and **FTP PRIORITY TRANSFER ORDER** can only be used with the optional Fujifilm FT-XH file transmitter.

# TOUCH SCREEN SETTING

All recent X Series models are touch-screen capable, and this setting is where to turn your touch-screen controls **ON** or **OFF** and control which touch functions are active.

- **TOUCH SCREEN SETTING:** Enables the LCD monitor for touch-screen shooting.

- **DOUBLE TAP SETTING:** Double-tap on the LCD to zoom in on subject while shooting.

- **T-FN TOUCH FUNCTION:** Enables touch-function swipe gestures.

- **PLAYBACK TOUCH SCREEN SETTING:** Enables LCD touch functions during playback.

- **EVF TOUCH SCREEN SETTING:** Choose which area of the monitor is used for touch-screen operation when your EVF is active. This allows for a very precise and individual feel that adapts to the way your hands and fingers naturally operate when you're holding the camera up to your face, or you can set it so that the touch screen is disabled when you're looking through the viewfinder.

Note: The X-T30 and X-E3 have only **TOUCH SCREEN ON/OFF** and **EVF TOUCH SCREEN SETTING.**

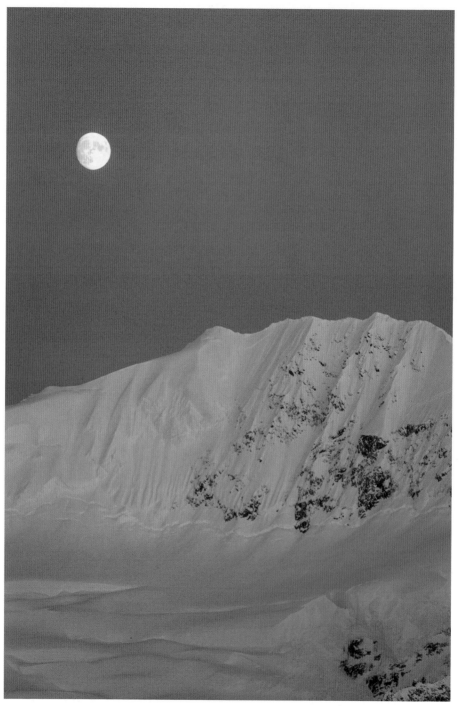

**7.24**

# LOCK

You can lock the camera to prevent accidental changes to any of your camera settings, by you or any other person who might inadvertently or purposefully hit a button and mess up the amazing shot you've got lined up.

These are the Lock settings:

- **UNLOCK:** This resets your lock functions.

- **ALL FUNCTION:** This locks all controls in the FUNCTION SELECTION list, including all of the Fn buttons, the Q menu button, the DISP/BACK button, the focus stick, the rear command dial, and a number of different modes and menu items.

- **SELECTED FUNCTION:** This locks only the controls selected in your FUNCTION SELECTION list. After selecting this setting, jump down to FUNCTION SELECTION and choose which functions you'd like to lock.

- **FUNCTION SELECTION:** This is the list of all the functions you can lock. If you choose SELECTED FUNCTION above, you then go here to choose all the functions you wish to lock.

In addition to these menu controls, **you can lock the Q menu and all four thumb pad buttons** by pressing and holding the MENU/OK button for about five seconds. Press and hold the MENU/OK button again to unlock.

I can think of any number of scenarios where you'd want to lock one or more functions. I've certainly changed the occasional setting by accident without realizing it until later. It might take some thought as to how you can make the most of this setting, but it could be time well spent.

## POWER MANAGEMENT MENU

The Power Management menu is where you access the features that help you increase (or decrease) your battery life, as well as improve performance with your AF settings and LCD/EVF refresh rate.

## AUTO POWER OFF

One way to increase battery life is to set the camera to turn off after a specified amount of down time. Your choices are **15 sec, 30 sec, 1 min, 2 min,** and **5 min.** If you select **OFF**, the camera will remain on until you turn it off manually. Or until the battery dies.

7.25

# PERFORMANCE

Most recent Fuji cameras have two power modes, **NORMAL** and **BOOST**. (On the X-T20, it's NORMAL and HIGH PERFORMANCE.) Some models have a third setting called **ECONOMY**.

In **ECONOMY** mode, the camera functions with a slightly lower level of AF speed and viewfinder display performance in order to conserve battery life.

In the default **NORMAL** mode, the camera functions with a normal level of AF speed and viewfinder display quality, with a viewfinder refresh rate of 60 fps.

In **BOOST** mode, the camera functions with a higher AF speed, and display quality increases with a viewfinder refresh of 100 fps (120 fps on the X-T4 and XH2/XH2S). As is to be expected, this mode causes faster battery drain.

Note: BOOST Mode on the X-T2 is only achieved with the use of the dedicated battery grip. The X-T3, X-T4, and new X-H models also have optional vertical battery grips, but they're designed only for extra batter power and longer video shooting. Even without the grip, these high-end models will still fire at their maximum frame rates, as does the X-T5, which has no grip available.

# EVF/LCD BOOST SETTTING

This is found on the X-T4, X-S10, and fifth-generation models only. This setting adjusts the behavior of the EVF/LCD when you are using BOOST Mode.

- **EVF/LCD LOW LIGHT PRIORITY:** The display brightness is automatically adjusted so it's easier to see dimly lit subjects when shooting in low light. In some cases, moving/blurred subjects may cause ghosting.

- **EVF/LCD RESOLUTION PRIORITY:** The display resolution is automatically increased to better show details.

- **EVF/LCD FRAME RATE PRIORITY:** The refresh rate of the EVF is increased, giving a smoother view of moving subjects.

# EVF PERFORMANCE

Some models, including the X-Pro 3 and X100V, have this setting, which allows you to select whether the EVF prioritizes **BRIGHTNESS** or **SMOOTHNESS** in the display. BRIGHTNESS is the default setting for use in most situations. SMOOTHNESS minimizes ghosting, which may appear in the EVF when shooting moving subjects.

# AUTO POWER OFF TEMP.

On the X-T4 and some fifth-generation models, the camera will display a warning message if the operational temperature reaches a certain point. If temperature keeps rising, the camera will shut down automatically. This setting allows you to choose a temperature range—either **NORMAL** or **HIGH**—that triggers the camera to turn off.

Keep in mind that when shooting at HIGH temperatures, the camera itself can become quite hot. It is highly advisable to use a tripod or other mount when doing prolonged shooting in these situations.

## SAVE DATA SETTING MENU

The SAVE DATA SETTING menu is where you go when you need to access or change your file management settings.

# FRAME NUMBER

The X Series cameras use a four-digit sequential naming convention. The FRAME NUMBER setting controls whether the file numbering is reset to 0001 when you insert a new memory card.

- **SEQUENTIAL** mode continues from the last file number used or the first available file number, whichever is higher. You should probably use this setting to prevent having pictures with duplicate file names.

- **RENEW** resets the file numbering to 0001 each time you format or insert a new memory card.

Note: If you're using **SEQUENTIAL** mode, eventually, your file numbers will hit 999–9999. When that happens, the shutter button will be disabled. Turn off the camera and insert a formatted memory card before you resume shooting.

## SAVE ORG IMAGE

This option allows you to save unprocessed copies of pictures taken using **RED EYE REMOVAL**. I've never used the RED EYE REMOVAL function, so I don't really have anything to add here.

## EDIT FILE NAME

The Fuji cameras attach two different file name prefixes to photos, depending on whether they're taken in the sRGB or Adobe RGB color space. sRGB uses a four-letter prefix, while Adobe RGB uses a three-letter prefix containing an underscore at the beginning:

- **sRGB prefix:** DSCF
- **Adobe RGB prefix:** _DSF

While you can't remove the underscore, you can change the default prefix to any alphanumeric combination you want.

7.26

For example, you could change it and get custom file names for your image files:

- **sRGB:** DANB0001
- **Adobe:** _DHB0001

I recommend setting your own file names. It helps you quickly identify your own images or images shot with different cameras. You could create prefixes denoting, say, a country, or a year. The opportunities are endless. Imagine the possibilities. I can hear your little brain wheels turning already.

## CARD SLOT SETTING (STILL IMAGE)

If you have a camera with two memory card slots, you have three options for how you store your images:

- **SEQUENTIAL** writes to the first slot, then switches to the second slot when the first card is full.
- **BACKUP** writes the same image to both cards at the same time.
- **RAW/JPEG** works just like SEQUENTIAL, unless you're shooting in RAW+JPEG. In this mode, it stores the RAW on card #1 and the corresponding JPEG on card #2.

7.27

One important note: As I cover in the "Zooming" section in the next chapter (page 282), you can press the rear command dial or double-tap the LCD screen to zoom in and check for sharpness at 100%. (On the X-T1, you press the Focus Assist button to zoom during playback.) Note that if you're shooting RAW only, you will not be able to zoom to full size, but if you're shooting JPEG or RAW+JPEG, you can.

However, in order to view your zoomed images at full size, you must store your RAW and JPEG files on the same card. So, using the **RAW/JPEG** setting in this menu will not give you the maximum benefit.

## So, Which Method Should You Use?

I'm pretty confident in my memory cards, so **I use SEQUENTIAL**. Plus, with a pair of fast, high-GB cards, this gives me an enormous amount of storage before I have to change cards.

BACKUP is obviously nice if you need immediate backup, like when you're on assignment, or if you just want duplicate cards for some reason.

RAW/JPEG can be handy when traveling, because you can quickly access and share your JPEGs from the second card without having to deal with or wade through all the RAW files. This is even more critical if you're downloading your cards directly to an iPad or other tablet that has limited storage.

However, there's one thing about the RAW/JPEG approach you should be aware of. RAW files are obviously way bigger than the JPEGs, so you'll fill up card #1 a whole lot faster. When that happens, you won't be able to take any more pictures until you change cards.

This means you'll be writing RAWs to the new card, but you'll continue to write JPEGs onto the second card, since it wasn't full yet. This creates a situation where your cards are no longer identical. It's no longer a true backup situation, if this was your intention in using this setting.

This could be a problem for organization if you like to keep your cards identical. On the other hand, you'll have fewer JPEG cards.

## SWITCH SLOT

If you have your cards set to **SEQUENTIAL**, this menu item lets you view the pictures on the other card, provided you're using both memory card slots.

Double-clicking on the joystick or holding down the PLAYBACK button when playing images does the same thing. Please read the other "Switch Slot" section in chapter 8 (page 286) to learn some important information about how this function works.

## MOVIE FILE DESTINATION

This option lets you designate which card is used to store your video files—either SLOT 1 or SLOT 2, if you have a second slot. This doesn't really matter, unless one of your memory cards is a fast UHS-II card. Then you should use that one.

## SELECT FOLDER

All recent X Series cameras allow you to create and name different folders on your memory card, and choose where to store subsequent pictures. This can help you organize and more quickly identify groups of photos when viewing the contents of your memory card on your computer.

**7.28**

For example, if you're traveling, you might create a new folder when you enter a new city. If you're doing a big portrait shoot, you could create a folder for each model. You could simply create a folder for each day of shooting or to group together any kind of subject or shooting parameter you can think of.

When transferring photos into Lightroom, you'll be able to see the folder structure in the Import pane and copy each folder individually. While the SELECT FOLDER setting can certainly help you organize your images, don't feel as if you have to do this. It makes things more simple if you don't, because what happens if you cross a border and forget to create a new folder?

Some older models allow you to store up to 999 images in each folder. All recent models allow you to store up to 9,999 images in a folder.

## COPYRIGHT INFO

You can set your camera to record copyright information into the EXIF data for your images.

The menus here are pretty self-explanatory. You can enter both **COPYRIGHT** and **CREATOR** name, if they're different, and you can set it to delete the info as well.

I recommend entering your **COPYRIGHT** info, which is usually your name. It's always a good idea to have your name attached to your image files.

## DEFAULT CAPTION

The new fifth-generation models allow you to enter, edit, and display captions for photos and movies.

## CONNECTION SETTING MENU

All current X Series cameras have Bluetooth, which allows you to control the camera and shoot remotely, as well as transfer images to your paired device via Bluetooth by using the FUJIFILM CAM REMOTE app for iOS and Android.

You can even set this up for automatic transfer of images after you take them. This allows for a continuous and low-power connection between your camera and your device so you don't have to keep connecting to Wi-Fi and opening the app.

The new fifth-generation models have all of their connection settings in a separate menu below the "Wrench" menu called **NETWORK/USB SETTING**. On those cameras, you can even set up multiple connection profiles for connection to different wireless devices, and you can use the optional FT-XH File Transmitter to do remote/tethered shooting, control multiple cameras, or upload pictures to an FTP server or wireless LAN network.

If you have an older, non-Bluetooth X Series camera, the order and location of these settings will be arranged a little differently, but most features are still available to you. Refer to the GENERAL SETTINGS Menu to read the descriptions of the applicable settings.

**7.29**

# BLUETOOTH SETTINGS

- **PAIRING REGISTRATION:** Use this setting to pair your Bluetooth-enabled Fuji with your smartphone or tablet. Select this option, then open the FUJIFILM Camera Remote app on your device and tap to connect. When your device is successfully paired, you'll see the little Bluetooth icon on your LCD screen.

- **SELECT PAIRING DESTINATION:** Choose a connection from a list of devices that have previoulsy been paired to the camera. Select NO CONNECTION to exit without pairing.

- **DELETE PAIRING REG.:** This terminates your Bluetooth pairing and removes the selected device from the **SELECT PAIRING DESTINATION** history.

- **BLUETOOTH ON/OFF:** With this setting **ON**, your camera will automatically connect with your paired devices when you turn it on. **OFF** will prevent it from connecting via Bluetooth.

- **AUTO IMAGE TRANSFER:** With this setting **ON**, photos will be marked for upload, and they'll be instantly transferred to your device as soon as you enter Playback mode (or if you turn the camera off without playing them back). If this is set to **OFF**, images won't be transferred automatically, but you can still select and upload them using the IMAGE TRANSFER ORDER feature in the PLAYBACK MENU.

- **SMARTPHONE SYNC. SETTINGS:** Choose whether to synchronize the camera to the time and/or location provided by your smartphone.

# NETWORK SETTINGS

This item allows for connection to wireless networks. (Not all models have this capability.) I have not tried connecting my camera to my computer, so I can't give you any input on what to do once you've connected. Using the **WIRELESS ACCESS POINT SETTING** option, you can connect automatically, or you can manually configure the connection. **WIRELESS IP ADDRESS SETTING** allows you to view or assign your camera's IP address.

# PC AUTO SAVE SETTING

This sets your upload destination when using the PC AUTO SAVE function in the PLAYBACK MENU to save photos to your computer.

Select **SIMPLE SETUP** to connect using WPS, or **MANUAL SETUP** to configure your network settings manually.

## GENERAL SETTINGS

Found only on older models, this menu item is how you can adjust your settings for connecting your camera to your mobile device.

## INSTAX PRINTER CONNECTION SETTING

This is where you set up your connection to an INSTAX printer.

**PRINTER NAME and PASSWORD:** The first time you use the printer, open this menu and copy the printer name (SSID) to your camera. Press **OK** and then enter the password. (The default password for INSTAX Printers is "1111.") Or enter your chosen password if you've used a different one to print from your smartphone.

Once you've got this set up, you won't need to come back to this menu again. You're ready to print!

7.30

# USB POWER SUPPLY SETTING

The newest models have this setting, which allows you to specify whether the camera draws power when connected to a computer or other device via a USB cable. When set to **ON**, the camera draws power from the device, allowing it to charge the battery. Note: The camera cannot draw power from a lightning cable connection if the connected device is not powered.

# CONNECTION MODE

Formerly called PC SHOOT MODE or PC CONNECTION MODE, this is where you adjust settings for tethered shooting, or backup/restore camera settings. Not all cameras have all settings.

This is also where you'll establish connection with your computer to use FUJIFILM X RAW STUDIO conversion software for Mac and Windows. It's available for free at the FUJIFILM website and is compatible with all current and recent models, and the GFX.[15]

**USB CARD READER:** Choose this option if you do not intend to use tethered shooting. Images you shoot will be stored to your memory card. This setting used to be called **OFF**.

**USB TETHER SHOOTING AUTO:** Tethered shooting mode is selected automatically when the camera is connected to a computer via USB. If there is no computer connected, the results are the same as USB CARD READER. This mode is also used to control your camera from gimbals, drones, and other remote USB devices if you use the X-T3 and later, or it allows you to use your X Series camera as a webcam with FUJIFILM X Webcam Software for things like Zoom and Skype conferences.

**USB TETHER SHOOTING FIXED:** The camera functions in tethered shooting mode even when not connected to a computer. At the default settings, pictures are not saved to the memory card. However, pictures taken while the camera is not connected will be transferred to the computer when it is finally connected.

**WIRELESS TETHER SHOOTING FIXED:** Choose this option for wireless remote photography, and select your network using the Network Settings menu item. Please visit the FUJIFILM website for more information about wireless tethered photography with the X-T2.[16]

When shooting tethered, make sure you set the **AUTO POWER** option to **OFF** in the **POWER MANAGEMENT** menu. This will prevent the camera from turning off in the middle of your shoot.

Tethered shooting is available with HS-V5 software for Windows (available separately)[17], FUJIFILM X Acquire (available for free download from the FUJIFILM website)[18], or when the FUJIFILM Tether Shooting Plug-in PRO or Tether Shooting Plug-in (both available separately)[19] is used with Adobe Photoshop Lightroom.

**USB RAW CONV/BACKUP RESTORE:** This setting allows you to use FUJIFILM X RAW STUDIO to perform RAW conversions directly from the camera. The software uses the image processor inside your X-T2, X-Pro2, or X100F to perform the conversions instead of your computer's CPU.

It's just like performing RAW conversions inside the camera, and in fact, the interface is basically a reproduction of the in-camera RAW conversion menu. The options are very basic, and although it's not nearly as full-featured as programs like Lightroom or Luminar, it does give you 100% accurate reproductions of the Fuji FILM SIMULATION colors like no other software can.

## BACKING UP YOUR CAMERA SETTINGS

The **USB RAW CONV/BACKUP RESTORE** option also allows you to back up and restore your X-T2 settings via USB cable using the FUJIFILM X Acquire app. It's a free app for both Mac and Windows. This is a great feature, since your settings and MY MENU slots can be erased with some firmware updates or if you have your camera serviced. This can also be used to copy settings from one camera to another.

## RESET WIRELESS SETTINGS

This lets you restore all your wireless settings to default parameters.

## FIFTH-GENERATION CONNECTION SETTINGS

As previously noted, the new fifth-generation models, including the X-H2, X-H2S, and X-T5, have a separate menu called **NETWORK/USB SETTING**, which is where you'll find most of the connection settings described above.

The following sections describe the items that appear in the NETWORK/USB SETTING Menu that are not described above.

## Create/Edit Connection Setting

This is where you pair your camera and establish a connection to your phone/tablet or other network/USB devices, like USB card readers, webcams, or INSTAX printers. You may also connect your camera to another device to do tethered shooting or to perform **USB RAW CONV/BACKUP RESTORE**. In this menu, you can also create and choose from up to eight connection profiles to different LAN devices for quick recall/transfer.

## Select Connection Setting

Once you have paired your device and set up your connections, you can choose between the different profiles here, which are the same as those found inside the Connection Mode Menu above.

## Airplane Mode

Select ON to disable the camera's Bluetooth and wireless LAN features.

## Bluetooth/Smartphone Setting

Select the functions as described in the Bluetooth Settings menu above.

## FTP Optional Setting

Adjust settings for FTP upload. To perform FTP upload, you will need to use the optional FT-XH File Transmitter. You can select images for AUTO IMAGE TRANSFER, choose the types of image/movie files that will be uploaded to the FTP server, apply captions to photos and movies during upload, pause or resume FTP upload, select whether the camera will continue to transfer when powered off, or turn the FT-XH off when all currently marked pictures have been uploaded.

See this page for information about file transfer using the FT-XH File Transmitter: https://fujifilm-dsc.com/en/manual/x-h2_connection/overview_usage/ftp_upload/index.html#ftp_transfer_option.

## USB Power Supply/Comm Setting

This allows you to choose whether USB connections to computers or other devices are used for power during data transfer. **AUTO** switches between power deliver and data transfer automatically. **POWER SUPPLY ON/COMM OFF** allows the camera to

**7.31**

draw power from the connected device, which reduces drain on the camera battery, and data transfer is disabled. **POWER SUPPLY OFF/COMM ON** allows the camera to change data with the connected device, but it won't draw power from that device.

Note: The camera cannot draw power from lightning connections that don't supply power. For connection to these devices, choose **POWER SUPPLY OFF/COMM ON** for connection and transfer to un-powered mobile devices.

## Information

Here you can view network-related settings. **HARDWARE INFO** shows you the camera's network IP information. **FTP TRANSFER ORDER STATUS** displays the destination and upload progress to the FTP server when used with the FT-XH File Transmitter. **ERROR DESCRIPTION** displays errors when the camera is unable to connect to the file transmitter.

## Reset Network/USB Setting

Use this to reset all network/USB settings to the default values.

# PLAYBACK MENU

The X Series cameras give you a wide range of options for viewing, storing, editing, processing, annotating, presenting, and sharing your images. In this chapter, we'll cover the PLAYBACK MENU items, but I'll begin with basic operation of the controls.

## BASIC OPERATION

First things first: the PLAYBACK button!

### Playback Button

Press it to view your images. How fun is that, right? You can even set your camera up with more than one playback button.

I currently have my AE-L button set as a second playback button, which lets me easily view images during times when I'm shooting one-handed, like when riding bikes or shooting while driving, flying, etc.

Instead of having to reach up with my left hand and use the regular PLAYBACK button, I can just tap the second button with my thumb. You could make any of the buttons control playback. You could even have three playback buttons if you'd like. Or four. Or seven.

## Scrolling

There are a few ways you can scroll though your images. The fastest way is to scroll using the front command dial. You can also use the left and right thumb pad buttons or the AF joystick. If you have a touch screen–enabled Fuji, you can swipe between images to scroll.

**If you want to review multiple images at the same time, simply turn the rear command dial to the left.** One click brings up a grid of nine thumbnails. Two clicks gives you a 100-frame grid. When viewing in either grid mode, you can scroll through all of your thumbnails using any of the scrolling methods described above.

Pressing the OK button or pressing on the joystick will bring up the image in full-size view. From there you can either scroll normally or return to the grid by rotating the rear command dial again.

## Zooming

When reviewing your images, you can press the rear command dial (use FOCUS ASSIST on the X-T1 or pinch/double-tap the LCD screen on touch screen models) to zoom in and check your images for sharpness. Once you tap, the image will zoom to the area where your selected focus zone was located when you shot the photo. Press again and it zooms back out to full size.

You can also zoom in and out by rotating the rear command dial. I recommend using the "press or double-tap" options, though; it's a lot faster. Or, double-tap on touch screen–enabled models.

### Zooming RAW Images

You should know that **if you're shooting RAW only, you won't be able to get an accurate assessment of sharpness by zooming in.**

This is because the embedded JPEG previews attached to RAW files are only medium-sized JPEGs. They're not full size. (This is true with any camera.) So, even though your images might appear sharp when you zoom in, they might not be quite as sharp as you thought when you download the file and view them on the big screen.

This is one reason why I recommend that if you like to shoot RAW, **you might as well shoot RAW+JPEG** with the **IMAGE SIZE set to L3:2 and IMAGE QUALITY set to (RAW)F.** With a full-size JPEG attached to your RAW file, you'll be able to zoom in and get an accurate view of sharpness, and you'll also have a JPEG of the image.

8.1

8.2

This also allows you to share your images much more easily, since they're much smaller and they're already processed with the look you want, at least in part, based on your chosen FILM SIMULATION and any other camera settings you might have applied. In addition, you can download and share your JPEGs quickly and easily if you're using the FUJIFILM Camera Remote app, as the app won't allow you to download RAW files.

And although you'll still have your RAW files, which obviously contain more dynamic range and allow for greater processing options, you may actually find that, in many cases, your JPEGs look great. So great, in fact, that you might decide that having the JPEG right out of the camera is more satisfying than spending time sitting at your computer processing your RAW files.

## Using the DISP/BACK Button

As I covered earlier, pressing the DISP/BACK button while in Playback mode gives you four different view options:

- **STANDARD:** Full-size image with shooting data.
- **FULL:** Full-size image with no shooting data. Nice and clean!
- **INFO:** Thumbnail image with comprehensive shooting data.
- **FAVORITES:** Full-size image with date/time, image number, and assignable "Favorites" or star rating. You can rate the current picture by pressing the selector buttons up or down to assign a star rating from zero to five stars.

During playback, pictures with assigned star ratings will be denoted by small star icons in the upper-left corner in the STANDARD view and in the FAVORITES view.

Unfortunately, these star ratings are written into the file in a proprietary, Fuji-only data format and do not correspond to the normal star rating metadata used by most photo software programs. They're for use in the camera only and are not currently exported to third-party photography programs.

## Viewing Your Shooting Data

When viewing an image in any of the view modes described above (except for FAVORITES view), you can press "up" to view all of the shooting data assigned to that image, including Film Simulation, image size/quality, exposure meter, battery level, and other screen effects you've turned on in the DISPLAY CUSTOM SETTING menu—things like framing grid, electronic level, histogram, shooting mode, etc. See chapter 7 for more on DISPLAY CUSTOM SETTING.

If you press "up" one more time, you'll be able to view all of the EXIF data that's tagged to the image, including the lens used, focal length, exposure settings, and creator/copyright info, as well as any assigned star rating.

## Playing Back Images from Other Cameras

FUJIFILM cameras will usually recognize and play back images shot with other Fuji cameras. However, there are limitations. Images shot on the 16MP cameras will look fine when viewed on the 24MP sensor cameras, but if you try to go the other way, the images will be rather blurry, or they won't play at all.

You can't perform any other playback functions on images shot with other cameras, unless they were created using the same type of camera.

8.3

# SWITCH SLOT

This menu item lets you switch card slots to view images on the other card. This is for playback only. It will still write according to the way you have it set in the CARD SLOT SETTING (STILL IMAGE) menu.

## Shortcut

On both of these cameras, pressing the joystick brings you right to the PLAYBACK MENU. If you haven't selected anything, you can just double-click the joystick to automatically switch to the other card. Or hold down the PLAYBACK button.

## Super-Important Warning!!!

If you've accessed any of the items in the PLAYBACK MENU, pressing the joystick will send you right back to that menu item. The reason that double-clicking the joystick switches cards is because SWITCH SLOT is the first item in the menu.

For example, if the last time you were in the PLAYBACK MENU you made an INSTAX print, then double-clicking the joystick would automatically try to connect to your INSTAX printer, and so forth.

**This is important because ERASE is also in the PLAYBACK MENU.** If, for some reason, you left the menu while on the ERASE setting, double-clicking the joystick will bring you right to the ERASE menu. Fortunately, it won't automatically erase your image; you'd still have to select the correct ERASE option for this to happen.

So, it's not really *that* big a deal, but it could be if you weren't paying attention.

# RAW CONVERSION

I once asked Billy from the FUJI GUYS YouTube Channel what program he uses to convert his RAW files. His answer?

"The camera!"

The X Series cameras feature an on-board RAW CONVERSION panel. This tool allows you to convert and save JPEG versions of your RAW files right in the camera. Okay, so what's the difference between this and simply shooting RAW+JPEG?

8.4

The real power of this feature lies in your ability to apply any number of different shooting options to the new file. During the conversion, you can adjust exposure, apply a different Film Simulation or white balance, adjust highlight tone and shadow tone, or even apply a different color space. You also get 100% consistent Fuji FILM SIMULATION color between your camera and your RAW conversions. Most RAW conversion software comes close with reproducing the Fuji colors, but they don't always get it 100% right.

What if you shot a killer RAW (or RAW+JPEG) photo using the VELVIA film sim? You might like how the image looks, but maybe you're also curious to see how it would look in black and white or with a Shade white balance instead of Daylight. Maybe you'd like to add a little bit of grain or increase the shadows.

You can do any one of these things. Or all of them. What if you'd like to see one version as black and white, one with darker shadows, and one with grain? You can do as many conversions as you want on any RAW file, and each one gets saved as a new JPEG image on your memory card.

This is particularly useful for photographers who prefer to shoot in RAW only, but still want to share their work using the FUJIFILM app on their phone. This way, you can select and process only the RAW files you want instead of having a duplicate JPEG of every single shot you take, which is what you get when you're shooting RAW+JPEG.

To make your conversion, play back your selected image and then press the **OK** button to bring you to the **PLAYBACK MENU**. RAW CONVERSION is the second option down.

**Even faster, when playing back an image, simply hit the Q button to bring up the panel.**

Once you're there, perform your desired adjustments and then press the **Q** button to preview the new image with your changes. If you like the edit, hit **Q** again to save the image, or you can cancel with the **BACK** button. Simple as a bowl full of ice cream.

Note: As long as you still have the original RAW file, you can stick it back on a memory card and put it back in the camera. Your Fuji will recognize the file as a valid file type and you'll be able to bring it into the RAW CONVERSION menu and process the file again.

Here are all of the available settings you can apply:

- PUSH/PULL PROCESSING
- DYNAMIC RANGE
- FILM SIMULATION
- GRAIN EFFECT
- WHITE BALANCE
- WB SHIFT
- HIGHLIGHT TONE
- SHADOW TONE

- COLOR
- SHARPNESS
- NOISE REDUCTION
- LENS MODULATION OPTIMIZER
- COLOR SPACE
- CLARITY*
- HDR*

(*X-T4, X-Pro 3, X100V, X-S10 and fifth-generation models only)

## FUJIFILM X RAW STUDIO App

If you have an X-T2, X-Pro2, or later, you can also use the FUJIFILM X RAW STUDIO app to perform your RAW conversions. Using this free app for Mac and Windows, you connect your camera to your computer and use the on-board image processor to do the actual conversion just as if you were using this function described above. The only difference is that you're using the computer to change your settings and view your results.

## HEIF TO JPEG/TIFF CONVERSION

This menu allows you to convert images shot in HIEF format to either JPEG, 8-bit TIFF, or 16-bit TIFF files. It's only an option for the fifth-generation models.

## ERASE

You can delete photos using the TRASH button on the back of your camera. You can also delete one or more photos by navigating to the **PLAYBACK MENU** and selecting the **ERASE** command.

After selecting **ERASE**, you have three options: delete the current photo (FRAME), delete a group of photos that you manually select (SELECTED FRAMES), or delete all unprotected frames (ALL FRAMES). (See the "Protect" section later in this chapter.)

Deleted pictures cannot be recovered in-camera (you might be able to save them with recovery software). Don't worry, though. You'll always get a final **"OK?"** confirmation message before any images are erased. And remember, if you ever want to back out, you can simply tap the shutter button or hit the DISP/BACK button.

## SIMULTANEOUS DELETE

This option comes in handy if you're saving duplicate images across both memory cards, like if you're saving RAW files to Card Slot 1 and JPEG or HEIF images to Card Slot 2.

If this setting is **ON** and you delete a RAW image, it also deletes the accompanying JPEG/HEIF copy from the other card.

If the setting is **OFF**, then deleting a RAW file will not delete the JPEG/HEIF copy from the other slot.

## CROP

Using this option, you can save a cropped copy of any image on the memory card.

Display your desired photo and press **OK** to bring up the **PLAYBACK MENU**, then select **CROP**. Using the rear command dial and directional buttons, zoom in and around the image to isolate the exact portion of the image you'd like to save.

Press **OK** to bring up the confirmation option, and press **OK** again to save the cropped photo as a separate file.

Keep in mind that your cropped photo will always have an aspect ratio of 3:2, but the size will be shown as either M or S, depending on how much you zoom in. If, while you're zooming, you see your dialog options turn yellow, your cropped image will be "640," which is suitable for a 4x6 print.

## RESIZE

This setting allows you to save a smaller copy of your selected photo. When you select **RESIZE** in the **PLAYBACK MENU**, you'll be given three options: **M, S,** and **640**. (This assumes you're shooting with an IMAGE SIZE of L. If you're shooting M or S, you may see different options.)

Choose your desired size and press **OK** to save the image as a separate file.

8.5

## PROTECT

You can protect photos from being accidentally deleted from your memory card. Select from one of these options:

- **FRAME:** Protect selected images. Press the selector left or right to view your photos and press **MENU/OK** to lock and unlock specific images, one at a time. When you're done, press **DISP/BACK** or tap the shutter button.
- **SET ALL:** Protects all pictures on the card.
- **RESET ALL:** Removes protection from all pictures on the card.

Protected pictures are displayed with a small "key" icon at the top of the frame whenever you're viewing pictures in STANDARD mode. Protected pictures cannot be assigned with star ratings, nor can they be rotated or erased.

Note: Formatting your memory card will delete all images, even those you have assigned as protected.

## IMAGE ROTATE

This menu item allows you to rotate your images directly from the **PLAYBACK MENU**. Simply select an image, go to **ROTATE,** and follow the prompts.

Note: Protected pictures cannot be rotated.

## RED EYE REMOVAL

This menu item removes red-eye from portraits. The camera looks at the image, and if it detects a face with red-eye, it will process the image and create a copy with reduced red-eye effects. If the camera cannot spot a face, it will give you a "CANNOT DETECT" message.

Note: You cannot re-perform RED EYE REMOVAL on a photo you've already processed with this setting.

## VOICE MEMO SETTING

This is another cool feature that was added in a recent firmware update. It's found on the X-T2 and later.

This feature lets you record a 30-second voice memo to any single image. In the **PLAYBACK MENU**, turn on **VOICE MEMO RECORDING** and press **OK**. Then back out and go back to your shot images.

While viewing your selected image, press and hold the front command dial until you see the little "red dot" recording light come on. (It takes a few seconds, so be patient.) Keep holding the button down and start talking. Or play music, or make sound effects or whatever noise you want. When you're done, release the front command dial.

Your voice memo is now saved. When you play back the image, you'll see a little "voice memo" icon over the picture.

To play your voice memo, simply press the front command dial. (You don't have to hold it down during playback.) If you want to overwrite your memo, simply press and hold the command dial again and record a new message.

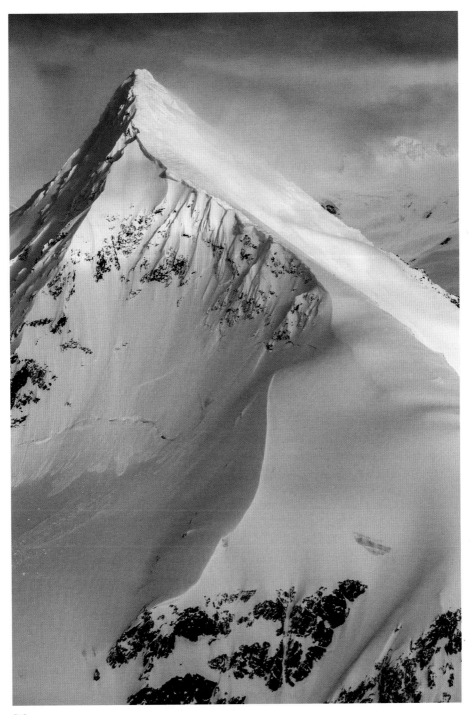

8.6

### How You Can Access Voice Memo in Lightroom

When you import any file that has a voice memo attached into Lightroom, the corresponding audio file will also be imported. Here's how to play it back:

1. After you import the file into Lightroom, press "G" for Grid View and select a photo that has a voice memo attached to the file.

2. On the right side of the Lightroom window, open up the "Metadata" tab.

3. Inside the dropdown box, you should see a section that says "Audio File." Click the little arrow that points to the right where it says "Audio File," and it will play back your recorded voice memo.

## RATING

This allows you to tag your pictures with star ratings. As previously mentioned, these ratings are not read or recognized by third-party photo software.

## IMAGE TRANSFER ORDER

This menu setting lets you select JPEG photos for upload to a smartphone or tablet that's paired to your camera via Bluetooth. At the time of this writing, this works with the X-E3 only, but I suspect that future X Series cameras will have this feature.

When you select this menu item, you can then highlight photos and press **OK** to select or deselect them for transfer to your device. **You can also add images to the transfer queue by pressing the AF-L button while reviewing images in Playback mode.**

Once you've completed your IMAGE TRANSFER ORDER, the selected images will be sent to your device automatically. The nice thing is that the transfer happens in the background; you don't need to pull up the app on your mobile device.

## COPY

Use the **COPY** function to copy images from one card slot to another. Choose one of the following options and press right on the selector:

- **SLOT1 to SLOT2:** Copy pictures from card #1 to card #2.
- **SLOT2 to SLOT1:** Copy pictures from card #2 to card #1.

Then highlight one of the following options and press **MENU/OK**:

- **FRAME:** Copy selected pictures. Scroll left and right to view pictures, using the selector buttons or either command dial, then press **MENU/OK** to copy the current picture.

- **ALL FRAMES:** Copy all photos.

## WIRELESS COMMUNICATION

This setting allows you to connect your camera to smartphones and tablets running the FUJIFILM Camera Remote app on your iOS or Android phone or tablet. Once connected, your mobile device can be used to browse the images on the camera, download selected images, control the camera remotely, or upload location data to the camera for geotagging your images.

As I mentioned earlier, all of the X Series cameras have a dedicated Wi-Fi button or a Fn button that has this setting assigned by default.

If you use a Bluetooth-enabled Fuji, you can simply initiate the connection right from the Camera Remote App. Once you're connected, you can browse and download images, control the camera, and shoot photos or movies remotely.

## Wi-Fi Problems and Dropped Connections

If you're using the camera Wi-Fi in an urban area where there are many other active wireless networks all around you, the connection can get a little spotty and it may drop off suddenly. Or the app will just quit.

I've had it work just fine in remote mountain areas, and yet sometimes I have the hardest time downloading even a single image at an airport or a downtown coffee shop. If you experience drop-offs, try moving to a different area away from other Wi-Fi signals.

# SLIDE SHOW

This item allows you to view your photos as a slide show. Press **MENU/OK** to start, and press the selector right or left to skip ahead or back. Press **MENU/OK** again to stop.

# PHOTOBOOK ASSIST

This is a fun feature! It allows you to create and display collections of images where it looks like you're flipping through a stack of tiny prints or turning the pages of an itty-bitty photo album. The photos end up a little smaller on the screen, but they have added presentation value, which can be nice.

To create a PHOTOBOOK, select this item in the **PLAYBACK MENU** and then select **NEW BOOK**. You can then scroll through your images and follow the prompts for choosing images for your book and selecting a photo for the cover. If you don't select a photo for the cover, the first image you selected becomes the default cover image. (Books can contain up to 300 images.)

When you're done, press **OK**, and the new book will be added to your list. You can now go back to the main menu and flip through your book. If you'd like to make changes or delete the book, press **MENU/OK**.

Unfortunately, you can't change the name of your PHOTOBOOKS; they're stuck being titled BOOK 1, BOOK 2, BOOK 3, and so forth. It would be a nice touch to be able to rename them.

If you use Fuji's MyFinePix Studio Software for Windows[20], you can copy your completed PHOTOBOOKS to your computer. (I've never used the software, so I can't comment on whether it's worth downloading or not.)

## PC AUTO SAVE

PC AUTO SAVE operates very much like the Camera Remote app for your phone, except it allows you to send pictures straight from your camera to your computer.

In order for this to work, your computer needs to be running the FUJIFILM PC Auto-Save app. It's a free download, and there is a Mac version and a Windows version.

For more information on how this app works, visit the FUJIFILM website.[21]

## PRINT ORDER (DPOF)

This setting allows you to create a digital "print order" for DPOF-compatible printers. (DPOF stands for Digital Print Order Format.) This is a format designed for recording print information onto your memory card, including which of the images shot using a digital camera are to be printed and how many copies are required of each print.

Unfortunately, like a lot of technology formats, this one seems to have passed. DPOF format is not used much these days, since most printers are going wireless. However, if you have a printer with an SD card slot, this feature may still work for you.

To start your PRINT ORDER, select this item in the menu, then choose whether you want the recording date printed on your pictures or not. Press **RESET ALL** to erase and start your order again, if you wish, then hit **MENU/OK**.

You can now go through your images to choose which ones to print and how many copies (sheets) of each you'd like to print. When you're done, press **MENU/OK** again.

Now, all you have to do is insert your memory card into a DPOF-compatible printer and press Print, and the PRINT ORDER information on the card will tell the printer which image to print. It's as simple as that.

## INSTAX PRINTER PRINT

If you have an INSTAX Share printer, you can print right from the camera. Turn your INSTAX printer on to initiate the wireless connection, then select this menu item on the camera.

Once it's connected, you can scroll through your frames to find the image you want to print. Then press OK to send it to the printer. Once you press OK, the printing process will begin and you'll have your print. Just like magic.

I love the INSTAX system! It's really a lot of fun, whether you're printing right from your camera or to your smartphone. The latest generation of the INSTAX SHARE SP-2 printer even has increased image quality and better dynamic range.

8.8

There's just something classic about taking a picture and being able to turn it into a tangible, baseball-card-sized print right before your eyes.

## DISP ASPECT

When connecting your camera to another device using an HDMI cable, this setting lets you choose how HD devices display pictures with an aspect ratio of 3:2.

Choose **16:9** to display the image so that it fills the screen with its top and bottom cropped out, or **3:2** to display the entire image with black bands at either side.

## YOU'RE DONE!

Congratulations! You made it through the entire book! Thanks for sticking with me through some of the more boring topics. You now know what every single feature and all the menu items do on your X Series camera. It's time for you to put this incredible bank of knowledge to good use.

I'll say it one last time: Photography isn't about accuracy; it's about look, feel, and creative intention/experimentation. And, of course, fun. There are no rules. There is only what you show and how you get there. As long as you get the shot you were hoping for, or at least feel good about the images you're getting, and you enjoy the process, then that's all that matters. No one can take that away from you.

I wish you the best of luck, and I hope you find the same kind of personal enjoyment with your photography and your Fuji cameras as I keep having every time I pick one up and head out the door.

Now take your newfound camera skills and go have some adventures! I look forward to seeing some of you out there and meeting you at a future event or workshop.

Thanks for reading.

—Dan Bailey, July 2017 (revised spring, 2023)

**8.9** On the summit of Arthur's Seat during my 2016 Edinburgh, Scotland, photo walk (Photo by Lauren MacNeish)

# ONLINE REFERENCES

1  http://danbaileyphoto.com/blog/fuji-tips-and-tricks-my-10-favorite-settings-
   for-the-fujifilm-x-series-cameras/

2  www.fujifilm.com/support/digital_cameras/manuals/x/

3  http://macphun.evyy.net/c/339076/325219/3255

4  https://en.wikipedia.org/wiki/Autochrome_Lumière

5  http://amzn.to/2BKEvLT

6  http://www.fujifilm.com/support/digital_cameras/software/fw_table.html

7  http://www.fujifilm.com/support/digital_cameras/software/firmware/x/compact/

8  http://lightroomsolutions.com/jb-xlr/

9  http://danbaileyphoto.com/blog/ebooks/going-fast-with-light-ebook/

10  http://danbaileyphoto.com/blog/shadows-are-your-best-friend-in-photography/

11  http://fujifilm-dsc.com/en/manual/x-t2_v2/peripherals_and_options/
    external_flash_units/index.html

12  https://www.youtube.com/watch?v=4UVGtLUEiuI

13  http://www.fujifilm.com/support/digital_cameras/software/lut/

14  https://en.wikipedia.org/wiki/Smoot

15  http://fujifilm-x.com/us/x-stories/fujifilm-x-raw-studio-features-users-guide/

16  http://fujifilm-dsc.com/en/manual/x-t2_v21/peripherals_and_options/
    wireless_tether_shooting/#introduction

17  http://www.fujifilm.com/support/digital_cameras/software/hsv5/win/download.html

18  http://fujifilm-x.com/us/x-stories/fujifilm-x-acquire-features-users-guide/

19  http://www.fujifilm.com/news/n161031.html

20  http://www.fujifilm.com/support/digital_cameras/software/myfinepix_studio/

21  http://app.fujifilm-dsc.com/en/pc_autosave/index.html

# INDEX